HYBRID CULTURE:

MIX-ART

JAMES W. DAVIS

KENDALL/HUNT PUBLISHING COMPANY
Dubuque, Iowa 52002

Front Cover Design: Bree Rogers
Back Cover Design: May Suen
Interior Design: Bree Rogers & May Suen

Cover image courtesy of Fonds National d'art Contemporain, Paris.

TABLE OF CONTENTS

ACKNOWLEDGEMENTS iv

INTRODUCTION 1

1. BORDER CROSSINGS: 10
Codices, Commentaries, and Conundrums by Enrique Chagoya

2. ART IN THE PETRI DISH: 44
The Parallel Micro-Worlds of Ken Botto

3. HYPHEN-SPACE: 73
Spaces Between Places in the Work of Gail Dawson

4. ASSEMBLY REQUIRED: 90
The Constructed Body

5. CORPUS TRANSITUS: 105
Orlan's Metamorphology

6. THE RASHOMON FACTOR: 123
Hidden Meanings in Works by Chester Arnold and Luna Topete

7. CHRON-ILLOGICAL TIME: 144
A Woman's Take on Manet's Olympia

8. THE NEW SALON DES REFUSÉS: 154
The Phoenix Factor in Works by Brian Goggin and Mildred Howard

ENDNOTES 166

CREDITS 172

INDEX 175

ACKNOWLEGEMENTS

Special thanks is extended to the two very talented and hard working designers who took on the difficult task of designing, formatting, integrating, and developing this book from its original condition as a sequence of relatively independent parts into a cogent and meaningful whole. Both of these designers worked as a collaborative team, and were far more under control than the author, especially when one considers the fact that they assumed and accomplished this massive job within a very brief time frame. For all this, I will be eternally grateful to Brianne Rogers and May Suen. It has been a joy working with them. Their efficiency, creative problem-solving skills, knowledge, dedication, and work ethic all went far beyond the norm.

Above all, the cooperation and support by the nine artists who are featured in this book are to be commended for their support and belief in the importance of the project. Their true natures are completely opposite to that tired old cliché in which artists are erroneously described as flaky and dysfunctional personalities. This claim is clearly not the case, and the publication stands as clear testimony to the vision, intelligence, and pertinence of art within their lives, and within ours as well.

INTRODUCTION

This book attempts to critically consider the presence and roles of hybrids within contemporary culture and the visual arts. Toward this end, a "hybrid" is defined as being a fusion of two or more otherwise discrete or alien elements that, when merged, result in an entirely new form or function. Attending this new, emergent form are new meanings in which one can recognize at least something of the original connotations of each constituent part, but now with an added overall meaning resulting from the hybridization. Both the original (localized) meanings and the new, hybrid (overall) meaning are usually collectively recognizable.

The author has been intending to write this book since 1967 when first developing a series of critical commentaries that included discussions on ways in which hybrids were increasingly appearing in the visual arts.[1] In the initial published article dealing with this topic, it was argued that almost all art is fundamentally a matter of hybridization because such works, to some extent at least, tend to all involve juxtapositions and combinations of visual elements that, when joined, result in a new meaning. It was also argued that such hybrids resulted regardless of whether the works were predominantly formal or figurative (involve recognizable subject matter) because both kinds of art involve combinations of visual elements. When such works are figurative, the fusion of subject matters result in more literal hybrid meanings in addition to those involving synthesis considered in formal terms alone.

At the time of these initial writings, hybridization had already become a common feature in my own creative work in a number of ways, and I was simultaneously becoming aware of its presence in the work of other artists. I was also beginning to recognize a corresponding presence of hybrids as an attribute within most areas of culture in general. Throughout the period since these first writings on hybrids commenced, there has been a relatively continual increase in both the types and numbers of hybridized expressions both within culture and in the arts. This explosion in hybridized forms may be perceived as an inevitable outgrowth of a parallel increase in the complexity within most cultures on a global level, not just in America alone. Furthermore, this increased complexity may be perceived as a direct outgrowth in the intercultural interactions, infusions and mixings of new ideas, and the increase in conceptual sharing that has occurred between cultures in the rapidly shrinking world.

Of course, thinking about writing a book on a given subject and actually doing so are two different things. But once the pervasive presence of hybridization became obvious to me, I knew I *had* to write the book. The turning point was the moment of realizing that what had previously been a mere interest in writing briefly on a topic had now become both a necessity and a matter of deeper inquiry.

The reader is no doubt aware that many others are already talking or writing about

hybrids as a major phenomenon in most areas of human life, in terms of languages, the sciences, technologies, and the arts. At the most fundamental level, we already know that each of us is an individual example of a hybrid since we were created from a combination of two distinct sets of DNA, with one from each parent. When the two sets of DNA were combined through the merging of a human egg and spermatozoa, a unique individual was formed. It is hard to imagine a more obvious form of hybrid, nor one so personal in nature.

Beyond our individual attributes embodying the undeniable and fundamental presence of hybridization as a root phenomenon in life, we can find many other examples paralleling this throughout the sciences, and especially in biology. For example, recent researchers in genetics report that transplantations of cells taken from the eyes of mice that can see have been implanted into the eyes of mice that can't see, resulting in restoration of vision. Such hybridization of cells suggests possible cures for humans suffering from macular degeneration. Related research using human stem cells holds similar hope for many with highly debilitating illnesses, such as Parkinson's disease or Sickle Cell Anemia. In medical science, we also find opportunities for rehabilitation and increased body function through development of hybrid methods, including organ transplants, prostheses, psychotropic medication for schizophrenia or ADHD, and countless other examples of bio-chemical combinations and infusions that bring relief or life-saving opportunities to many.

In the field of horticulture, we have been aware for centuries of the advantages for deploying hybrid grafts that combine (attach) the shoots and trunks from two or more plants, or through inter-seeding methods, in order to create better tasting, longer lasting or disease-resistant grapes, fruit trees, or corn. In agriculture, the productivity and quality of meats, milk and numerous other farm products have been improved considerably through interbreeding and related animal husbandry techniques.

Fusions in languages, foods, clothing styles, automobiles and numerous other things within our lives are the result of various mixings and hybridized processes. No doubt the reader can think of many related examples within her/his own life in which such hybrids have contributed to the quality of life or provided otherwise nonexistent opportunities. Of course, many trivialities will no doubt come to mind as well.

The earliest forms of hybrids are rooted in many kinds of historical events and conditions. One form of these resulted from the movements and encounters among differing cultures. Such cultural inter-mixings resulted in new forms of political thought, new kinds of religious assumptions, new world-views and expressions that had never existed before. The idea of a hybrid is as ancient as civilization itself, and it is entirely global. Obvious and well-known examples of hybrids within very early cultures include the chimera of antiquity (a mythic monster comprised of a mix including a lion's head, goat's body and a serpent's tail), the griffin of ancient Babylonian origin (eagle's or hawk's head, lion's body, serpent's tail), the Aztec creation deity called _Quetzacotl_ (with a bird's head and serpent's body), or the minotaur of Greek mythology (bull's head and human's body; an Assyrian version employed a reversal with a human head and bull's body).

INTRODUCTION

In America, perhaps the most notable form of social hybridization may be found in what has been referred to as the "melting pot" characteristic first identified during the 1950s. At that time, cultural uniformity was the motivating ideal. The melting pot implied a togetherness that transgressed significant differentiating traits both within individuals and within cultural groups comprising the culture taken as a whole. One was "American" first and foremost, and whatever forms of skin colors, unique cultural perceptions, differing beliefs, world views, and varied lifestyles comprised it at a deeper level were all considered secondary concerns under the aegis of an all-pervasive nationalism. But this cloak of patriotic uniformity masked a multitude of discriminatory attitudes and laws, and, during the two decades subsequent to the 1950s, the importance of recognizing and addressing these "underlying" differences–and the concurrent fact that people weren't treated equally–began to manifest themselves through increasing cultural conflicts.

It can easily be argued that the underlying differences between individuals and groups provide a democracy with its unique vitality and vision. Recognition of, and allowance for, such differences are what initially made the country unique when it was founded, though the present ethnic diversity is largely a product of more recent history. Recognition and celebration of differences have come slowly and painfully, and they are obviously still evolving. Even though human differences haven't been fully accepted by all Americans, they have (based upon the law at least) been "protected" for over two hundred years in the Declaration of Independence and Bill of Rights. While the first of these documents establishes a priority for life, liberty and the pursuit of happiness as unalienable rights, the second provides absolute freedom in matters of belief, speech, the press, assembly, and opportunity to redress what might be considered to be errors in government. Even more than two hundred years after the Declaration of Independence and Bill of Rights were written and "accepted" as precepts for American liberty, however, there continues to be opposition toward giving full and equal opportunity to others who don't conform to a stereotypical definition of what constitutes an individual American. In short, true cultural hybridization is more of an ideal than a reality at present, and the melting pot metaphor (we're "all Americans" as the pre-emptive notion of identity) served mainly to sidetrack attention from the remaining economic and social steps required for all individuals to be treated in a truly equal manner.

After determining that the general purpose of this book would be to focus upon major ways in which hybridization has increasingly characterized our lives, the next step was to determine major themes or ways in which this has happened, with one to be stressed in each chapter. After the chapter themes were established, the selection of artists occurred. A revision of the concepts being stressed within each chapter occurred with this integration of the ideas unique to each artist. One goal was to establish a balance between the ideas that seemed necessary for the book taken as a whole, and the unique works represented by the various artists.

When speaking of hybrids within art, other writers have commonly used the term more as an aspersion than as a constructive identifying feature. This may be

due to a lingering assumption that anything that involves combinations of elements from differing sources couldn't possibly be "pure" enough to be taken seriously. Similarly, modernism itself has been largely constructed on the prevailing idea that "art is about art." There are discussions about this issue that appear in several places in the main text of this book. Furthermore, the nature of a hybrid has continued to be thought of as something unnatural or uncomfortable, perhaps even contradictory. It is frequently considered to be a combination of elements that simply don't belong together in the first place, as if the previously alien but now constituent parts had been somehow coerced to cohabit the same body or condition. Hopefully one can see how the maligning nature of this view leads one to things that such works are products of a dictatorial and unnatural sort. Such fusions have been considered "weird," "against nature," "contradictory rather than sensible," "surreal," "nightmarish," or any number of other unappealing circumstances or results that ultimately lead one to assume that they shouldn't be taken seriously.

In response to such biases toward the very notion of hybridization, one can only offer the simple truth: almost everything in the universe is fundamentally a hybrid. Accept it or live in denial. Furthermore, purity is an illusion.

The themes for each chapter was chosen based, in part, on the degree of its importance as a major form of hybridization in both contemporary culture and in art. These hybrids form at junctures within time, space, and culture, and–on a very personal level–within our own bodies. The chapter themes include:

1. *Border crossings.* Intercultural hybrids are formed at the intersections between differing social groups, and involve combinations, and even reversals, in the traits or assumptions originally contained from within each of the contributing cultures. Parody is a frequent trait of such hybrids;

2. *Parallel micro-worlds.* These small, artificially constructed worlds parallel what we normally consider to be the larger, "real" world, but are every bit as real as their larger counterparts. They serve as sites for miniaturized experiments–whether in art or science–and ultimately provide some form of feedback to the larger world;

3. *Hyphen-space.* This is a space between simultaneous and otherwise invisibly connected worlds, where hybrid ideas that reflect upon the separate worlds may be formed;

4. *Constructing the human body.* This possibility provides opportunity for hybridization from body parts that were previously discrete and alien elements. The result is a new living body. Western culture has had a love/hate relationship with this possibility for many decades;

5. *The transience of the human body.* By re-defining the human body as a site of continual change, it becomes both what it is (changing) and what it can be (an extension of thought and attitude). Artists and others are increasingly claiming their own body as a location for personal expression and a site of personal, rather than external, control;

6. *Communities of hidden meanings.* These hybrids result from a layering of multiple meanings that must be unraveled over time, and can't be "read" instantly or simultaneously. This form of hybrid requires reflection and time; the longer one looks, the more one sees;

7. *Resurgent imagery.* This form of hybrid involves time-mergers, with images being transplanted from the past and filtered through and joined with present perceptions and realities;

8. *A new kind of Salon des Refusés.* This is a methodological approach in which hybrids result from redeployment of discarded materials and objects, with these being relocated to new circumstances and environments where new meanings may be formed.

After establishing the above conceptual frameworks, the next goal was to determine which artists might best serve to exemplify each theme through the unique approach taken in their creative works. Early in the process it became clear that the San Francisco Bay Area had an abundance of artists who had been using a variety of hybrid concepts, methods and themes closely paralleling those being addressed in the book. It was equally obvious that works by these artists were at least comparable in overall quality, imagination and execution skills to what one found elsewhere. One hope was that each artist's work would provide more than an illustration of a given theme. In fact, it was desired that each such work be unique and stimulate further thought concerning the role and implications of hybrids in contemporary culture. It seems impossible to imagine a better group of artists for this purpose than those ultimately included.

Another unique facet of this venture was that the writing of each chapter included more dialogue with the artists involved than is normal. Typically, a critic writes with little direct reference to the ideas of the artists themselves. In this case, however, each chapter was shared (via email or snail mail) with the artist(s) being discussed, and opportunity for feedback was provided. Only two of the nine artists included didn't (or, more accurately, couldn't) respond, largely because their gallery or another agency was serving an intermediary role, which made it difficult to have direct communications. However, most of the artists did engage in direct dialogue with the author, and several of the insights that this provided helped steer the discussion in new and meaningful directions. In a related vein, direct phone discussions with most of the artists were also conducted during the writing process, resulting in additional useful ideas and information. With four of the nine artists included, interviews were conducted in order to supplement the text with directly obtained information. These are included in the pertinent chapters (the artist with interview included: Enrique Chagoya, Ken Botto, Gail Dawson, and Luna Topete). It seems important, too, that all of the artists expressed highly enthusiastic and positive views toward the project and their relationship to the critical and cultural issues being addressed within it. All of the artists considered the presence and importance of hybrids to be important both in their works and in contemporary culture. It is gratifying to know that the assumptions

serving as the underlying premise of the book were considered valid by those whose works served as examples. This correlation was very important to the author.

In the end, all of the artists except one lived in the Bay Area at the time of writing the given chapter associated with their work. One might be struck by the fact that a significant number of these artists have been focusing upon themes closely related to the book in their work. The large number of artists employing hybrid ideas and images initially struck the author as surprising, but, upon further reflection, the reason became more obvious: the very essence of hybridization—as a merging of differences—is a given in this region of the country perhaps more than in most others. One could even argue that this is one of the defining characteristics for the San Francisco Bay Area, along with its arts scene, and has been for some time. It isn't merely that "differences" comprising the culture in this region are more extensive than elsewhere (though they historically have been), but these differences reach more deeply into the conceptual, visionary, scientific, medical, and cultural landscapes than one tends to find elsewhere. This doesn't mean that there weren't other artists, from other regions, who could have comfortably fit into one or more of the select themes, but no single geographic region, in itself, so thoroughly exemplified one of the main assumptions embodied in the book: that from combinations of differing elements invested within a hybridized form of expression, new and meaningful meanings could emerge. The one geographic exception is Orlan, a French artist, who, since 1999, has split her time living in Los Angeles (also in California of course) and New York City. But she is frequently considered to be a special "affiliate" of the Bay Area due to her particular vision, ideas and creative sensibility. Also, given her many visits and lectures at local sites, such as Southern Exposure Gallery in San Francisco, she has maintained a dialogue with artists and others in this area. Perhaps most significant, her form of bodywork in essence serves as a far-reaching study in cultural criticism, as a continuing metamorphology with global implications that will be addressed in the chapter featuring her work (Chapter 5). On a related note, one other artist (Luna Topete) subsequently moved from the Bay Area to Southern California after the chapter associated with his work was completed.

Because hybridization has served as the overall theme for this book, the first half of each chapter is dedicated to a relatively extensive introductory discussion on the particular form being examined. This discussion includes consideration of literary, political, philosophical, and cultural precedents to the chapter's premise, potential connotations of the theme, and consideration of some variants that are suggested when employing differing conceptual tracks related to the topic. It is hoped that the depth and extent of these discussion will assist the reader to better understand the implications of the premise underlying each chapter.

It was found that the introductory commentaries used in each chapter energized and more clearly shaped the general discussion, as well as provide a framework for the discussion on creative works that followed. More commonly, books on art criticism seem to be primarily centered upon discussion of images considered more as ends in themselves, rather than as extensions of the cultures in which they are formed. It

is also notable that the discussions on the artists' works tended to provide a concrete visual parallel both complementing and expanding upon the chapters' premises.

A brief summary of each chapter is provided below. However, the reader is cautioned to interpret these summaries as rather terse suggestions concerning the contents rather than definitive statements. Only two or three of the major points later made within each chapter could be squeezed into brief summaries of this kind.

Chapter 1 is entitled "BORDER CROSSINGS: Codices, Commentaries, and Conundrums by Enrique Chagoya." This chapter stresses ways in which cross-cultural hybrids result from images that Enrique Chagoya fuses while drawing from sources as far-ranging as his roots in Mexico, pre-Columbian cultures, American pop icons and European tradition. The resultant works comment upon contemporary inter-cultural political struggles and issues.

Chapter 2 is called "ART IN THE PETRI DISH: The Parallel Micro-Worlds of Ken Botto." This section examines artificially constructed small worlds that have appeared in various realms of contemporary human life, such as the petri dishes employed by medical researchers. In these small, constructed environments scientists and medical researchers introduce, manipulate and experiment with organic materials. These spaces are micro-worlds that parallel the larger world with which we are familiar. The results from such experiments are then relocated into the larger, macro-world in which we live our daily lives. In Botto's work, a closely similar micro-world is constructed through combinations and arrangements of small objects the artist has collected throughout his life. The combinations of small objects are result in small sculptural environments, which are then photographed as commentaries upon the tragedies and conflicts that are prevalent within our larger, ordinary world.

Chapter 3 is named "HYPHEN-SPACE: Spaces Between Places in the Work of Gail Dawson." This segment inquires into new ways of understanding both space and place, as involving events occurring between two places or spaces, where things can be examined and understood in new ways. Dawson also creates works that explore realms at the intersections of seemingly discrete media, such as painting, TV, and video, and, in so doing, experiments with the transferability of features and concepts from one to the other.

Chapter 4 is "ASSEMBLY RFEQUIRED: The Constructed Body." This portion of the book evaluates the prospects for constructing the human body from scratch, using otherwise discrete and seemingly alien body parts. This process is sometimes identified as the "Arcimboldo Effect," based upon the odd portraits of a Renaissance artist who fabricated images of people using a variety of images derived from sources outside the human body, using fruit, vegetables or animals as body parts. The chapter begins with a discussion of Mary Shelly's *Frankenstein: or The Modern Prometheus*, and considers the on-going relevance of this story in matters concerning construction and reconstruction of the human body, and of life itself, within contemporary medical practice. Relationships between this phenomenon and a work by Ken Botto (entitled *Séance*) are addressed. The artist's use of artificially constructed bodies to serve as surrogate humans within fabricated environments are examined. Further consideration

is placed upon possible parallels that might be drawn between virtual and fabricated life forms.

Chapter 5 is called "CORPUS TRANSITUS: Orlan's Metamorphology." This chapter examines hybridization as the fusion of external elements into and upon an existing human body, and also considers prospects for a new definition of the human body as a perpetually changing site or landscape. We will take note of various ways in which works by Orlan have embodied experiments with this theme for several decades and in a variety of ways. The artist's use of her own body as the location for re-sculpting her self-image, using both surgical and digital methods, will be examined in terms of methods employed. Additionally, cultural questions that are raised from her use of these processes will be considered.

Chapter 6 is identified as "THE RASHOMON FACTOR: Hidden Meanings in Works by Chester Arnold and Luna Topete." This segment discusses the phenomenon of the simultaneous presence of multiple or hidden meanings within individual works of art, and the subtle paths that one must pursue in order to unravel meanings that intertwine. The concept is discussed as a manifestation of the way in which the famous Japanese film-maker, Kurosawa, constructed his film called *Rashomon* in which several witnesses to a murder and rape testify in conflicting ways, suggesting the multiple ways in which "reality" is constructed, and also the ways that we all perceive things uniquely. The principle artists whose works serve as examples for this discussion are Chester Arnold and Luna Topete.

Chapter 7 is entitled "CHRON-ILLOGICAL TIME: A Woman's Take on Manet's *Olympia*." This portion addresses the hybridization of images transplanted from past times and cultures into the present, where they are subject to a merging with contemporary perceptions and experiences. The reclining female has been a common subject throughout the last four hundred years, but almost always as a subject examined from a male perspective. This chapter evaluates the unique attributes that a woman might bring to this traditional subject in Western art, with a focus upon a specific work by Jessica Walker that is constructed so that those who experience it are encouraged to interact within, and collaborate in, its presentation.

Chapter 8 is referred to as "THE NEW SALON DE REFUSE: The Phoenix Factor in Works by Brian Goggin and Mildred Howard." This chapter considers prospects for things that have been discarded being reused as elements within works of art. It also includes consideration of two distinct ways in which this can be achieved—one as social commentary and the other as a personal odyssey—and exemplified in works by Brian Goggin and Mildred Howard.

Finally, the anticipated audience of this book has been a significant factor in shaping the technical and production considerations. One can see from the above chapter summaries that the emphasis throughout is oriented toward serious social criticism as the framework within which creative works are discussed. We have attempted to avoid approaching the nature and roles of hybridization in culture and in art as a matter of superficial concern. As a consequence, the result is not a big coffee table book composed of splashy color reproductions throughout, and with

cozy little anecdotes on the artist's preference for cocktails, clothing styles or a view of the beach at Malibu. Instead, we find a limited number of black and white reproductions, low-cost production methods and an emphasis upon ideas with some degree of social gravitas. The ideas stressed throughout, along with the creative works chosen to exemplify these, tend to unflinchingly confront matters of human struggle and inequity, as matters directly linked to survival and life rather than as examples of pure aesthetic concerns alone. The results will thus be of more interest to those with academic, creative or critical inclinations, rather than those with name-dropping interests. Similarly, the selection of artists was similarly approached with a seriousness of intent in order to assure that the creative works to be included not only parallel the critical discussion accompanying them, but also cause one to stop and reflect upon the powerful implications conveyed by these works.

BORDER CROSSINGS:
Codices, Commentaries, and Conundrums
by Enrique Chagoya

The border is many borders. It is the physical border of today, the historical border of yesterday, the mythical border of everyday. It is a psychological border, always to be crossed. It is a place of consequence, interaction, creativity, transformation. For Chicanos, the border is a state of mind.

In 1848, at the end of the U.S.-Mexico war, Mexico lost all its land north of the Rio Grande River and elsewhere—more than half its total area. The border changed overnight. Some 100,000 Mexicans became instant U.S. citizens. Their descendents say, 'We didn't cross the border, the border crossed us.'

— René Yáñez, Curator, *CHICANO NOW: American Expressions* Exhibition, de Young Museum, San Francisco, 2006.

Following the events of September 11, the fetishization of Otherness by the global media and the sanctioned culture of extreme behavior as depicted on TV, movies, and the Internet have suddenly become unfashionable again. The Other is once again perceived as seriously threatening, as "un-American." There's been a total overnight shift of parameters and attitudes toward, say brown people. We are no longer hip, sexy, and exotic creatures on the global menu. In the world according to Bush and his evangelical cowboys, we are all "suspicious."

The "mainstream bizarre" has been temporarily deported back to the old silent margins, and dominant culture has become once again extremely centralized, authoritarian, euphemistic, and artificially wholesome...like in the 1950s. It's back to the pre-civil rights era. It is no coincidence that the two most popular movies of the season are 'Harry Potter' and 'The Lord of the Rings.' Americans want to escape. The world seems too incomprehensibly frightening.[1]

— Guillermo Gómez-Peña, in *Ethno-techno*

When a stranger sojourns with you in your land, you shall not do him wrong. The stranger who sojourns with you shall be to you as the native among you, and you shall love him as yourself; for you were strangers in the land of Egypt: I am the Lord your God.

— *Leviticus* 19: 33-3

It seems fitting that the first chapter of a book dedicated to examination of hybrid expressions in the visual arts focus upon the work of an artist whose work confronts the political and social debates concerning both the cultural and national borders. This is especially fitting within a society that has built strength and character as a compository of differences in terms of its citizenry, traditions, beliefs, political

premises, and arts. These attributes are, to a large extent, traceable to a long history of involving interactions and contributions of a citizenry from dramatically differing cultural and ethnic origins.

In addition it its role as a major trait of American society considered as a whole, the notion of a "unity of the many" (*e pluribus unum*) is also notable as a prevailing feature of many of the sub-groups that comprise the American cultural enterprise. The phenomenon of the many within the one–but now as a condition of personal, internalized hybridization–is also a significant and defining attribute characterizing many individuals within American society. Enrique Chagoya is clearly one who epitomizes hybridization at a personal level, and for whom an accurate portrayal is impossible without accounting for the confluence of characteristics that energize his art. We will attempt to examine this artist's work in ways that both acknowledge the presence of cultural hybridization influences and also ways in which his work can be considered on its own terms, as a unique panorama of perceptions formed from seemingly countless and every-changing threads of thought and influence. But, as will also be the case with our ensuing chapters, we will first provide a conceptual framework addressing significant factors that are of special import as underpinnings of our general theme. In this case this theme concerns cultural borders and their impact upon the experiences, thinking, and expressions of those who are most intimately impacted by the prevailing attitudes toward those borders. This discussion will also include consideration of the impact of Chicano and border experiences that influence art forms produced within the United States today.

There are thus three primary areas of concern that we will initially consider. These include:

1. *The emergence of a unique and difficult form of hybridization that often results within Third World Nations when they experience a rapid change from a traditional and agrarian form of society to one that is modern and industrialized.* Such changes have occurred, in part, from the recent move from relatively localized forms of economy to those that are suddenly globalized. Countries that experience this change within a very short time span often end up lost, or struggling, within an awkwardly formed hybrid space that is located somewhere between the old and the new, the traditional and the modern, and has features of both without quite being either;

2. *The long tradition of hybridization that has existed within Mexican culture and its arts for many centuries.* This inquiry will include consideration of unique composited forms that existed during pre-Conquest periods of Mesoamerican culture. We will also examine hybrids that resulted from the intercultural mixing of ideas involving a mixing of recollections and continuities from past traditions with new ideas and forms brought with, and after, the colonization of post-Mesoamerican cultures;

3. *The present highly charged cultural debate concerning the role and nature of*

borders between cultures and nations. This debate has recently focused upon the borders between the United States and its two neighbors of Mexico and Canada. Repercussions from this debate endanger the positive nature of relationships between these countries (during recent years at any rate), and the role of the borders as sites where cultural interactions were commonly characterized by relatively simple and free access.

From these topics, we will begin with a brief discussion concerning hybridizations that have resulted in Mexican and Latin American societies as a result of rapid changes from agrarian to modern societies. In *Latino and Latina Writers* (2003), editor Alan West-Duran observes that a commonality among all Latin American writers lies in their willingness "to explore and explicitly examine cross-cultural encounters."[2] Cross-cultural hybridization is a common attribute within the work of many visual artists from Mexico and other Latin American countries as well, as we will see in the work of Enrique Chagoya to be addressed later in this chapter. The extent of this interest in cross-cultural encounters among Latino writers and artists should not be surprising given the fact that hybridizations and relationships between cultures are a logical outgrowth when those living within these cultures are nudged into the schism lying between traditional and modern/industrial societies.

In Néstor Garagía Canclini's *Hybrid Cultures: Strategies for Entering and Leaving Modernity*, a unique form of cultural hybridization is now perceivable as a common trait within most Latin American cultures. This hybrid condition is seen by Garagía to be an inevitable outgrowth of efforts to convert to democratic forms of government and capitalist economies from what were historically quasi-socialist systems. The condition has accompanied the rapid expansion of industries from within the United States and other industrialized countries, and that then moved into Latin American cultures where they have proliferated during the post-NAFTA period. Garagía observes that societies do not easily nor comfortably skip from ancient to modern, yet do they tend to retain their historical authenticity and fundamental traditions in a meaningful way when such rapid industrialization and modernization occurs.[3] A conflict emerges in the location between the desire to maintain pure traditions and the acts necessary for achieving modernization. This contradiction, in turn, may be partly rooted in the material assumptions that frequently drive modernization, along with their attendant tendency to convert meaningful traditions into materially definable and marketable commodities that are now recognized as representative emblems of their associated cultures. Another disturbing result of rapid modernization may be found in the way that many Latin American cultures have actually legitimized and fixed prior inequities that already existed within their social orders. This has occurred while trying to maintain autonomy and also participate in the expanding transnational economic system. In we find in this case, hybridization is not always a positive attribute, due in large part to an inevitable clash of conditions that results when rapid industrialization is laminated over prior traditions, with both having little inherent commonality as value systems.

Each tends to become a skeletal version of its self as a result. This happened earlier to Native Americans within the United States as well when a similarly dramatic and quick shift from rural and nature-based philosophies were rapidly replaced with urban, industrial, and materialist values.

Hybridization is a common attribute in other facets of Latin American cultures as well. In Mexico, for example, we find a long tradition for mixing the old with the new, as well as the self with the other. Nothing epitomizes these fusions better than in the unique forms of visual art that have developed during the post-Cortesian period. Many of these hybrid expressions fall into a broader category often termed *mestizo*. This word is frequently used to identify people with mixed cultural identities (those who are bi-cultural, but also to identify forms of expression combining indigenous and European attributes. As a notable example, Frida Kahlo was truly a *mestizo* person, given her genetic mix of Mexican-Indian and European-Jewish heritages. Her art works, of course, stand as excellent examples of *mestizo* expressions reflecting these same bi-cultural origins, along with her own unique within the *mestizo* tradition Mexico are those referred to as *retablos*, *ex-votos*, and *ofrendas*. In post-Conquest Mexico, these art forms were developed as hybrids that fused traits from indigenous Mesoamerican forms of expression with forms of expression imported at the time of, as well as after, the Conquest.

The traits and hybridized nature of these three art forms are worth at least some inquiry at this point due to parallels between them and aspects of the Chagoya's works that we will soon discuss. *Retablos* are small paintings, usually expressed on pressed tin surfaces though later ones were on wood or canvas. The images comprising the paintings were of the Holy Family or saints drawn from within the Christian tradition. These images were often combined with images and stylistic qualities more specifically derived from local traditions. *Ex-votos* were also small paintings (and also usually on tin), but stressed imagery of an event in which the life of the subject (who is often also the patron for the work) was imperiled due to extreme illness or a comparable threat. Through prayer to a favorite saint, the subject or patron was reputedly saved, and, in recognition, commissioned the work as a commemorative image dedicated to the intervening saint. In addition to visual images depicting the miraculous event, *ex-votos* also commonly employ a written narrative account of the event, usually located near the bottom part of the work. This added an element of story telling to the finished piece, and also parallels the comparable kinds of story telling that is predominantly visual in nature that one finds in the far older codices produced in Mesoamerican cultures. Finally, *ofrendas* are sculpture-like installations comprised of photos of the deceased and related memorabilia, along with marigold flowers that the returned soul is believed to follow when visiting the earthly realm. The *ofrenda* tradition has continued to the present. The construction of these altars devoted to the deceased continues to the present, and are especially common during the period of the annual *Dias de los Muertos* (Days of the Dead) in Mexico, as well as by Chicanos living in the United States. The *Dias de los Muertos* includes separate days for acknowledging the souls of children, those who died by accident and for those who died a natural death. Recognition of

this day continues a tradition that goes back to early Mesoamerican cultures, when it was believed that the souls of the departed returned to the earth once a year on certain days. In order to commemorate the event, members of these societies celebrated the return of the souls by joining the departed in feasts at cemeteries or in homes. This tradition is continued today in modern Mexico, with annual meals experienced at the gravesites of family members who have died.

Hybridization may be perceived as a major and very early attribute within pre-Cortesian Mesoamerican cultures. Early codices from this period, for example, represent an amalgamation of writing, mathematics, philosophy, calendars, mythology, story telling, history and visual art.[4] Given the powerful images, religious teachings and imaginative story telling expertise contained in these books, the Christian priests who were pursuing a massive effort to convert the native saw them as a threat to their goal. As a consequence, all but four of the so-called Lower Mayan screenfold (accordion design) hieroglyphic texts were destroyed, and many others from the later iconic script tradition were destroyed as well.[5]

The hybrid traditions of Latin American cultures continue in contemporary Chicano art. In the view of Max Benavidez, these expressions appear in the form of a hyper-hybridity stresses existential anxiety, fusion of primitive and modern sensibilities, and a means for satisfying a general need to prove oneself as equal to the dominant group.[6] Similarly, in a collaboratively written book called *CHICANO ART: For Our Millennium*, Gary D. Keller, Pat Villeneuve and others identify three kinds of hybrids at work in contemporary Chicano art:[7]

1. *Yuxtaposición.* This form of hybrid favors juxtapositions of Chicano and mainstream cultural elements that are combined in novel ways. The elements are difficult to synthesize in rational ways due to the rapid nature of cultural assimilation occurring today.
2. *Transición.* This kind of hybrid stresses movement across cultures and value systems, and often reflects a trans-culturalism, or merging of cultural sensibilities.
3. *Nuevo milenio.* This manifestation borrows elements from Mexican or Chicano sources, and combines these with elements drawn from mainstream sources. The end product represents an expression that is more than the sum of its parts alone.

We shall discover in our ensuing discussion of the work of Enrique Chagoya that his work embodies all three of these possibilities, and varies according to the specific theme that the artist is focusing upon within a given work. As such, his works can be considered among the most hybridized kinds of works to be found almost anywhere, as the epitome of "border culture" expression, and as a classic form of inter- and trans-cultural synthesis.

Cultural hybridization is an increasingly common phenomenon with the lives of Mexicans and Americans alike. A positive use of hybrids as bridges between cultures

has been a potential for decades. But, driven by a post-9/11 paranoia, Americans seem more willing than in the past to construct walls between their country and that of others. As our readers know, the construction of a huge wall between the U.S. and Mexico is now being considered. Building such a wall, of course, represents a fallback to the old binary visions of the world that created the old Berlin wall and that prevailed during the Cold War. The repetition of such a history suggests that we haven't learned very much from past experiences. In the words of Guillermo Gómez-Peña in his book called *Ethno-techno*:

> Both the U.S. and Mexico's monolithic visions of nationhood are being confronted by multiplicity, hybridity, tolerance, and autogestion ciudadana (citizen negotiation)–direct products of the border would. It is the new South reminding El Norte, and the new North warning El Sur, in Spanglish and from the grass roots up, that no democratic vision of the future can be fully realized without including the Other–which, it turns out, is no longer so "other." As ghost citizens of a borderless nation, we may soon have to redefine the meanings of a long list of dated twentieth-century terminology. Words such as "alien," "foreigner," "immigrant," "minority," "diaspora," and even "border," and "American" may no longer be useful to explain our new condition, identity, and dilemmas.[8]

Our final concern here is acknowledgement of some of the roles now provided by metaphors within the communication systems of many cultures, and, for our specific purposes here, within Chicano, Mexican, and other Latin American communities. In the words of Miguel de Unamuno:

> For a single metaphor, I would discard all the syllogisms and their corresponding *therefores* on which so much scholastic verbiage is hung. One metaphor teaches me more; it reveals more to me. Above all, I am inflamed beneath a metaphor. Imagination only works where there is fire.[9]

Otto Santa Ana, in his book *BROWN TIDE RISING: Metaphors of Latinos in Contemporary American Public Discourse*, emphasizes that Latinos everywhere must seriously consider adopting the use of the above kind of metaphorical language urged by Unamuno.[10] Santa Ana reminds us that our entire notion of reality is formed from metaphors, as opposed to deduction, logic, and argument. This may come as a surprise to many, since we are so frequently told to "think about issues" before making decisions. Yet it is apparent that people operate from a psychological foundation rooted in fear, hope (or fantasy), uncertainty, bodily endangerment, and the desire for safety. If they are convinced that any of these things are threatened, they react negatively, and, in many cases, this occurs even if the "threat" is false. Metaphors capture the imagination, hopes, and fears. They are emotionally rooted and directly tied to experience, not mere extensions of the analytical mind as it experiences thought as a

more purely formed mental process. It is apparent that both Unamuno and Santa Ana believe that a stronger case must be made for the development and use of metaphors in daily language for those from Latino heritages, and, by extension one must assume, in their art forms. It is very significant to note that those most active in their opposition to equal and just recognition and treatment of people of all colors have developed a highly effective use of metaphors for more than twenty years.

Many of the readers are no doubt familiar with the powerful and seemingly endless stream of negative metaphors used by many extreme conservatives to demonize immigrants from Latin American countries. One recent and obvious example of such metaphors may be found in the phrase "illegal aliens," which is frequently used to identify Mexicans who have come to Southern border-states in order to find work to feed their families. The phrase connotes that Mexicans are essentially little no more than common criminals who will likely steal from Americans. Looking back at the frightening period in the 1990s in California, one might recall three political initiatives that were proposed and most likely passed due to use of inflammatory metaphors that frightened citizens into supporting them. In each case, one can see how orientation of voters can be swayed on emotionally charged grounds when these are generated through the use of metaphors that appeal to a potential public paranoia that enflames the deepest fears that people have concerning potential violations of their safety.

During recent years, of course, such metaphors have become increasingly common. We're all deeply aware of the many times we have been put under "Orange Alert" or "Red Alert"? The paranoia extends to more than legislative propositions alone, and seems to have come to exist throughout the general public dialogue occurring both in the media and on the street, with the result that those from Mexico or other Latin American countries are commonly depicted as threatening, dangerous, and animal-like beings. Images of a swarm of aliens representing an invasion, or as possessing diseases that are attacking and threatening the very existence of the nation, have become common metaphors as well.

Of three California initiatives that we will address, Proposition 187 was proposed as part of the 1994 election process. It passed by a substantial majority. The initiative attempted to restrict access to public services, including schools and hospitals, by undocumented immigrants. Advertising in support of this proposition was based largely upon implications, both blatant and subtle, that people from Mexico were like animals, diseased, and a burden to society. Even though Mexican immigrants have historically proven for decades that they have a strong work ethic, are dedicated to their families, are honest, and diligently pay state and federal taxes, they were presented as being unworthy of receiving basic services that are fundamental for all long-term inhabitants regardless of their citizenship status. Fortunately, the courts later struck down the proposition based upon constitutional issues. Another example came in the form of Proposition 209 in 1996. This proposal appealed to the (then) California state majority of whites in an effort to end affirmative action in the state's educational institutions, claiming that such equality had already been achieved. One of the main things that blind-sided most citizens was its metaphoric claim to be the "California

Civil Rights Initiative," implying that existing Affirmative Action laws actually denied civil rights! In one swoop, the proposition demolished programs aimed at remedying centuries of discrimination that had accumulated against Americans of color. Then, as if the other two measures hadn't already done enough damage, Proposition 227 ended bilingual education for 1.3 million non-English-speaking children under the metaphoric banner of being the "English for the Children Act" of 1998.

Of course, we've also seen many other smoke screen metaphors used in efforts enact similarly demeaning propositions, at the national legislative level. One of these is the so-called "Clean Air Act," This title is a genuine oxymoron, in that it makes the claim that the legislation would actually contribute to the prevalence of "clean air," when, in actuality, industries that were producing large qualities of particulates and ozone-destroying chemicals into the air that we all must share were to be subjected to weaker oversight over these acts of irresponsibility. Another example is the so-called "Healthy Forests Initiative," a legislative proposal that actually allowed clear-cutting of massive swaths of old-growth trees claiming that the remaining trees would comprise a "healthier" forest. Would we have a healthier society if we weeded out a few million of our citizens? Needless to say, the logging industries were very happy with the healthy forests law. Perhaps most tragic and misleading of all was the "No Child Left Behind Act," which had bipartisan support in terms of its premise of supporting smaller classes, higher educational standards, and better prepared teachers, but was passed without the funding that would be necessary to actually enact the changes that would be necessary to fulfill the stated goals. One of the biggest results was simply more paperwork for already overworked teachers. This increased paperwork was supposed to prove accountability, but have proven to be little more than another form of bureaucratic filing cabinet filling.

One might wonder why–instead of fixating on phrases like "illegal immigration" or the "gay agenda"–extreme conservatives don't address matters that would serve the total citizenry rather than divide it, and make proposals having a positive impact on everyone's lives? It is very important to note that those who scream the loudest about "illegal immigrants," and who isolate and attack other small constituencies of the overall society for actually being who they are, never articulate the kinds of metaphors that would contribute meaningfully to the basic survival needs serving the common good. Why aren't such people shouting metaphors identifying "Illegal Global Warming," the "Illegal War in Iraq," "Illegal Eavesdropping on U.S. Citizens," "Illegal Torture of War Prisoners," "Illegal Overspending by Government," "Illegal High National Debt," "Illegal Disregard of the Collapse of Medicare and Social Security," or the "Illegal Disregard of Those Who Are Poor or Young"? Instead of addressing issues such as these–ones that would truly impact the quality of everyone's lives–the metaphoric on-going metaphoric attack serves to demonize and criminalize those who don't fit a constraining definition of what a citizen might be, or who are among those from other countries who come here to do an honest day's work in order to take care for their families.

With our discussion of the three preliminary areas of concern now complete, we

will now turn attention to discussion of works by Enrique Chagoya. The creative work of this prolific artist now spans several decades and encompasses several art forms. His works include large charcoal and pastel drawings, smaller caricatured line drawings, "accordion-structured" codices, large paintings, prints, and collaborative books done with Guillermo Gómez-Peña and other artists. Due to limits of space here, we will only be able to examine two of these art forms. These will include two large drawings using charcoal and pastel and two panels from two of the artist's codex-based books.

One of the more obvious features of Chagoya's works is that they are frequently inhabited by various combinations and fusions of images extrapolated from cultures from throughout the world, with many of these borrowed from works by artists who are both familiar and unfamiliar to us. Goya, especially, has been a favorite source because his interests in political and cultural issues closely parallel the related concerns of Chagoya. Other notable sources of imagery come from the works of Picasso and Monet. These borrowings, in turn, are further intermixed in various combinations with political figures from recent history in America and elsewhere. Providing elements of cynical humor and serious insight are several characters transplanted from Mexican and American popular culture, including Disney figures, such as Mickey Mouse, and Adelita, from Mexican comic books. Also, of particular interest to Chagoya has been the use of mythic images and pictorial methods borrowed from the ancient pre-Cortesian codex traditions of Mesoamerican cultures and fused with these other elements. This is clearly an unusually broad array of sources for images within the work of a single artist, yet, for Chagoya, these combinations provide fertile ground for cultural insights and commentaries that are both serious and humorous.

In the work entitled *When Paradise Arrived* (1988) Chagoya employs familiar icons as metaphors to convey corrupted cultural power and control over those who are most vulnerable. A small Chicana girl is shown in the lower left corner, where she is "wearing her heart on her shirt," and serves as the embodiment of Chicano/a immigrants who have come to the United States. She is looking outward at us, the audience, and is apparently oblivious to an impending danger looming by her side. Juxtaposed next to this tiny figure is a massive black hand (approximately five feet tall in the actual work) threateningly poised and ready to strike. The hand appears ready to strike her from the face of the earth with a flick of one giant a finger. The finger that is cocked and ready to strike has the words "English only" printed on its side. The impending extinction of the little girl is thus posed as the equivalent to elimination of the familiar communications tools of Chicanos (and, by extension, Latin Americans in general). That their language is imperiled by newly applied and strict impositions on the form of communication that may occur between people in American society further suggests endangerment of other aspects of their culture as one aspect in the process of assimilation (or rejection). This expectation is frequently imposed without regard for indigenous traits and how these can constructively contribute to a complex and pluralistic American society rooted in difference rather than sameness. The work also conveys something of the struggles an outsider must face when entering this society. And perhaps most important, the imposition of a single language alone has the

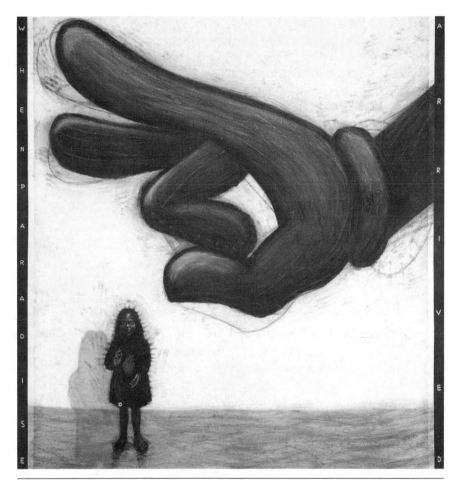

Enrique Chagoya, *When Paradise Arrived*, 1988. Charcoal, pastel on paper, 80 in. x 80 in. Collection di Rosa Preserve, Napa, California. Courtesy of the artist.

effect of erasing the linguistic histories of entire groups of people in a land founded upon the contributions of immigrants. The message seems to be: you can keep your skin color since we can't erase that, but you must think, act, talk, and, in every other way, appear to be like other, "normal" Americans. The absurdity of this, of course, is its complete contradiction to the laws of the country within which it occurs. The impact upon the little girl is simple: "Get out!"[11]

The little girl's *Corazón* (heart) is, as we said, "on her sleeve" (on her dress actually). This condition expresses both her vulnerability and her humanity as one "with heart." As with the ancient Egyptians, the heart is frequently viewed as the principle center of thought in Latino cultures in general, as opposed to the brain-centered forms of awareness stressed in European traditions. Here, the little girl also appears to have attributes in common with what is arguably the most dominant Christian image in Mexican tradition: The Virgin of Guadalupe. Traditional images of this version of the Madonna, as first recounted by Juan Diego (the Mexican peasant who saw her

reincarnated vision on a hill near Mexico City in 1531), include similar kinds of radiating marks that look like beams of light radiating from around her body. In the case of Chagoya's little girl, the marks appear to have been created by the artist through use of a technique of pressing his finger against the side of the charcoal contour of the figure and "dragging the lines outwardly" using the fingertip. This is a fairly common strategy when using charcoal due this media's unusual pliability. The lines gradually fade out when done in this manner, and they provide the appearance of the outwardly radiating beams of light that one can see in the area surrounding her small body.

In her essay for a Chagoya exhibition catalogue published in 2000, Shifra M. Goldman compares the hateful gesture of Mickey in this work to "the powerful hand of God extended to Adam in Michelangelo's Sistine Chapel ceiling but totally bereft of any creative or magnanimous feeling."[12] As Goldman further remarks:

> To flick away a human being as one flicks off a spot of dust marks the gesture not only as one of violence, but as one of contempt. It is the polar opposite of Michelangelo's cosmic gesture establishing God's benevolence and love for all humankind, commencing with the first of the species.[13]

The "English only" command imprinted on Mickey's cocked finger also connotes the xenophobic fear for any humans other than those who are closely similar to those in power and who represent the status quo. It essentially commands one to "be like me or feel the wrath of my finger." Anyone who had their ear plucked with a resounding snap from behind can sympathize with the power of this gesture. It really hurts when it's done when you least expect, as we find here with the little girl. Sadly, the pathetic kind of paranoia to which Chagoya alludes here is all too common today.

Yet to others, recollections of Mickey Mouse might conjure cozy thoughts of a small, cute rodent who was smart, enterprising, adventurous, and courageous. And, indeed, all of these attributes do portray the character. But if one digs deeper into the history of the figure's history, the stories and actions of Mickey are also found to be an extension of the military might of America during WW II, the Korean War, and later. Mickey also became one voice–among many–screaming for militant solutions, even when diplomacy would work much better. Mickey has always been a hawk in the guise of a mouse. Don't let his small size fool you; it's only one of his attributes.

In Chagoya's work, too, one finds one of the most potent traits of his work: an ability to produce a true sense of drama through the interaction of disparate images combined in a painting or print. In this case, of course, the explosive sense of power is produced through the potential for impending action, which in this case is the destruction of the little Chicana girl from the likely result of the threatening actions conveyed by Mickey's cocked giant finger.

The complex array of themes and issues described above is conveyed within an extreme economy of means. Only two images comprise the work. Yet, as we can see, the way each of these is drawn conveys many subtle inferences and inspires thought that goes well beyond the work alone. As such, the work is very much a seed for thought.

Chagoya again reveals his capacity for achieving a delicate balance between large and small, powerful and vulnerable, and the fictional and the real in his work entitled *Untitled (Road Map)* (2004). Through the potency of this balancing act, Chagoya also produces a strong metaphor with clear connotations concerning recent events in world politics.

In this work the artist produces a tension between those who are vulnerable and those with great power that is reminiscent to what we encountered above in *When Paradise Arrived*. The figure, in this case, is Alice, the main character in Lewis Carroll's well-known *Alice's Adventures in Wonderland*. Little Alice is shown standing on the back of a dodo bird, an extinct creature that couldn't fly and with bizarre proportions. Given the precarious circumstance where we encounter Alice in this particular work, one must assume that she chose this improbable location to give her greater leverage and elevation (stature) than if she was standing alone and on the ground. We might also recall, that in the original Carroll stories Alice employs many similarly strange and highly imaginative implements and actions in order to achieve her goals. Given this, Chagoya's realignment of the borrowed images in unique configurations fits both the original source and Chagoya's own apparent aims in the specific instance of this drawing. Alice is shown with a flamingo held in her left hand, and she appears to be using this gangly creature as a weapon to ward off a giant military helicopter that is in attack mode and has her locked in as the target. In the original Carroll story, of course, Alice used a flamingo as a croquet mallet in an

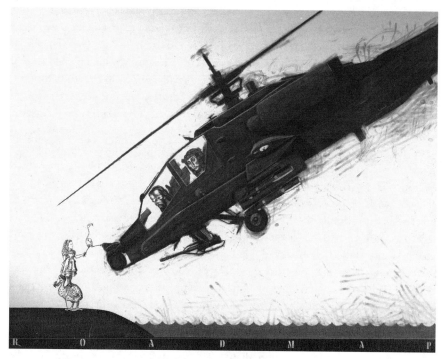

Enrique Chagoya, *Untitled (Road Map)*, 2004. Charcoal and pastel on paper mounted on canvas, 60 in. x 80 in. Private Collection, Connecticut. Image courtesy of George Adams Gallery, New York and the artist.

equally quirky and chaotic game in the Queen's garden.

The attack helicopter shown in this work is an AH-64A Apache attack helicopter commonly used by the U.S. military for heavy initial attacks on enemy locations. It is a heavily armed, fast, highly maneuverable, and deadly machine. Co-piloting the Apache are two versions of what appears to be the image of Jesus Christ, implying that "God is on the side" of the attack being enacted by the plane. Both versions of the two images of Christ are shown in the form of the authentic original sort of image that he would have represented as a Middle-Eastern person, with dark hair, dark eyes, and Middle Eastern beard. This version, of course, contrasts with the reconstructed kind commonly presented in Western societies, with blue eyes and wavy blond hair. The version of Christ shown positioned in the front cockpit is what might be considered as a "regular" image of Christ, while the version seated behind this one is the "sacrificial" version of Christ, with a crown of thorns upon a bleeding head which signifies the pain and suffering endured while giving up a physical life so that others could be saved.

One impression that might be formed in response to Chagoya's image is that the unexpected might be confronted when invading a sovereign country under false pretexts and with inadequate planning, as occurred in the case of the U.S. invasion of Iraq in 2003 under the leadership of President George W. Bush. The attack occurred shortly before the artist's work was executed which suggest a correlation. Over time, Americans gradually–far too slowly–came to realize and acknowledge that the reasons given for the invasion were false, and only later came to express concern that the kinds of diplomatic efforts normally pursued by countries when disagreements occur were not part of the scenario. In effect, a "shoot first and ask questions later" approach was taken. The United States invaded Iraq with little, and perhaps no, tangible reason, and this was done with the support of only a very small number of countries, most of whom were coerced into actively "supporting" the invasion. As one consequence, the United States had to carry the brunt of the workload (which translated into the deaths of many citizens) and costs. Because it was also evident that the invasion was based upon patently false pretexts, the international community, included many important allies, refused to cooperate. False charges toward Iraq were lodged before the United Nations. These charges included the assumption that Iraq possessed biological and chemical weapons, weapons of mass destruction (WMDs), was fully ready to invade America with these and were in collusion with, and actively training, al Queda terrorists (al Queda is the name of the group that killed almost 3,000 Americans in the World Trade Center tragedy on September 11, 2001). However, not one of the sweeping claims made before the U.N. proved to be true, but the invasion was pursued nonetheless. Given this, along with a complete lack of planning concerning how to complete the mission or how to eventually reconstruct the highly fractured Iraqi society and government afterwards, ended in chaotic and tragic results. Countless innocent Iraqi's lost their lives due to the invasion and the ensuing battles (estimated figures ranged from 40,000 to more than 800,000, with the low figure being from the United States government).

Chagoya's metaphor of a massive war machine stopped in its tracks by the

unexpected actions of a little girl standing on a dodo bird and awkwardly wielding a flamingo at the nose of the attack plane encapsulates the essential features of the Iraqi war. The seeming impossibility of the circumstance expressed in the artist's work is no stranger than the trumped up reasons for the actual attack in itself. One absurdity begets another one might say, and the world's most powerful army is paralyzed in its tracks.

The passages in *Alice's Adventures in Wonderland* from which the images of Alice, the dodo bird, and the flamingo are borrowed were from a description of a bizarre game of croquet in which rolled-up hedgehogs served as the balls, mallets were live flamingos, and soldiers were bodily doubled up in order to create the arches through which the hedgehog-balls could pass. Among the more pertinent passages in Carroll's story that closely relate to Chagoya's drawing are the following:

> The chief difficulty Alice found at first was in managing her flamingo... as the doubled-up soldiers were getting up and walking off to other parts of the ground, Alice soon came to the conclusion that it was a very difficult game indeed...The players all played at once without waiting for turns, quarrelling all the while, and fighting for the hedgehogs; and in a very short time the Queen was in a furious passion, and went stamping about, and shouting 'Off with his head!' or 'Off with her head!' about once a minute...

> 'I don't think they play at all fairly,' Alice began, in rather a complaining tone, 'and they all quarrel so dreadfully one can't hear oneself speak—and they don't seem to have any rules in particular...'[14]

The original Carroll story captured the chaos that occurs within play that is strikingly similar to results that occurred from the extreme lack of planning for completion of the invasion of Iraq by the United States in 2003. Even as of three years after the invasion, there was no sign of a clear plan from the George W. Bush administration, and the only comment that was given for queries concerning the increasing terrorism and civil war conditions was that we "must stay the course" (which essentially meant to continue with no plan). No plan for effectively reconstructing the country invaded, nor for its political stability, was visible even after several years of such "effort." To continue increasingly seemed to the American public more a matter of continued and even increased chaos, as one finds in the Carroll story, rather than a clear mission. Even the words that Chagoya places at the bottom add to the irony and parallels with the muddles Middle-East efforts through the inscription of the word, "Roadmap." And this reference, of course, refers to the so-called "Roadmap to Peace" that collapsed and was to serve as the basis for a plan to resolve a parallel and culturally related conflict between Israel and the Palestinians, also in the Middle East.

Among Chagoya's most powerful works are those developed in codex form. The artist's efforts to revive this tradition from pre-Conquest Mesoamerican cultures are among his most frequent creative forays. As we mentioned earlier, the codex book-

making tradition existed as the principle depository of ideas, philosophy, mathematics, storytelling, myths, and religious beliefs within the pre-Cortesian cultures throughout Mesoamerica. By combining these multiple purposes within a single art form, these works were among the earliest form of hybrids in art if compared with other cultures on a global basis. In keeping with the purposes and structural nature of the original codices, Chagoya develops narrative works, intended to be read from right to left (as one must with the original versions), and also constructed in the traditional "accordion" (folding) method. This method resulted in a continuous narrative, as opposed to the use of totally distinct pages that one finds in most book traditions worldwide. In the accordion-books, the pages that are contiguous are attached, though folded so that the entire book would be compact in form. Chagoya also revived the ancient tradition of painting his imagery for his codices on amate paper. This surface is of ancient origin, and was developed by pre-Columbian cultures and employed as the painting surfaces within the codex tradition.

In the artist's book entitled *An American Primitive in Paris* each rectangular panel occupies a twelve by twelve inch square format, with the entire length of the sequence measuring one hundred and twenty inches when all of the pages are viewed in an open manner.

The theme of this particular work reflects the Chagoya's interest in what he terms a "reverse anthropology." This is a condition in which he reverses or creates an alternative history, one in which the occupied becoming the occupier, the invaded the invader, the victim the victor. His goal when doing this is to counter the fact that those who triumph in wars of colonization write their own histories, typically

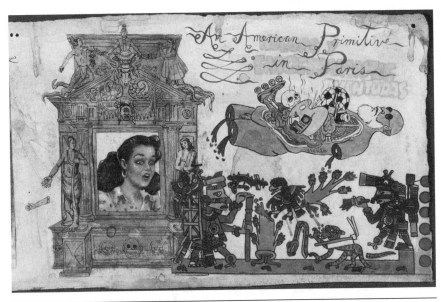

Enrique Chagoya, *An American Primitive in Paris*, 1999. Detail of page 1 from within a 10-page artist's book. Acrylic and water-based oil with solvent transfer on amate, 12 in. x 12 in. (entire book 12 in. x 120 in.). Private Collection, New York. Image courtesy of George Adams Gallery, New York and the artist.

revising events to mirror a perception that "being right" and "being good" was on their side, not on that of the losers. The artist is quite correct in making this claim. In a 2006 NPR panel, historian Kyle Ward discussed his book *History in the Making* (2006). Among other examples, the book describes Ward's discovery of dramatic change occurring in the accounts political leaders and historians have employed as justifications for the Mexican-American War of 1849. Initially, President Polk based his rationale for a U.S. attack upon the Mexicans who then occupied what today is the Southwestern United States upon what he perceived as a "manifest destiny," claiming also that Mexico represented a "threat to the U.S." By 1890, this cause for the invasion was revised by historians to a somewhat milder (though still distorted) claim that "Mexicans were inferior." By the 1990s, historians were finally recognizing that entry into this was done without substantive provocation at all, and was actually pursued in order to expand U.S. territory. Ward also compares the use of a falsified history for this earlier American war and the false claims of an "Axis of Evil," "WMDs," and "threats of Iraqi terrorists invading the United States" as justifications for the U.S. invasion of Iraq in 2003.[15]

The same kind of false paranoia is presently being deployed against undocumented immigrants coming from Mexico today. The American public is even being led to think that this "invasion" of "illegal aliens" threatens to destroy American society, using the same arguments used by President Polk in 1849 to invade what was at that time the territory of Mexico. It is worth reconsidering the words of Guillermo Gómez-Peña that appeared the beginning of this chapter:

> Following the events of September 11, the fetishization of Otherness by the global media and the sanctioned culture of extreme behavior as depicted on TV, movies, and the Internet have suddenly become unfashionable again. The Other is once again perceived as seriously threatening, as "un-American." There's been a total overnight shift of parameters and attitudes toward, say brown people. We are no longer hip, sexy, and exotic creatures on the global menu. In the world according to Bush and his evangelical cowboys, we are all "suspicious."

> The "mainstream bizarre" has been temporarily deported back to the old silent margins, and dominant culture has become once again extremely centralized, authoritarian, euphemistic, and artificially wholesome...like in the 1950s. It's back to the pre-civil rights era. It is no coincidence that the two most popular movies of the season are 'Harry Potter' and 'The Lord of the Rings.' Americans want to escape. The world seems too incomprehensibly frightening.[16]

In the top-right area of this first of the panels within the sequence, we fine the book's title, *An American Primitive in Paris*. Faintly shown behind these words are additional words written in Spanish, stating: "*Nuevas y emocionante aventuras*" (New and

exciting adventures). The use of images and words that are either erased or lightened is a recurring method in many of Chagoya's works, and tends to be used like an "echo" from the past, or as an utterance from those whose voice isn't seriously or adequately considered within the mainstream, as is the case with voices from within the Chicano and Latino cultures who are being treated like animals and criminals ("illegal aliens"). The artist is giving a voice to the voiceless, but keeps its presence faint in order to also reflect the prevailing reticence within the dominant culture to recognize these voices. Chagoya also uses such whitewashed or blurred words and images as an attribute when such elements are relocated from the past, or when they might be thought to exist as faint reverberations or vague recollections from remote circumstances. Yes these are being reborn in the present in a not quite material form that provides hints of wisdom concerning the present reality, with the latter also shown, but in contiguous spaces within the art work. Such works might even be thought of as hybridizations of multiple moments in time and space.

The panel that is of special concern to us here shows a figure from the American (Western cultural) comic tradition as peering out from a frame resembling the shapes in the tin frames that one finds surrounding the small painted works within the *ex-voto* and *retablo* traditions in Mexico. We had earlier discussed these works as typifying the hybridized nature of many expressions in Mexico, and, in this case, as works commonly produced during the last two hundred (or more) years. Such *mestizo* (mixed-cultural) works were an outgrowth of cross-cultural combinations of imagery and ideas, Of course, Chagoya's work in general tends to typically embody this same kind of hybridized amalgamation of cultural traits, though frequently deriving its images and themes on a global scale.

In the case of *An American in Paris*, several kinds of combinations of mixed cultural imagery may be found. On the right half of the panel, the reclining figure with a white beard is the same figure that the artist had used as the basis for a "portrait" of Claude Monet (a French artist) in a series of works done as take-offs of that artist's famous Water Lily Series of paintings. Monet's legs and arms, however, are now shown as if they have been cut from his body, perhaps as a parody of the sacrifice of body parts in pre-Conquest cultures and that one finds in Hollywood films in which this is typically stressed as a stereotypical image, though usually missing the important cultural importance of sacrifice within the cycle of life. One of the arms reappears to the far left, as being dropped by a sculptural-like figure imbedded within the classical architectural framework on the left side of the panel. The falling body part seems to resemble the images of body parts that are depicted within Mexican tradition in order to invoke a cure of the injured or poisoned body-part. If so, these would be what are called *milagros* (miracles). From Monet's gutted belly sprouts a conglomeration of cultural artifacts from both Mexican and Western traditional, representing a mixing of "gifts" both cultures. These objects born from the belly of Monet include a soccer ball (the earliest form of soccer was played many centuries ago within ancient Mesoamerican cultures as a symbol of sustaining the cosmos), a skull (a *calavera* from the *Dia de los Muertos* tradition), an in-line style roller skate, an addict's hypodermic

syringe, a cell phone, pack of cigarettes, artist's palette, camera, and, or course, Monet's own intestines. The figure, when taken as a whole with all the "gifts," also resembles the form in which food products from nature are shown as being produced from the belly of an earth goddess in one of the panels of the famous *Codex Borgia*. This image is in the section of this book depicting "The Five Directions and Their Supernatural Patrons." In the image the earth goddess (as the earth herself) is giving the fruits of life, such as the Tree of Life and maize, in return for sacrifices made by the attending two deities (which include *Quetzalcóatl*, the creation deity, who in this case appears in the form of Lord Stripe Eye).

Beneath the floating-Monet-as-earth-goddess is another scene showing a figure borrowed from the Mayan *Codex Borgia* on the right and another, taken from the same source, is on the left. Both are standing on a "pathway," and a bird, a broken tree, and a snake are among the occupants of the path.[17] The two figures at each end of the path are based upon the red and black beings called *Tezcatlipocas*. Of these, the Red *Tezcatlipocas* is the figure on the extreme right. In the stories of the *Codex Borgia*, this figure is a traveler on a mythic journey who is here shown with his walking stick and backpack. On one level at least, this figure may be interpreted as an evocation of the artist's own personal journey while he was in Paris and at Monet's water lily garden at Giverny, in France. At the time this work was completed, Chagoya was visiting and working both in Paris and Giverny while under a creative work grant. In the work, the figure on the left side of the path is the Black *Tezcatlipoca*. In the middle section of the path is the Tree of Life, which is shown as being cut in half, with the Quetzal bird (a Central American bird associated with the creation deity called *Quetzalcóatl*) hovering between the two separated sections of the tree. To the immediate right of the severed Tree of Life is the similarly dismembered body of a snake, with a leopard deity shown as the culprit who likely implemented this misdeed. As one finds elsewhere within much of the pre-Conquest traditions, the sacrifice of life (as seen here in both the tree and the serpent) is considered to be in the service of creating life, as opposed to a sacrifice that is considered an end in itself. In a related way, the image of Monet that is in the upper portion of the work is also shown giving life to new ideas and new images. On another but related level, it is generally conceded that Monet served as a major source of inspiration to many artists during the decades after his life, as occurs with the Chagoya work. So, in a sense, one might conclude that an over-riding theme of this work is to inquire into various ways in which things give birth to other things in myriad ways.

Like Chagoya's *An American Primitive in Paris* book discussed above, *Illegal Alien's School of Art and Architecture* is structurally based upon the Mesoamerican pre-Conquest codex tradition for devising a series of images as a continuous narrative, to be read from right to left and, in this instance, comprised of fourteen pages. Like the previously discussed work as well, this sequence of panels is again painted on amate paper. In this case, however, the artist also employs one of the ancient methods for page pagination, which one can find on a lower corner of each page. This system is comprised of dots and dashes.

The themes in *Illegal Alien's School of Art and Architecture* have been transplanted

Enrique Chagoya, *Illegal Alien's School of Art and Architecture*, 2006. Detail of pages 9 and 10 from within a 14-page artist's book. Water-based oil, ink,with solvent transfers on amate, 11 3/4 in. x 16 in. (entire book 11 3/4 in. x 112 in.). Image courtesy of George Adams Gallery, New York and the artist.

from ancient Latino and Chicano sources as well. The combination of images also invokes a clash between pre-Conquest and Latino cultural traditions by being combined within a Western cultural context. The images within the fourteen pages also include borrowings from Western pop imagery, Western aesthetic values, Middle Eastern history, the war in the Middle East, and early twenty-first century border conflicts between the United States and Mexico.

In panels one and two of the *Illegal Alien's School of Art and Architecture* a hybridized human-animal figure approaches an architectural framework that is derived from classical architecture traditions, having Corinthian columns and a framed, geometric space (similar to the architectural framework shown on the left side of the above *An Primitive in Paris* reproduction). Panels five and six present images representing conflicts and contradictions between Western European and pre-Conquest Western hemisphere traditions. In these two pages, a demon is being ejected from a Corinthian capitol on the left-hand page. A blood-like splatter appears on the rear end of the cast-off animal, with its red color accenting his exit as he is spewed (or born) from the plant-like, irregular shapes that one finds on such a capitol. On the right side, another demon floats in mute response to a tidy and highly geometrical perspective study of a Doric column. The words spoken by this latter demon are erased within the white space of a word bubble. The bubble is like those one finds in cartoons and comics. The erasure (or whitewashing) of images is an important feature frequently found in Chagoya's work,

and is equal in importance to the "painting in" (addition or concrete presentation) of an image. The erasures pose the possibility for conjecture and multiple histories being read into the work when these are used. Such blurred, erased, or whitewashed images might also suggest the presence of ghost-like apparitions of thoughts or events lurking or reappearing from the past. Or they might also be thought of as truths from past events that historians or politicians have revised when attempting to create their own, false history to justify their actions. They might also be interpreted as a way of silencing the voices of victims of the violence or control imposed by those who in power.

The stress upon the Doric and Corinthian systems of architecture (these systems are called "orders," each of which reflected a distinct set of ideals valued within Greek culture) in this series by the artist evokes the kinds of opposites that are stressed in art schools. Since this entire book is called *Illegal Alien's School of Art and Architecture* the introduction of these two orders seems significant. The influential and observant nineteenth century German philosopher named Friedrich Nietzsche has identified these two orders as epitomizing an idealized balance of opposite traits that had been stressed during the Greek origins of Western culture. He identified these as Apollonian and Dionysian. When writing in *The Will to Power*, Nietzsche associated several attributes as typically Apollonian. These included "perfect self-sufficient," and "all that simplifies, distinguishes, makes strong, clear, unambiguous, typical." In simple terms, one can interpret these attributes as representing the rationalistic aspects of human consciousness that were highly valued. In contrast to these traits, Nietzsche also identified what he called the Dionysian aspects of Western culture, with its attributes being affiliated with the emotional, subconscious, and imaginative domains of human awareness. When defining the Dionysian, he used phrases such as "reaching beyond the personality," "across the abyss of transitoriness," and "a passionate-painful (condition) overflowing into darker, fuller, more floating states."[18] It is important to note that Nietzsche perceived the Apollonian and Dionysian aspects of Western culture as being opposition, or binary, in nature.

The cultural contradictions represented in the above reproduction of a page from *Illegal Alien's School* are evoked by the tiny figure of pre-Conquest origin looking outward toward a chaotic combination of perspective-like geometric structures floating in space. The images have a theoretic quality due to their floating on the light space of the drawn surface. Above the architectonic images float a scattered arrangement of the planets as symbols of the cosmos, that, according to ancient Mayan and related traditions, must be held in equilibrium through the efforts and contributions made by humanity so that life may go on. Yet the planets are scattered randomly throughout the top half of the double-page format, as if thrown asunder by the highly rationalistic premises represented by Western Euclidian and Albertian theories of space often stressed within Western art (and political) traditions. That this particular image may represent the artist himself is suggested by the title at the top stating "El Ilegal Cosmovisionary" (the illegal cosmic visionary). In using this title, Chagoya blatantly confronts the attitude held by some that a person who is from places or situations outside the norm, or outside the dominant culture, is unacceptable, or at least questionable.

Additional panels in this book series includes a two-page depiction of a hybridized Middle Eastern war machine, comprised of elements from modern warfare and those of ancient Assyrian origin, zapping superman, the ultimate icon of "goodness" and "strength" within Western society. Addition comic references are presented in transferred images from WW II comics. Taken as a whole, it is clear that the artist is commenting upon the Middle East invasion conducted by Western allied powers mainly comprised of British and American forces under the false aegis of "preventing al Queda terrorists from invading America" and "finding Weapons of Mass Destruction (WMDs)." Of course, when neither of these claims proved accurate in reality, the purposes were revised to, instead, claim that the purposes for the invasion were to spread democracy, bring order, establish fairness, and institute justice for Iraq and the region of the Middle East. Sadly, these proved to be specious claims as well, with increased chaos and needless deaths ensuing in a tragically escalating manner, even for several years after the President of the United States prematurely (and thus immaturely) proclaimed, "Victory has been accomplished," causing further consternation and confusion within the citizenry of America and its allies.

Chagoya terminates the fourteen-page codex with the thirteenth page showing a Mexican figure in the right-hand panel, with his body painted over and a startled look on his face. The adjoining left-hand panel shows a blond gringo woman with tears in her eyes, with her body whitewashed as well. When peering through the whitewashed color cloaking the body we can see a skeleton done in the tradition of the *Dia de los Muertos* tradition that is rooted in pre-Conquest history. From the upper-right corner of this last panel, the words of God are shown within a comic-strip bubble, saying, "God says, This is EL FIN." The finality and encompassing nature of the final declaration represents a complete annihilation of the bodily presence of both figures. Rather than sustaining the universe in the pre-Conquest tradition, nature, the world, and humanity as well (in short, all things comprising life) have been entirely obliterated. The artist has even whitewashed his own signature (and thus himself) at the far left margin where the entire narrative ends.

Our final section will provide an interview with the artist that was conducted during the summer of 2006. The questions were formed by the author to fill in gaps of missing information that was unavailable in exhibitions catalogues and other writings on the artist's work.

INTERVIEW[19] - ENRIQUE CHAGOYA

JD: I understand that your first college studies, completed in Mexico, were in the field of Political Economics. This reminds me of the way that the French Post-Impressionist Paul Gauguin changed from being a lawyer to being an artist about the age of forty. Given your own change in direction, when did you first become involved

as an artist, and why did you change from political economics to being an artist? And what compelled you to make this change?

EC: I have done art since my dad gave me my first drawing and color theory lessons when I was seven years old. My father studied art in a commercial design school, but he never made a living as an artist. He ended up working for the Banco de Mexico (the Central Bank/Mint of the country), and painted in the evenings at home (he still paints at 92 years of age). I have not stopped making art since then. Perhaps my dad was the wrong role model, but I thought I would never make a living as an artist. However, when I was studying economics I read a lot about art theory and the connection of art and politics in history (from the French, Mexican, Russian, and Cuban revolutions, and I took few art classes (printmaking and drawing) at some national schools in Mexico, at San Carlos (the oldest art school in the continent established in the 1700's) and also I got accepted for an undergraduate program at the Escuela Nacional de Pintura y Escultura, but I quit because it was generally limited to mural art and figuration at a time when I was more interested in abstraction and constructivism. I felt that the faculty was not going to be very supportive, so I left to focus on political economy. But I was lucky to have access to a painting studio without having to pay rent, so I kept painting, doing mostly non-figurative work as well as basic cartooning. I was also doing work for union newspapers. My interest in economic theory was due in great part to the political unrest of the country in the late sixties and early seventies. All of my friends were studying social sciences. I went through several different academic fields (sociology, anthropology, architecture, and finally economics; I still love to read about these fields). When I move to this country in 1979 (having lived briefly in Texas in 1977), I wanted to continue studying economics, but to my surprise most of the schools in the Bay Area were not as interesting to me as the one in Mexico. I now realize that, while I was in Mexico, I was very lucky to be studying at a time when the university (U.N.A.M. or Universidad Autonoma de Mexico) was full of great international faculty (mostly South American refugees who were former deans of universities in Argentina or Chile, and also some old but great Spanish refugees from the civil war). We were reading all kinds of critical writings on economic theory. We criticized Marx for being Eurocentric, because his writing in *Das Kapital* was very focused on English economic assumptions as the dominant model for the rest of the world. We were also critical of the School of Chicago (Milton Friedman's neo liberalism) as the working model when free trade was first tested in Chile under Pinochet.

JD: Your development as an artist seems to indicate a consistent concern for political and social issues, if not literally at least as an underlying element. Due to this, it might be said that your earlier interest in political economics isn't actually as far from where you ventured later in your life as one might think. What major events within your life inspired you to focus upon the social conditions and welfare of your fellow human beings? Looking back on your life, how would you trace this concern?

EC: As I mention in my previous answer, the political climate of the late sixties and early seventies in Mexico shaped my views of the world. During one demonstration I literally had to run for my life. This event was June 10, 1971. Government paramilitary groups killed between sixty and seventy students that day. A former President, Luis Echeverria, was responsible not only of the 1971 massacre but also the one on October 2, 1968 (in which five hundred died). Echeverria was indicted about two months ago (in 2006), but he was not sentenced due to the legal established time limits that had elapsed since those massacres took place. Today I just keep informed about national and international events. I read the NYT, The Economist, The New Yorker, Newsweek, and few blogs. The political imagery in my work develops without my trying to make any specific statement. It is more a way to exorcise my anxieties

JD: I realize that you do not view your work as something that is intended to "change people's minds about politics," but one must admit that it has political overtones nonetheless. The subjects are frequently very serious (such as the slaughter of innocent indigenous peoples by the priests representing the European "religion" during the period following the arrival of Portuguese), yet these are presented in ways that might be seen ludicrous or humorous. Terrible events are often cloaked within outrageously silly language or circumstances, and the envelopment of tragedy within humorous visual contexts may be a way for people to confront and come to accept the truths of the ugly events in both the past and present. In this way I think your work "informs" perhaps more than it attempts to "change minds." Could you comment on the role of serious topics conveyed through humor or presentation as part of outlandish situations? And also can you comment on how your work might inform rather than serving as a vehicle to convince people to arrive at a particular conclusion.

EC: While creating my work I don't worry at all about drawing any conclusions. Humor is an open door to think about serious questions.

Also, I don't want to make my work as some kind of ode to victim hood. I am also not pointing fingers at who may be responsible of atrocities, but addressing the fact that all of us are involved in a world that is more complex than good versus evil alone. We are all good and evil at the same time, or, to be more accurate, we have the potential of being either one or both. Just think of Gunter Grass who just this past week (in August 2006) made a "confession" about being part of the SS in Nazi Germany. In art we are not forced to be linear, or serious, about grave matters. In Mexico I grew up in a culture that has some sense of humor about death. I would rather laugh than cry when I am faced with a circumstance in which either direction is possible. Our sense of humor is essential for us to survive emotionally in an insane world. If we lose this sense of humor, we would be unable to cope. So far I don't feel we have lost this capacity.

JD: Your art works often draw images and compositional devices from the codices of the indigenous peoples of the geographical region that has become modern day Mexico. This appears to include images both from the lowland Mayan "hieroglyphic" form of codex imagery and the central "iconic script" tradition of later Aztec, Mixtec, Toltec, and Nahuatl traditions that combined letters, art, and mathematics into single pictures. When did you first begin to use these images, and why?

EC: After I read about the massive destruction of the pre-Columbian books (Mayan, Aztec, and Mixtec-Zapotec), I was thinking a lot about how history is written by the war's victors. From that perspective, history is more of an ideological construction than a science. As an artist I feel free to create my own ideological constructs about history with a language without words or few words. I wrote an essay about the pre-Columbian books in *The Road to Aztlan* catalog published by the LA County Museum in 2000. I made a mistake numbering the Mayan books in that essay. I wrote that there were four such books. There are actually only three pre-Hispanic Mayan books (these codices are in Madrid, Paris, and Dresden). The rest of the facts in the essay are accurate as far as I know.

JD: Given that these codices served as one of the sources of imagery in your art, it seems ironic that you essentially revived an art form that was almost entirely destroyed by the Jesuit priests who burned most of the Mayan books in order to establish the text of their own religion (the Bible) as the dominant text soon after the fifteenth century conquest of the region of Mexico. Do you

feel a responsibility as an artist to sustain that older and highly jeopardized codex tradition? And in what ways does your work draw from that tradition?

EC: The books were not only destroyed by Jesuits, but also by members of the Dominican, Franciscan, and other Catholic orders. Some credit should be given to other priests that made an effort to rescue some of the local ancient history, like Fray Bernardino de Sahagun who wrote 12 volumes on the history of the indigenous culture derived from direct interviews with surviving Indians who were familiar with their own history, or Fray Bartolomeo de las Casas who commissioned many engravings denouncing the atrocities the Spanish soldiers were committing in the Caribe (Caribbean) and in Mexico during the conquest. Even Fray Diego de Landa, who single handedly burned all the Mayan Books (except for the three mentioned above) was repentant for his actions when he stated that he could not begin to "Christianize" the Mayan Indians without knowing their history and culture. Due to this, he began to interview Mayan Indians in order re-write many Mayan books like the *Popol-Vuh*, or the *Chilan-Balan*.

The codex format was used for a precise language that did not use phonetic or verbal elements (this approach is not very different in spirit from contemporary non-verbal/phonetic languages that are precise, as one finds, for example, in mathematics, music, traffic signs, airport signs, etc.). That kind of visual language is ideal for my work (and any visual artist's work). I have only seen one pre-Columbian codex in person, the Mayan book known as *Codex Madrid* that is on display at the Museo de America in Madrid. When encountered directly, they are even more beautiful than in reproduced form. I tried to see some ancient Mexican books at the Biblioteque Nationale in Paris when I was living in that city in 1999 but the people at the library were so bureaucratic that I gave up on them. I hope some day those stolen books will be returned to Mexico. In the meantime, I love to make my own versions of those books, using the same kind of paper (amate from the bark of a native tree of the same name), but also I like to make versions of any art that I admire. That could be said also about my admiration for Goya's or Philip Guston's artworks.

JD: While reviving, and providing continuity to, the older images that you borrow from the pre-Conquest codex traditions, you also infuse it with new life by combining it with newer images. This reminds me of the Balinese shadow puppet theatre tradition in which the puppeteer combines ancient stories that are over a thousand years

old, from an oral tradition, with contemporary narrative segments pertaining specifically to the lives of the Balinese living today. Infusing the wisdom of the past with the issues of the present can provide both with greater import. This is a purpose that has been almost entirely forgotten in our contemporary culture in which everything is considered to be obsolete almost before it exists. Although many images (and "looks") from the past are constantly being repeated, these are mainly as temporary images for immediate cultural consumption, not as metaphors that significantly inform us. In fact, when many people boast of how "traditional" they are, they really have no idea what the real nature of the past was, nor its original meanings. Such people generally suffer from a serious case of selective memory, and only choose those things that fit their personal agenda of the moment.

In your case, newer images are drawn from American pop culture (Elvis, Mickey Mouse, Superman, etc.). In my personal view, your works are enlivened in unique ways by this synthesis of, and interaction between, the old and new. Can you provide any insight into why you specifically chose to combine Mayan, Mixtec, Aztec, and other codex imagery with contemporary pop imagery?

EC: I depart from the codex imagery and format, but that is only a way to structure my images and also a way to expand as far away as possible from the ancient past into contemporary popular culture. This might include not only American or Mexican, or Catholic iconography, but, as one finds in my more recent works, several other sources to: Buddhism, Islam, European pop, military equipment, stereotypes of any race and culture, and anything that goes through my mind without any consideration of political-correctness.

JD: There is a long tradition for mixing the old and new, and especially for mixing images from differing cultural contexts, within Latino cultures of Mexico and Central America. Some refer to this as *mestizo art.* Could you comment upon how you perceive both similarities and differences between the mixed (hybrid) nature of your work and this tradition for synthesis of elements from differing cultural origins?

EC: Hybrid is the new and more common term for a mix that we now find in most critical essays on mixed cultures. In my opinion, there are few cultures in the world in which we would not find mixes of various kinds, or that is not a "hybrid." There are no pure cultures even in the

region of the Amazon, not to mention Europe, the Middle East, Africa, Asia, or North America. The interesting phenomena is that we are all now experiencing a fortification of borders, and the creation of new architectonic boundaries at the same time that excessive capitalism is destroying, or at least absorbing, many national and cultural identities throughout the world. Also, some borders are invisible but real nonetheless. These boundaries include ideological constructs like those we find in the interpretation of history or, as an extension of these, in maps. Such boundaries are perpetually shifting.

JD: Part of the development of your work, of course, has included book works done in collaboration with Guillermo Gómez-Peña. These books include *FRIENDLY CANNIBALS* (published in 1996) and *Codex Espangliensis: From Columbus to the Border Patrol* (initially published in 1998, and republished in a more affordable format in 2000).[20] How would you describe the ways in which the kind of work you have done alone compares to these collaborative projects?

EC: Ours was a non-collaborative collaboration. It was more of a coincidence in paths, and an effort by a third party to put us together. His text does not address my images nor my images illustrate his text.

JD: Guillermo is best known as a performance artist and writer, not as a visual artist. My impression is that your joint ventures provided him with a new opportunity to add a visual dimension to his otherwise predominately narrative and performance kinds of expressions, just as the narrative power of his art expanded upon the primarily visual orientation of your own work as an artist. At the same time, the actual content that one finds in your work and in his seems very compatible and parallel to each other, although I find his a little more literal and specific, most likely due to its roots in the more literal language of spoken and written text. I recall reading somewhere that you have said that you both see things in very similar ways, despite the differences in methods of expression. Is this true, and, if so, what would you consider to be the essential concerns for content that you both have in common?

EC: We come from similar background experiences, and sometimes our concepts also coincide, but we use different media and we have different specific experiences and ideas. Sometimes these do cross over. But we also have very different languages. My language is the ambiguity of multiple interpretations behind visual symbolism. His language is

verbal, and as you said, more specific, occurring in a performance form. I think one could get to the essence of our work not through what is alike but though what is not repeated. If I need to access what is essential in my art, then I can only speak about what I think is within my work that is not repeated in other artists' works even when we have similar concepts. The essence is the specific fingerprint, and not that others have fingerprints too.

JD: **In a summer 2006 panel discussion that played on KQED, the participants made some very stimulating comments.[21] You were the artist representative on the panel. The theme was to comment on issues raised by the "Conflict and Art" exhibition then being featured at the Cantor Art Center at Stanford University. In the discussion, Patience Young (the curator for the show) pointed out that your work involves a "dismembering of images from their original context,"[22] with these images then being re-contextualized. This recombining of imagery from varying sources appears to go well beyond the old idea of collage, in which artists recombined images and textures from varying sources because the looked good (aesthetically) when combined in a certain way together. Your own work doesn't seem to be driven by appearance or formal composition so much as the potency for images as voices that informs us. Could you respond to this?**

EC: I think Patience Young was right on the mark. The images re-contextualized in my work are like visual "words" that have been used in the past and present from very different sources, and then mixed within my own drawings and paintings. But the same language for distinct writers and times is read very differently. If I compare myself to a writer, I would say that I would love to write in English by borrowing from Shakespeare to James Joyce, to Superman, or the KKK hate books, and then my own writing, all within the same novel, while hopefully saying very different things if compared to the writings of others. In Spanish it would be like using Cervantes, Borges, Octavio Paz, El Santo comic books, and the racist Memin Penguin, but stating my own stories in a ways that are unlike any of these alone. If I was a musician, then I would have fun with the classics, pre-Columbian sounds, Tex-Mex, Italian Opera, Middle Eastern music, Rock and Roll, and then also music composed by myself mixed with all of that. In fact a musician friend of mine, Guillermo Galindo, told me he got inspired to do just that when he saw some of my works. Similarly, I gave Guillermo Gomez-Pena some tips about possible counter-mixings that he might consider using in some performances, like dressing some

Mexican Tex-Mex musicians as KKKers, or classical music performers as mariachis while performing in an opera. He ended up using a black woman singing an opera dressed with a KKK hood. All of this is very different than collage for sure.

JD: During the same panel you comment upon the work of Goya as a major influence in your own creative work. I have noted that you have even done take-offs of some of the cycles of print series in the Spanish artist's work of the late eighteenth and early nineteenth century. You stated that Goya "didn't take sides" in his visual work based upon the theme of the Napoleonic conflict when the French army entered Spain. Do you feel your works that are based upon the Goya prints have this kind of objective distance too? Are you "just stating the facts"?

EC: No, I wish I could be as impartial as Goya. But sometimes I aim at elusiveness of meaning as way to create multiple narratives that lead to no specific point.

JD: Could you identify and describe the series of works that you have done as take-offs on Goya's prints, and also describe what you maintain as intact from Goya's original works and what you added to or changed in these?

EC: I have "cannibalized" ten of his Disasters of War works, eight from his Caprichos series, and three of the Proverbs etchings. Goys' prints are about the same size, though mine are a bit larger. I traced the outlines on etching plates and then re-did all the lines both within and outside the contours of the figures. I also added elements of contemporary politics using my own drawn images. I used visual guesswork to determine the treatment times for the plates when placed in the acid for the aquatint and lines. I did the same with Philip Guston's drawing series "Poor Richard" which were a political satire of Nixon. I saw the original drawings in San Francisco and fell in love with them. So I got the catalog, followed the same size of the paper, and changed the face of Nixon and his aids for that of George Bush and other people in his administration. To see my complete versions check the web site of Segura Publishing at Segura.com. An exception is one "Proverb" I made at Rhode Island School of Design. To see examples of my drawings that represent responses to Guston's work check the website of George Adams Gallery in NYC, and for examples of drawings done in response to "Poor Richard" (mine are called "Poor George") check the website for Gallery Paule Anglim of San Francisco.

JD: Your cultural background is obviously unusually varied, given the fact that you grew up in Mexico, have lived in the United States since 1977, and (if I understand it correctly) have citizenship in both countries. In the above panel you said that you "change (yourself)–(your) soul–as (you) move from one place to another more than (your) passport." What did you mean by this?

EC: The main change happens within one's cultural richness when becoming exposed to different cultures. It may take a long time to notice that one is no longer close to a given culture (both the original one and new one). Learning a new language also involved learning a new cultural way of thinking, and there is a point when a quantitative change occurs (with more languages learned, more places known, more of everything). At this point, one makes a qualitative internal change, for better or for worse. I feel like a tourist in Mexico, and I don't feel like I am American either. In place of my original clarity of connection with a place and culture, I now feel that I belong everywhere, and that people are actually not that different from each other. If we could see beyond cultural, ethnic, national, class, and gender differences alone, we can find that there are the same fundamental homo sapiens roots (humanness) within all of us, though with many individual qualities and defects that are not bound by culture. Sometimes our differences are seen as aspects of our richness; other times our differences are used against us. I guess what I am saying is that we are all different and alike at the same time, but we become richer by accepting our differences as natural attributes. Our identity changes from such exposure and personal expansion. Some people see it as a treat; I see it as a natural experience, which makes us more open to the world. This is something we don't obtain by simply changing passports. We may get a new passport but that doesn't guarantee that we really will absorb the new experiences that we can be provided by interacting in new situations. I have met some Americans in Japan who have lived there many years and they didn't speak Japanese; I have also met other Americans there who speak great Japanese. For me the ones who did not speak Japanese have not "landed there" yet, even when they have been there for a number of years. The same could be said about people that come to the US from Latin America or Asia. Sometimes it takes a generation to truly "arrive" (to learn the new language, costumes, etc.). These changes in acclimation involve internal transformations that can occur to anyone moving to a different cultural context, unless they are seriously closed to the conditions of the new environment. It is an inner change. I feel very lucky with my own experiences while living in Mexico, the US and in Europe. If I could I would love to explore even more.

JD: A very important topic for this chapter of the book is cultural borders. In the KQED panel you stated, "Borders are ideological and imaginary structures. We draw them. There are many kinds of borders that include class, gender, race, and other differences." In a related way, your art works seem to consistently represent a space or place that serves as a meeting point where distinct timeframes, contrasting cultures, highly individualized images, dissimilar perceptions, and conflicting political perspectives all meet and interact (or clash). Could you comment on your own perception of your work as a meeting-ground for such disparate elements?

EC: I think my work reflect what I was addressing in the previous question. Consciousness is a social experience. If we were never exposed to a social context we would not have learned even a single language, not to mention all of our cultural perceptions that we get from social exposure. But we are not just sponges; we are also producers of reality as artists, workers, writers, etc.

JD: Given this, do you envision a world in which such clashes cease to exist? It seems that human differences are even more debilitating when pursuing efforts to create a harmonious world today. Or is it that we are just becoming more aware of all of our differences?

EC: As I said in the radio program, conflict is different from violence. I think conflict is actually a necessary ingredient for social evolution to occur; certainly it is necessary for change. One only hopes that the changes among individuals, as well as in society, are not violent and that they are for the better. Of course that is wishful thinking. We have an economic and political system that has a lengthy history of violence as the basis for cultural, national and economic growth, and, unfortunately, we have not found an alternative yet. The collapse of socialism had been doomed almost from the beginning due to its ideological base. A change may need to come more out of necessity if we want to survive as a culture and society, as well as from accepting differences and negotiating a more even distribution of power and wealth while working towards a sound ecologically goal. Otherwise we will join those prior animals that inhabited the earth but are now extinct!

JD: You are presently working on a new sequence of prints that you call the Saint George and the Dragon Series. The theme is satirical, and is on the topic of the presidency of George W. Bush. Could you give us a summary description of this series and some of the political implications embodied by the works?

EC: Those are the drawings I ended up doing after Philip Guston that I thought I was going to make as a print series titled Saint George and The Dragon. Although that was the title of the show when I first showed them in NYC at George Adams Gallery, I did one print only with that same content at Trillium Press in Brisbane which is featured in a short documentary aired at KQED's "Spark" TV series.

JD: **As you know, the United States annexed more than half of Old Mexico in 1848 at the end of the U.S.-Mexico War. A huge amount of what we, today, call the "United States" was the territory of Mexico before it was taken over. And, of course, prior to Mexico's occupation, these spaces were populated by many other, older cultures.**

An introductory quote at the beginning of this chapter refers to the transient nature of borders between cultures. In respect to the specific and current border between the United States and Mexico, the descendents of those who found themselves overnight in a different country in 1848, even though they hadn't moved an inch, found themselves in another country. As they said, "We didn't cross the border; the border crossed us." It seems so strange how short term memories have dominated the political landscape in recent America, and how little we have learned from both our own past and from the pasts of others. With the currently impending construction of a massive and seemingly endless wall between Mexico and the United States, one is reminded of the insular philosophy that drove the ancient Chinese to build the Great Wall of China, or of the divisiveness that motivated the Cold-War wall in Germany, though that cultural wall eventually collapsed under the weight of its own preposterous and outdated purposes. And yet, here we are doing it all again. How do you feel about the prospects of a wall dividing Mexico and the United States?

EC: All trans-cultural walls have failed throughout history. The Chinese are now busy speaking in English. Regarding the US, and all of the Americans, the first illegal aliens were the conquistadores and the pilgrims; they did not have passports (and the resident Indian nations had their own laws that were not respected), and the conquistadores and pilgrims committed crimes against humanity because of this. I could speak volumes about how immigration is yet one more ideological border, invisible but real. But laws are for those in power to keep the power. Slavery was legal; the holocaust in Germany was legal. Apartheid was legal; segregation was legal. Should one break the law if it is immoral? Or should we respect the law even if it is not ethical, just because it is the law? All revolutions

are illegal because they challenge the status quo, but, when they occur, new laws are formed to suit the new regime. The dilemma is in the questions of whether the law should adapt to humanity, or humanity should adapt to the law? Perhaps this is one of those aspects of society that will continually bring conflict, but one must still wish that the results were not violent, as they typically are.

JD: Have you included in any of your recent works any references to the impending construction of a major wall separating the U.S. and Mexico? If not, do you feel this might become a consideration in your work?

EC: The new print I just did here in Colorado addresses the subject. The title is *The Pastoral or Arcadian State: Illegal Alien's Guide to Greater America*. You will be able to see it online in a couple of weeks hopefully. Look for the web site in few days at Sharksink.com. They have published many of my codices during the last seven years. The new print is not a book but it relates to my codices. It is going to be shown for the first time at the Armory Print Fair in NYC during the first week in November.

This chapter has attempted to clarify issues related to present border conflicts between cultures, and especially those involving the United States and Mexico. We have also addressed underlying concerns related to border issues, including unique forms of cultural hybridizations occurring within societies experiencing rapid transitions from traditional to modern economic systems, forms of hybrid imagery common within Mexican traditions over the last two hundred years or so (and especially within present Chicano culture), and the present political debate concerning the border between the U.S. and Mexico. We then addressed four works by Enrique Chagoya that were characterized by several kinds of hybridization, including fusions that involved borrowings from current politics, pre-Conquest imagery, cartoons, fairly tales, and world politics. We will now turn to a discussion on works by Ken Botto, in which the artist experiments with the creation of micro-worlds comprised of hybridizations of imagery he borrows from his collection of artifacts representing Americana. We will also address ways in which the resultant micro-worlds parallel and comment upon our own, human-sized reality.

The cultural contradictions represented in the above reproduction of a page from *Illegal Alien's School* are evoked by the tiny figure of pre-Conquest origin looking outward toward a chaotic combination of perspective-like geometric structures floating in space. The images have a theoretic quality due to their floating on the light space of the drawn surface. Above the architectonic images float a scattered arrangement of the planets as symbols of the cosmos, that, according to ancient Mayan and related traditions, must be held in equilibrium through the efforts and contributions made by humanity

so that life may go on. Yet the planets are scattered randomly throughout the top half of the double-page format, as if thrown asunder by the highly rationalistic premises represented by Western Euclidian and Albertian theories of space often stressed within Western art (and political) traditions. That this particular image may represent the artist himself is suggested by the title at the top stating "El Ilegal Cosmovisionary" (the illegal cosmic visionary). In using this tite, Chagoya blatantly confronts the attitude held by some that a person who is from places or situations outside the norm, or outside the dominant culture, is unacceptable, or least questionable.

CHAPTER TWO

<div style="border:1px solid">

ART IN THE PETRI DISH:
The Parallel Micro-Worlds of Ken Botto

</div>

Through the stark trees we saw it, the immense toxic cloud, lighted now by eighteen choppers—immense almost beyond comprehension, beyond legend and rumor, a roiling bloated slug-shaped mass...In its tremendous size, its dark and bulky menace, its escorting aircraft, the cloud resembled a national promotion for death. [1]

– From Don DeLillo, *White Noise*

This chapter takes its title from the petri dishes used for biological experimentation by medical researchers. The dishes are small, used in the isolated spaces of research labs, and serve as tiny para-environments that, in many ways, may be perceived as paralleling the larger, ordinary spaces in which we all live. In fact, the events observed to occur within the petri dish are often referred to as manifesting a "culture" by the researchers who work with them. In this case, culture is a term used to identify phenomena occurring within a space in which living elements interact and change. On another level, and through its application, the petri dish serves as an alternate world that is equivalent to the biological body ("in vitro" literally translates to mean "outside the body"). The results of experiments that occur within this parallel space are later (re)introduced into the corresponding entity of the human body. The events that occur within the petri dish are comparable to many of the events occurring within our bodies throughout our lives. These include the introduction, interaction (organic manipulation) and transformation of organic materials and entities, including human eggs, sperm, flesh, organs and other organic substances. The main difference is that the events occur within the space of the dish within which experimentation with the materials occurs. In some instances the researchers introduce potential medicinal cures, or even implant human eggs with sperm in preparation for later relocation into a human uterus or womb for eventual development into a human fetus. Occasionally, the materials, and manipulations of these, are deployed as a stage of research that impacts animal (non-human) life. In yet other instances, the research initially involves the use of animals, but is later shifted to be applicable to humans. Potential cures for cancer or other diseases have been researched in this latter manner.

In all of these circumstances, however, the space of the petri dish has been transformed from an inert space into a small-scale environment that may be understood

as a "world" that exists parallel to the human-scaled space in the "real" world as we know it. The in vitro space is also often conceived as ultimately being interchangeable with the "regular" world, since the interactions, behavior, and conditions of the materials studied within it are later transferred to actual human bodies, or the knowledge gained from the experiments, or the observations of these, are transferred to a general knowledge-base that, in turn, directly contributes to human life and health.

So, what does this have to do with art? Visual artists have worked within studios for centuries, and, in doing so, have come to experience the nature of this space in ways that might be compared to that of a scientist's laboratory, especially in terms of its isolation and the personal control one gains in terms of the events that occur within it. For the scientist, however, the detached and controlled space is necessary in order to achieve objectively and measurably provable results that aren't intermixed with the indeterminate, and even unpredictable, events that would occur if they did the same thing out on the street. To be considered "science," in fact, the project must be verifiable, and to be verifiable the events must be repeatable. And the verifiable repetition of such an event, condition, or observation, in turn, is only possible within clearly controllable circumstances. Even the context within which the observations are made is considered to be an inherent feature of the events. The combined impact of these concerns results in the necessity for a controlled environment within which the experiments occur.

Conversely, artists don't create in order to replicate prior events (unless they are slavish academic realists), nor do they create works to prove the veracity of a prior expression. Working in isolation, instead, serves the purpose of allowing complete focus for extended periods so that the work can be completed in the first place. A dependable studio environment also provides a familiar and workable backdrop within which the artist can establish the array of contextual elements that is needed to complete the creative enterprise. This might include any number of things, such as easily accessible materials, or reference to a variety of prior works, plans, or drawings that inform the next works in a series, or perhaps research materials from which one draws ideas or inspiration. Even more common, the isolation of the studio environment provides the kind of familiarity and comfort that allows the artist to "let it all hang out" without the inhibitions of wondering what others might think if they were peering over the one's shoulder while waiting to judge the next action or decision. Most often, the artist's working environment involves all of these things at once.

In the work of Ken Botto, we find this condition taken one additional step. The artist constructs small environments within the larger studio environment. Most often, the small constructed environments are developed in the larger studio comprising the artist's yard. The yard is enclosed by plants and filled with an amazing array of collectibles, some of which have occasionally been integrated into the artist's developing work. The constructed environments are small and personal in scale. They are also distinguishable by being somewhat like "studios within a studio." He has generally constructed the small environments in a fixed location in his yard in Bolinas, California. In the small-environment works, each scenario is approached as an end in

itself, as a single work, even though it might lead to related scenarios or environments that are thematically linked. After constructing the small environment and introducing mirrors or mylar to enhance the lighting, the artist then photographs the set-up several times using differing camera settings in order to assure a quality result. After the photographing stage is completed, the setting is deconstructed, and new settings are constructed in sequence to take its place. Taken-as-a-whole, the entire series associated with a given theme constitutes each phase of the artist's work (see the list of some of these below). Some of these cycles overlap others, others last about a year, and additional ones last several years. Most recently, the constructed small environments have been alternated with ordinary spaces in which large mannequins or actual humans enter the space to be photographed and become the primary subjects, and the works are then paired, with one being a small environment like the older works and the other being within a human-scaled environment. This method will be discussed in terms of specific works below.

Botto's small environments have some similarities to the dioramas one finds in natural history museums. Normally, dioramas are reconstructions of environments and events from the past. However, Botto's works stress the urban decay and cultural corruption that are common within our contemporary world, rather than in a world long past as one would normally find in a natural history museum. As such, the miniaturized works might be better understood as "un-natural museum" dioramas. The artist, himself, refers to some of these works as products of his interest in what he calls "Urban Archeology," a personal inquiry he conducts into the environment in terms of "the urban decay in our cities, and the ruins that they have increasingly represented in recent years" (see interview below). There is also far greater drama instilled into the artist's constructed spaces than one would typically find in the comparatively calm panoramas in natural history museums. The conditions that he imparts also serve more as a warning or reminder of the impending cultural and environmental destruction that we face if we do not correct our errors, rather than as specific proposals or solutions to these conditions.

Botto represents one of those anomalies that we rarely encounter in life, yet never forget. In his case, the oddity is that it is almost impossible to figure out why–after about fifty years of creating unique and powerful works, that are of high quality and possess obvious social relevance–he has not been recognized for his accomplishments on a par consistent with the uniqueness, range of vision, and quality that one finds in his work. It would be tempting, and relatively easy as well, to respond by simply saying, "his works are too serious" or "too terrorizing in their realistic portrayal of the truth of the idiocy and folly of our destructive tendencies as humans." His gallery representative has told him that his work frightens people because they evoke the ugly truths in the world. While his works are clearly "serious" and occasionally "frightening" in nature (though with an accompanying dark humor), these traits alone may impact the works' marketability. However, such qualities don't really explain why his art hasn't received far more critical recognition. It is doubtful that most of us would buy a Botto photograph because it looks good with our furniture, but it is highly likely that we might do so

because of the many ways the works inspire us to reflect about the world in which we live. We might agree that art, in and of itself, can't change the world. But we might also concur that it certainly can, and should, be capable of motivating serious thought about the social and environmental conditions for which we are collectively responsible. It might also provide us with the motivation to do something about the collapse of our society's complex infrastructure, and reassess the prevailing assumption that the private sector will somehow bail us out. History teaches us that private enterprise does not have a major commitment toward correcting its dramatic and repeated mistakes.

It is this writer's view that the comparative critical disregard of this artist's work is also largely due to a general malaise within much writing on art today, and which largely determines the selection of the kinds of art that receives attention. One wishes that the nineteenth century poet and critic, Baudelaire, were still around to articulate the necessity for art to address the essential link between creative works and the world's bitter truths. In the poet's words, "that which is not slightly distorted lacks sensible appeal," and from this "it follows that irregularity—that is to say, the unexpected, surprise and astonishment—is an essential part and characteristic of beauty." Similarly, Robert Henri, the spokesman for the American Ashcan School, stated that "the subject can be as it may, beautiful or ugly...the beauty of a work of art is in the work itself."[2] The term "beauty" alone, of course, doesn't even begin to impart the grisly truth permeating Botto's work, nor the unique kind of energy with which this truth is delivered like screeching chalk on a blackboard. To find the closest parallel one must look closer to the nature of unfiltered reality, pay serious attention to the countless blunders, along with their selfish motivations, that are destroying our world at an increasingly rapid tempo. Only when we realistically confront the painful nature of the world and the behavior of those controlling it, will we be able to similarly face the work of artists who unapologetically convey this in their work.

Many of our most prominent contemporary art critics resist art that wades into the murky waters of life. In a book titled *The End of Art* Donald Kuspit posits a view that modern art loses its creative potential when it "turns to everyday life to revitalize itself, for everyday life—life in the crowd—is insidiously entropic."[3] To reinforce his argument, Kuspit borrows Rudolf Arnheim's use of the term "entropic" that is used in Arnheim's book *Art and Entropy*. However, Arnheim was not exactly using the term "entropy" to redress the blurring of the boundary between art and life, but in reference to what he considered to be an insipid monotony and lack of configurative imagination in much of the Minimal Art of the 1970s, as well as the extremes of frenzied decoration that characterized much art during the 1980s. Arnheim felt that the extremes of blandness in Minimalism and unreadable chaos in art forms at the opposite extreme collectively reflected a pervasive breakdown in society that foretold the death of culture (hence his use of the term "entropy").[4] Indeed, it is possible to perceive a cultural bipolar pathology embodied in these extremes—in the arts (and in human behavior as well for that matter)—but to conclude from this that art should be rigidly disconnected from life seems rather irrational, and conflicts with the tendency for art to mirror and comment upon life. To truly fulfill the autonomy from life that

Kuspit seems to advocate would only result if one totally hides behind the insular umbrella of the adage "art for art's sake." In his misplacement of Arnheim's main criticism–namely to identify a destructive tendency toward extremes in contemporary art–Kuspit places life at odds with art.

Kuspit continues his discussion with a scathing indictment of Allan Kaprow's advocacy of a "blurring of art and life," forgetting that it was precisely this sort of blurring that served as inspiration for the beginnings of Realism and Impressionism to the dismay of a rigidly resistant French Academy in the nineteenth century. As we know, the Academy favored art forms that were disconnected from life–the farther the better–and tended to be receptive only to themes that occupied worlds other than the bloody truths of that time. The preferred themes included history, mythology, and religion...in short, anything but the real events in the here and now.[5] The innovative reactions by modern artists to the academy's entrenchment was, in fact, the main basis for the emergence of many of the most dominant features characterizing early modern art. Many of these characteristics were originally reactionary (responses against the Academy's expectations), and have also continued to serve as dominant traits characterizing the visual arts up to the present during the modern era. Among these vital elements has been the use of subject matter that pertains to, and comments upon, the conditions of life itself along with the social struggles that have occurred in connection with these. Later in his book, Kuspit extensively quotes Baudelaire to support his desire for art to be totally distinct from reality, as a condition "foreign to our world,"[6] again misplacing the purpose of that author's intentions, just as he did with Arnheim's. It is well known that Baudelaire intended his comments in favor of art as a separate world–such as those of a "special order," or "the language of the dream," or the "infinite"–as syllogisms for a defense of the creative visions common to works in the Romantic and Symbolist movements. As we also know, Baudelaire later employed an entirely different terminology when discussing the emerging Realist and Impressionist movements as reflections of life itself, as opposed to the dreamscapes dominant in the other two movements. One wonders whether Baudelaire, Goya, Courbet, Manet, and others who have focused upon the ugly truths of life in their work would have rolled their eyes had they heard the displacements of terminology, now erroneously maligned with concerns that pertained to earlier and very different artistic concerns.

While Kuspit may feel revolted when confronting expressions reflecting the struggles and errors of humanity in works of art, it is fortunate that there are a few individuals who are willing to dig deeper and address the critical presence of these issues in works, as exemplified by the images we are addressing here. Indeed, positive critical acknowledgement has been directed toward Ken Botto's works. One of his photographs was the featured piece printed on one of the two or three versions of the poster for the New York MOMA exhibition entitled "Pleasures and Terrors of Domestic Comfort" (1991). His works are also represented in several major collections, and he has been included in some major group shows in major museums and galleries in Germany, New York, San Francisco, and elsewhere. His was represented in feature

shows at Monique Knowlton Gallery in New York in 1997 and 1998, and his work has been represented by a major gallery (Robert Koch Gallery) in San Francisco for several years. Some of his photo works have been printed in journal articles and books. At least seven interviews have been published in journals both in the U.S. and Europe,[7] and one book specifically on his work was published in 1978 (*Past Joys*).[8] But even these forms of recognition seem relatively minimal if one seriously examines the significance of the artist's overall productivity, range of quality work, and highly stimulating creative imagination.

In additional to the prevailing "fear of the real" experienced by many critics, and discussed above, one of the biggest problems may lie in the manner in which artists are frequently "typed" far too early in their development. This usually occurs in order identify the nature of an artist's work in its resemblance to an existing marketing niche in the gallery system. Since we live in a society that loves to categorize everything in ways that conform to a supermarket mentality, finding an artist who doesn't comfortably fall into a single, fixed style or subject matter, presents a considerable challenge for the system. In Botto's case, at an early stage in the development of his work, he occasionally included Barbie Dolls within the scenarios he constructed within small environments and later photographed. Because of this relatively minor "blip" in the development of his work resulted in his erroneously being considered "being too much like" the work of Laurie Simmons, an artist whose work more consistently stuck with the use of Barbie images as a primary trait. In contrast, Botto's work has actually spanned countless themes beyond the brief interest in the Barbie image. Likewise, it is notable that Botto's use of original, constructed small environments in which he places small objects to then photograph began in 1974 (two years before Simmons began her use of Barbies). These earlier, pre-Simmons works by Botto also employed a large array of toys and other collectibles that he has been gathering since the early 1960s when Simmons was but a teenager. It is critical to note that the brief period during which the Barbies appeared in Botto's work is extremely minimal compared to the scope and complexity of the themes and interests expressed over the past fifty years or so.

Additionally, while Simmons' works are directed toward a feminist critique, Botto's broadly address issues of social decay, over-militarization, economic meltdown, and related matters. The differences between these approaches far exceed any similarities. Simmons focused upon a legitimate critique of the association of women with dolls, along with the corollary miniaturization of female roles that fell (and often continue to fall) under that rubric.[9] There is no question concerning the import and potency of Simmons' theme, but one must also recognize the legitimacy of the broader social implications imbedded in Botto's works, and that are approached in a complex and entirely individual manner as discussed in this chapter.

One might argue, too, that Botto's works epitomize the artist as political critic. One would be hard pressed to find another artist who more effectively penetrates the façade and exposes the dementia and destructiveness inherent to contemporary consumer culture. His work also does so without taking on the trappings and methodological

maneuverings common in most "post-object" art forms involving performance art, site-specific art, environmental art, ethereal art, collaborative art, and other, non-studio forms of expression typifying the post-modern era.

The following description of the socially engaged artist is from Carol Becker's *The Subversive Imagination*. Becker, in turn, had developed these ideas from Herbert Marcuse's ideas. These views serve as an excellent conceptual framework for gaining access to an understanding of the essential nature of Botto's work:

> Within the creative process *is* resistance. In the process of making images, they can be transformed, utilized, co-opted, inverted, diverted, subverted. The personal becomes political; the political is appropriated as personal.[10]

Becker continues by observing that the stubborn act of will embodied in personal creative expression represents a necessary resistance toward the dehumanizing tendencies we presently face in our world. In her words, "...the sheer act of concentration necessary to produce art resists the diffusion and fragmentation characteristic of postmodern society."[11] For Becker, like Marcuse, the desire to resist the status quo lies at the heart of any claim for revolutionary or progressive expression. She further observes that:

> If there is a utopian aspect to art, it is in the spaces where artists can free themselves from the expectations of the art market and the contingencies of economic reality to immerse themselves in the making of their work. Or it is where, unable to free themselves from these concerns, artists are able to comment on them through a reconfiguration that becomes the art piece itself.[12]

Botto has invested almost five decades in the development of his art. One could never say that he has created works to satisfy anyone but himself. While this may have placed his work outside the more comfortable arena in which most blue chip artists reside, it certainly hasn't imposed limits on the scope of vision within the resultant work. The artist's evolution has included a significant number of Phases. Many of these overlap, and sometimes the overlaps occur over the course of several years. Some of the periods are indicated in the following simplified listing:

1969-Present: Works on paper, drawings, collage, watercolors, travel books.

1970-1975: Road Art series; photographs, travel photos.

1974-Present: Photos of old toys, miniature dolls, figurines in small environments, mylar backdrops.

1978-1979: Black Art series; photos on racial stereotyping.

1981: Barbie Doll series; parodies of contemporary culture.

1983-2006: Urban Nightmare series, also called "urban archeology" works; stress upon urban and cultural decay and the decadence caused by extreme materialism in consumer society.

1983: Venus Hotel series; first use of real people in miniature environments.

1991:	Paris series, miniature environments with college and objects set in Paris.
1993-1994:	Portrait series; images of American and European artists.
1997:	Allan Ginsberg Portrait series; settings combined with images of the famous American author.
1998:	Bachelor and the Bride series; miniature poolside scenes with figurines.
1999-2006:	Driftwood Figures series; fabricated, life-size, using Barbie Doll heads, ceramic heads, fabric backgrounds.
2001-2003:	9/11 series; N.Y. World Trade Center disaster theme.
2004-2005:	Black Mariah series; photo narrative series, mixes dolls in miniature environments with life (full-scale) human models in life-size environments.
1999-2006:	Conversation series; photo narrations, mixed with human-scaled driftwood figures, and small environments.

It would be impossible to discuss all of the above, complex phases of the artist's work within the limits of this brief essay. In the remaining space, we will touch upon a few of the phases, examine four works selected from three of these, and complete the chapter with an interview with the artist that was conducted in 2006. It should also be mentioned that the above listing of periods is, in itself, incomplete in that it doesn't account for the periods of work that occurred before the author first met the artist in 1969, and also represents a radical simplification of the almost forty years since that moment. Nonetheless, it is hoped that the reader can at least sense the multiple paths—each with its own highly charged trajectory—along with the intricate overlaps and interlacing of interests in this artist's highly nuanced development.

Ken Botto, *Fort Winnebago*, 1986. Ektachrome print, 20 in. x 24 in. Courtesy of the artist and Robert Koch Gallery, San Francisco, CA.

Ken Botto, *Red Shoe*, 1989. Ektachrome print, 20 in. x 24 in. Courtesy of the artist and Robert Koch Gallery, San Francisco, CA.

A potent example of the ugly truth is to be found in *Fort Winnebago* (1986). This work features an environment in which a child's playhouse establishes the psychological space as being the American suburb. A toy child is shows jump-roping in the driveway, and a gas guzzling Winnebago is parked out front, ready to head into a countryside that may no longer exist except in our imaginations. Parked next to the house if a WW II tank, with it gun pointed menacingly toward the street, suggesting a need to extreme protection from an unknown enemy that only our paranoia can create. An iridescent flickers as the backdrop of the family home, with its exaggerated reflections mocking a real sky, just as the military tank mocks whatever sense of true security that having such a monstrosity parked next to our home would create. This photo was the one featured on the MOMA poster for the "Pleasures and Terrors of Domestic Comfort" exhibition of 1991.

This work is from the Urban Nightmare series that began in 1983 continues to the present. The works in this sequence are among those the artist refers to as involving "urban archeology," an inquiry into the apocalyptic future of modern life and culture if we continue our present addiction to selfish values and destructive behavior. Though emphatic in it reminder of our destructiveness, the work also displays a strong current of cynical humor that typically also pervades the artist's work. One might say that the humor is like the "spoonful of sugar that makes the medicine go down," and its presence does allow one to approach the work in a reflective manner despite its frightening implications. It is clear that humor can serve as a mediator for our most frightening nightmares: those that we create and, consequently, must redress.

Red Shoe (1989) is another work within the Urbane Nightmare phase. Like many

of the other works in the earlier portion of this sequence of work, this example shows a decaying urban environment, in which clutter and deterioration are among the principle traits. The author is familiar with a work expressed from a similar point of view within this series, entitled *Cash Cow*. The latter work shows a shiny black limousine parked at the edge of a street in which potholes and discarded debris of various kinds clutter the surface, with the words "cash cow" spray painted on the fence along the sidewalk. In this work, the phrase "cash cow" conveys a clear sense of parody when considered in relation to the limousine, and suggests the ways in which the rich and powerful commonly capitalize upon the vulnerabilities of the poor in this kind of neighborhood of cities throughout the United States.

In the example of *Red Shoe*, however, we find a massive billboard of the Marlboro Man calming looking out over his kingdom of decay. Another figure, with the brightest red lips imaginable, surveys the same scene, but from the other side of the environment. The background sky is entirely unlike the false optimism reflected in the iridescent sky found in *Fort Winnebago*. Conversely, the sky in *Red Shoe* represents a density, darkness, and impenetrable foreboding. In the foreground, on the sidewalk, sits a comparatively large-scale bright red shoe, seemingly a monument commemorating the red-lipped queen who lurks in the background surveying her kingdom of decadence. Perhaps the shoe was left during a hasty departure.

Ken Botto, *Enfant Terrible*, 2005. Ektachrome print, 24 in. x 20 in. Courtesy of the artist and Robert Koch Gallery, San Francisco, CA.

Our next example is from the Black Mariah series of works, and is entitled *Enfant Terrible* (2005). The title of this work refers to what, to many, has come to be considered as the mythic traits typifying the artistic personality, as one that is unpredictable and idiosyncratic. The facts, of course, indicate that the idea is a distortion and romantic notion. The idea originated in France through implementation of the phrase, *les enfants terribles*, and continues to flourish as a prevailing cultural perception of artists in the modern world in general, including those in American society. The entire idea seems to have come to represent a kind of "psychological enabling," contributing to the further isolation and dismissal of artists and their work from mainstream culture as representing something inconsequential due to their "weirdness."

Taken as a whole, the Black Mariah series is comprised of works done in pairs. Within each pair, one of the two works is comprised of a photo taken of a small environment, continuing the conventions established in much of the artist's earlier work from much of the preceding forty years. However, in the case of the second work in each pair, the figures (or mannequins) are full human scale. Except for the Driftwood Figure series of works done between 1999-2006, most of the artist's works had focused on small environments. The actual humans, or life-sized mannequins, are shown doing the same things that the toy (small) figurines are doing in the other image in each pair. Each comments upon the other through the shifts in scale: small to large, and large to small. The interplay between the two worlds tends to create a sense of dissonance–or even myopia–concerning formation of a perception of what can reliably be considered the "real world" in the mind of one viewing the paired works.

In this relationship–one in which two parallel worlds are interposed, with one being familiar in its scale at least, and the other a miniaturized parody of the first–one attempts to reconcile which world is the most convincing. This interplay is not always simple, and one often comes away feeling the small world is even more authentic than the one inhabited by "acting" adults in their "real" world. Each of the worlds is pretending to be the other, resulting in a jarring contradiction between the two. This kind of pairing of two worlds, with one being what we normally think of as "real" and the other as one we thing of as "virtual," hits closer to home than we find in the wildly popular *Matrix* films, with their futuristic and highly manipulated look. Botto's pairing of worlds is a highly potent concept. It will be very interesting to see where this new direction leads him in his future works involving this theme.

In the specific case of *Enfant Terrible*, the full-scale live figure, of course, is an actual infant. This, in turn, reverses the tendency in the other works in the series, which employ adults in the "large" worlds, resulting in a further parody on the notion of what constitutes "life size." The anomaly is carried even further in this case by situating the infant in an environment that is actually comprised of the small couches and lamps that would be associated with a child's playhouse. The resultant perception is somewhat claustrophobic as a result. The hemmed-in nature of the drama, in itself, reinforces the parody, which isn't at all about logical relationships or an analytically correct world. Despite the small size of the pieces of furniture surrounding the child, these accoutrements are still too small to comfortably accommodate even the small, but actual, person who is trying to inhabit this cramped space. The infant seems to be ready to burst from the confines of his new womb, and his capacity for growth as an actual small human is thus accentuated. The work thus serves as a parody of birth and evolution within the span of a single life, and within the constraints of an inhabited, though temporary, architectural space.

Within a Black Mariah series is another, closely related, sequence of works that combine life size mannequins and real people. This interjection of surrogate images that are life size, and intended to interact directly with people or environmental elements in a real-life scale world, is not entirely new in the visual arts. Bernini's Baroque environment in the Cornaro Chapel in Rome is one obvious historical example. In

this work (constructed between 1642-52), the artist developed a design for a chapel in which sculptural replicas of the donors were created and then placed off to the side in the upper, gallery level. These figures face out into an adjacent space in which the miraculous and highly sensual transformation ("ecstasy") of the Saint Teresa of Âvila is depicted at the supreme moment in her vision. By combining two separate moments in time–the moment of St. Teresa's ecstasy and the depiction of the donors witnessing of the event, which, of course, occurred much later–the work represents a time-hybrid.

In the earlier twentieth century, we encounter another work that combines a life-size artificial human figure within a room environment. We are speaking here of *Étant Donnés* (1946-66) by Marcel Duchamp. The artist concealed this evolving work from the public until after his death in 1968. The piece is in the collection of the Philadelphia Museum of Art, and reveals a highly personal, though baffling, arrangement when compared with his earlier, more mechanistic works. *Étant Donnés* is at least as complex and the artist's earlier works, but it doesn't conform to the artist's forays into relationships between multiples forms of language, mechanical and systemic features of human behavior in a technological world, and the products of material culture. Instead, the work reveals a world hidden within an enclosed interior, one that is visually accessible only through two peepholes (resulting in a stereoscopic perception). When peering through the peepholes, one also sees (and looks through) another, but larger and irregular opening within a second wall. One thus perceives through two different sets of apertures, which increases the sense of intrusion within the viewer. One might be struck when peering through the two walls at the scene beyond, that they are actually re-experiencing many of the numerous visual methods that artists have devised over the centuries to present a separate reality: overlapping parts obstructing complete perceptions of select objects, progressively smaller subjects shown in the background, and atmospheric space. In this case the overall scene is a mix of actual objects and painted, illusionary spaces. This combination of the two art forms of traditional perspective painting and installation art is observed by Pia Hoy to form a unique, and new kind of hybrid in the annals of visual art.[13] Hoy further contends that Duchamp's approach in the construction of this work set the stage for the ways in which later installation art works embodied the joining of elements one normally thinks of as discrete, and extracted from the panorama of human experience. However, the surreptitious use of a privatized space accessible only through peepholes employed by Duchamp in *Étant Donnés* is generally quite different from the ways that installations were developed in the decades after the artist "completed" this work.

But it does appear that just as Duchamp began as a painter, he ended as one as well. Beyond the two walls, one sees a landscape environment in which a female mannequin lies in a field, with her legs splayed and her genitals blatantly exposed. The head is hidden, which depersonalizes the figure, adding further to the sense of stealth that one experiences when viewing the piece. In the distance a sickly waterfall trickles amidst a hilly woodland setting reminiscent of those electrically lit and shimmering waterfall/landscapes hanging on the walls in small town bars and that also serve as beer

ads. The landscape in which this figure resides is ambiguous and otherworldly. The work is part nightmare, part fairytale. Yet, despite the overall otherworldly character of the work, the reclining nude female figure within it situates the piece within that vast history of reclining nudes that appear in art history over the last five centuries. And, rather than being a representation combining two parallel, but detached, life-sized worlds with an implied interaction between them as we encountered in the Bernini, the viewer is personally implicated within the work itself, at least psychologically, through an intrusion made possible only through one's decision to look through the peepholes. Since the apertures provided the only form of visual access, and since the viewer personally chooses to employ this devise, Duchamp implicates the viewer in unique ways in the perception in both disturbing but intellectually intriguing ways.

A more absurd, though humorous, example of human artifice involves the relatively well-known story about Oskar Kokoschka, the twentieth century German Expressionist. The artist ordered a life-sized doll made to order, one that duplicated the appearance of his former lover, Alma Mahler. He even took the doll out on a "date," appearing in public where he interacted with it as if it was a human. When told of this, his former lover appropriately stated, "At last he has me the way he wants me."

Among the more recent artists working with surrogate or synthetic human figures may be found in Cindy Sherman's use of medical mannequins in her photographic series of the 1980s, and in which women's experiences are the focus. More recently, we find that Elena Dorfman has explored the combination of life-sized dolls with real humans in her "Still Lovers" series (1999-c. 2003).[14] Dorfman worked in collaboration with Elizabeth Alexandre, and was able to contact buyers of life-size, artificial latex "women," and gain their consent to photograph them while interacting with their latex "friends." Dorfman's works in this series of photos are highly realistic portrayals embodying a distinctly transgressive approach to image making. One image shows a young man lying on his belly in his backyard engrossed in his computer. Reclining next to him is his "friend," a life-sized female doll. The doll is fully clothed, but is lying on her back with her legs parted, staring blandly up into the sky. His yard has a high fence with no openings, and the environment appears very private as a consequence, adding to the voyeuristic feeling of the work. Another piece by the artist shows an entire family sitting at their kitchen breakfast table and engaged in the normal morning routine, while a life-sized "doll-sibling" (and named "Jamie") sits on one of the chairs in the midst of the family. Everyone appears to be relaxed in this setting, and the family appears to have fully accepted the doll as a family member and equal. These works reflect the extensive commercial photographic involvement of the artist; all of the pieces have perfect lighting and vivid, clean printing surfaces. Both the "real" people and the life-size mannequins are carefully posed in every work. There is an air of total acceptance in these works that parallels the social reconstructions involving programmed wives in relationships with their husbands that one finds in the film *The Stepford Wives*.

When compared with the Dorfman works, Botto's set-ups and photographs are much more handmade looking, and focus much more upon in the ugly truth concerning people and their behavior. Acceptance of the artificial relationship is not

nearly as apparent as a cynical criticism of this increasingly frequent aspect of modern life. Pretense and artificiality represent dehumanizing features of the modern world in Botto's work, while they represent simply another option in Dorfman's work. In fact, her works seem closer to Hans Belmer's inquiries into potential rolls for dolls as personal fetish objects than they do to Botto's commentaries on contemporary culture. Additionally, Botto's combinations of mannequins and real people are presented more as counterfoils within a dialogue between the two, rather than merely posed together at a select moment in a pseudo-interaction. Further relationships (and differences) between Belmer's works and those by Botto will be examined in a later chapter called "Assembly Required," in which the discussion will address the fabrication of human bodies from found materials.

Our final example of Botto's work in this chapter is *Blind Leading the Blind* (2005). Once again combining many elements that parody the world in which we live, this piece shows two life-sized mannequins contemplating a strange arrangement of objects on the center of a tabletop. The object being examined is made up of a box that has an American flag decorating its surface, suggesting the box is some sort of commemorative edifice is to be associated with patriotism. Projecting vertically from the top are bayonets

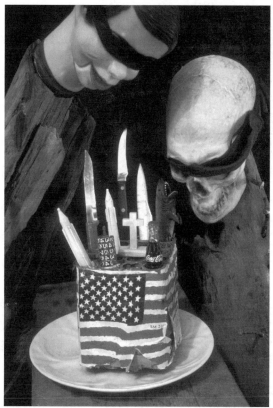

(or knives), toy missiles, and a Christian cross. The small space encapsulated by the box seems to simultaneously represent a burial ground and implements of violence that presumably are associated with the death of those who are suggested to be buried within it. The box, in turn, is isolated on a dinner plate, suggesting that is it like a meal in the form of "food for thought."

That the two figures are contemplating the central box area reinforces that notion that the entire set-up is a miniature edifice of some sort. Yet both figures are blindfolded, so that they couldn't actually see the object of veneration even if they wanted to! Thus, they truly are the "blind leading the blind." The series from which this work is selected is entitled "Conversations." The series employs a life-size mannequin

Ken Botto, *The Blind Leading the Blind*, 2005. Ektachrome print, 24 in. x 20 in. Courtesy of the artist and Robert Koch Gallery, San Francisco, CA.

modeled after the Danny O'Day dummy manipulated and voiced by Jimmy Nelson in the 1950s and 60s. This figure will be discussed at greater length in a later chapter called "Assembly Required." But, for the moment, suffice to say that the figure represents another in the artist's many ways of presenting levels of reality and parallel realities which have already been suggested in the works discussed above. Danny's sidekick in this case is a life sized driftwood sculpture being with a skeleton head. This figure also appears again as the sidekick in the work to be discussed in the later chapter.

The driftwood figure is an extension of the overall series entitled Driftwood Figures. The human skull suggests the presence of death itself, somewhat in the manner of the *vanitas* in seventeenth century Dutch and Spanish paintings. A *vanita* is typically a still life painting that includes a human skull, which symbolizing the presence of impending death within life, but presented in the midst of an assortment of partly eaten food, shown as if it is caught in the midst of the meal. In these works, the food was associated with life and sustenance, while the skull was to remind one of the transience of lie and its inevitable conclusion in death (e.g., the skull). Given this historical tradition, the presence of the skull in Botto's Conversation series represents a logical role for the image.

The use of blindfolds worn by the two figures, however, presents an enigma. The figures appear to be studiously meditating upon a central icon in the center of the work, one that combines emblems associated with patriotism as militarism, on the one hand, and death, on the other. These, in turn, are connected with our own world. Our world is evoked through the presence of the American flag and the temporal affinity to the tragedy of 9/11 with its seemingly endless contradictions of values, as well as its ever-unfolding violent events. That the "observers" are actually "blind" also suggests the all too true traits of naiveté and deception that characterized the reasons given for the American invasion of Iraq in the emotional aftermath of the 9/11 events. Like works in the overlapping Black Mariah series, this work continues the commentary upon human failure and tendencies toward deception. The life sized dummy, and his buddy (the driftwood figure with a skull head), are aptly chosen as appropriate commentators on the repeated failures of human efforts to address their own inability to understand and effectively interact with the very world that they have created.

Finally, we must ask in what ways are the works by Ken Botto related to the notion of hybridization that serves as the over-arching theme for this book? No doubt the reader has noted many points made in our discussion to this point that provide clues concerning ways in which the artist's work stresses this phenomenon. The artist's works involve hybridization in several ways, one of which is to be found in the materials employed. The combining of toys, collectibles, mannequins, driftwood, photographs, mylar, mirrors, and other materials represent the material aspect of the hybridization. Furthermore, the process through which the works evolve occurs in stages ranging from the initial small-scale environment to the final photograph. Collectively, these represent a hybridization of temporal stages.

Additionally, in the more recent Back Mariah series of works, the combining of works into pairs—one representing a miniaturized environment and the other a human-

scaled one, with the events being similar in both–represents a scale (or size) hybrid. The overlaying of parts that each has its own narrative and contextual meanings is another form of hybridization, as is the psychologically charged merging of multiple worlds in which the small scaled works evoke the literal terrors and experiences we have in terms of our surrounding cultural decay. In terms of the latter, though the small environments may represent experiences somewhat independent worlds from our own our own world–as more than a mere surrogate for our own human-scaled world with its parallel trappings–the powerful correlations between the small world and the larger world, and the mirroring of a crumbling environment when comparing both worlds, is impossible to ignore. This doppelganger phenomenon provides an "echo" impact, in which each world adds potency to the other when experienced in unison. A collision of the two floundering worlds occurs through our perception and thoughts in response to them. The thoughts tend toward a bicameral experience in that they come to exist both analytically (through the comparison) and subjectively (through the inherent nature of each).

Finally, an additional aspect of hybridization that seems rather obvious in the artist's work is the fact that each series is sustained as a relatively cohesive narrative sequence. While we cannot reproduce enough works within a given series here to graphically illustrate this point, looking at twenty or more examples within any given series results in a cogent, collective expansion of relationships between the common elements within each work in the given sequence. One begins to see how certain elements reappear in varied ways, like bit players with multiple roles in a low budget play or film. When looking at a larger set of examples within a series, one also begins to better understand the unifying themes binding them together. Looking at a complete sequence of the works in the Urban Nightmare series, for example, results in a collective vision that is even more powerful than any single work within the group. This, in itself, conveys the consistent potency in the artist's work as an entire body of work. Conversely, many other artists' works are best read individually, with many seeming to be tangential, or as nominal variations of each other.

Our concluding material on the artist is comprised of the following interview, which was conducted by the author and artist at his home on May 7, 2006. The comments were refined through an additional two-week period using phone dialogues.

INTERVIEW [15] - KEN BOTTO

JD: When I first met you in 1969, your work had been mainly involved with drawings, collages, and watercolors on paper. These works stressed highly energized lines as a dominant feature. Many of those works focused upon broken things, trashy things, ordinary things, almost in the vein of the American Ashcan School of artists (Robert Henri and others), but presented in a highly

narrative manner. I recall drawings and watercolors of a vast dumping ground of old toilets you found in a small town in the Midwest, or an old ironing board with things piled all over it. In short, these works stressed ordinary things in a state of decay or disarray. A few short years after this, your work shifted from predominately being highly charged, linear, handcrafted works on paper to the construction of small environments that you then photographed as your primary interest. Did any of the qualities of the earlier drawings continue in the construction-photo works?

KB:I don't consider myself as a photographer per se, or a maker of photographs, as my main concern. I consider myself to be an artist who uses the camera as a tool in one of the several steps in my process of image making. As the works changed from being mainly line drawings to being small environments that I photographed, the use of "drawing" became an aspect of the composing of the various images that lead to the final photograph.

JD Do you still draw?

KB:Yes. I just published a small press set of pen drawings.

JD: The early phase in the development of your work in which you stress drawing also seemed to reflect an interest in comic art. Is this true? Wasn't Robert Crumb (famous Bay Area underground comic artist who has since moved to France) one of your influences at that time?

KB:Yes, that true. I always considered R. Crumb to be an important American artist. He had a great classical drawing style, and a unique vision of American culture. I saw the movie on his life several times. We both came from a typical, screwed-up American family.

JD: When did you first create small environments using collected toys and other materials, and photograph these as works of art?

KB:In 1974 I started making small environment set-ups to be used for photographing. This was a few years after I began collecting the toys.

JD: These same small environments that you construct and then photograph are related to those employing a very similar process but created by Laurie Simmons and David Levinthal. Were you aware of their work when you first began developing these works?

KB: David and I began developing our related works of this sort about the same time. Soon after we both began our ventures I came upon David's small book done with Gary Trudeau called *Hitler Moves East*, and in which he used small model soldiers as surrogates for humans in their depiction of this tragic chapter of human history. I became aware of Simmons a few years later.

JD: It's interesting how more than one artist can arrive at related ideas or methods for working without having contact with each other. It is obvious that all three of you arrive at a related, or parallel, way of creating works of art about the same time, without each of you being directly aware that the others were doing it. Do you consider this a case of the "ripeness of an idea or method," and that you all became aware of it due to this ripeness?

KB: Yes, I think you are right. I believe that art history shows that certain ideas spontaneously occur because those ideas are "in the air."

JD: How would you compare your work with theirs?

KB: David uses a soft-focus photographic technique, and he is concerned with similar issues as I am. However, Laurie approaches her work from a feminist perspective.

JD: Could you explain the technique, or steps, you use for constructing and then photographing the small environments?

KB: The majority of my miniature constructions are fabricated on tabletop outdoor studio. My light source comes from the sun, and sometimes I use a small electric light to augment or dramatize this. I supplement all this with mirrors. The most recent work used mirrors more than the earlier works. Sometimes I photograph on-site, and at others I use interior sites using natural light coming through windows. The most recent human-scale set-ups are photographed with natural light.

JD: The environmental aspect of these works also seems to parallel the tableaus, installations, and settings to be found in the work of Edward Kienholz, as in his *Barnie's Beanery* or *Back Seat '38 Dodge*, that were created during the 1960s and 70s. His tableaus often stressed decay and the transience of human life. Another artist who may be germane to your work is the seemingly decaying cocoon series he created in the 1960s and exhibited at

the SF Legion of Honor. The later works were constructed from wax and silk stockings, and then suspended from the ceiling like bats or real cocoons.

KB: Yes, Edward Kienholz was a profound influence on my early development, especially in terms of his assemblages and life-size tableaus from the 1960s. And Bruce Conner has been a definite influence. H. C. Westerman comes to mind as well, with his dark, humorous work expressing human gloom. Also, my European influences include de Chirico's plank floors and Max Ernst's images of children being threatened by a nightingale.

JD: How is your work different from, or related to, theirs?

KB: In respect to Kienholz, Conner, and Westerman, our processes of making works are similar in that we have all fabricated environments from found or existing images or common materials. We also share a concern for addressing critical social issues. The parallel with de Chirico and Ernst is more in the realm of our common use of threatening or nightmare images in the works cited above.

JD: In what ways are your works focused on "a way" to create, and in what ways are they "ideas"?

KB: My method is to be focused upon what I am doing and aware of the possibilities of what the work can become through the process of creating it. I like to mine ideas that can be sustained through a series of works developed over time. For two years, for instance, I collected and worked on themes related to America's commercial airlines, as well as military planes such as the iconic B-52.

JD: I recall you referring to your works that stress the decay of cities as a form of "Urban Archeology." This is an intriguing and potent term to use for identifying the nature of your work. This is an especially significant idea given the escalating decay of the infrastructures and environments in the major metropolitan centers in America today. How would you define urban archeology in relation to these works, such as your piece entitled *Red Shoe* 1989)?

KB: The Urban Archeology series comes from my awareness of the urban decay in our cities, and the ruins that they have increasingly represented in recent years.

JD: Many of your works seem to evoke events in the contemporary world in additional ways as well. Do you see such works as commentaries on the world or as mirrors of the world? Or both? In other words, are you a sage or a messenger?

KB: I'm often accused of being a dark visionary. I don't really know, and maybe I am. But an image I created in 1984 shows a couple sitting on their couch in the city of New York as an airplane crashes into their personal space. The couple is watching TV. The work is entitled *Quick, Change That Channel*. The series this work is part of pre-dates the 9/11 tragedy. Is there a connection? I don't know, but it's a little freaky when I think about it.

JD: This suggests that there may occasionally be a fine line between impending doom and actual doom. Sometimes, when we think about tragic things that might happen, we are foreseeing what will happen. I am fully aware of the tragedy of 9/11, but I also can't help but think about whether we (America) somehow increased the likelihood of it happening through the attitude that we project onto the world. Most of our politicians seem to have avoided acknowledging any responsibility in the conditions that led to this tragedy.

KB: I agree.

JD: You have likely heard of the petri dish that biologists and medical researchers have used for several decades, and in which they place biological material in order to conduct research into it as a miniature "culture." The scientists and doctors observe the development and change of the implanted material(s) under varying conditions and over time to discover new knowledge about life, and also to create antidotes for disease. Even more recently, the petri dish has been used as a "stage" in which human eggs can be impregnated, after which the eggs are implanted in a woman's uterus for development into a fetus. Individuals who cannot become impregnated in the usual way increasingly use this process. In all of these cases, the small environment of the dish has served as a small -scale, isolated space within which materials are manipulated in what is a parallel, miniaturized reality, one in which life, itself can be created or altered. I've occasionally thought of your work as involving a comparable space–though an artistic one–where collectables, toys, figurines, 2-D images, and other materials are introduced and manipulated by you, the artist,

resulting in a new, parallel reality that comments upon the larger "regular" reality outside the work. Of course, you then photograph the fabrication, and the photo becomes a documentation of the original environment. You then move on to another work. How would you respond to these observations?

KB: I see my work as being more shamanistic or more like alchemy, as opposed to the activity of the scientist. I agree that art and science may have a lot of similarities. Both question their realities of the world. Art may shock and impact popular culture, as in the case of Warhol's "15 minutes of fame" quote. I'm not sure how much art can change the contemporary world if compared with science. Art must compete for attention with popular media, such as TV, video games, etc.

JD: Your own form of petri dish may be shamanistic and more subjective in nature if compared to the more analytical goals pursued by the scientist. But the similarities are equally impressive and are structural in nature. These similarities range from the initial creation of a small environment or staging area within which materials will be introduced; introduction of material and fragments drawn from a larger, parallel reality; manipulation of, and experimentation with, the materials introduced into the small space in order to maximize their potentials (albeit for obvious, different purposes); and provision of new insights into the broader, parallel reality as a result of the events and interactions created between the elements placed in the small environment. These similarities seem to represent a significantly number of parallel traits, regardless of the differing goals between you and the scientist. Your work also seems to range from the ridiculously humorous to the terrifying edges of human experience. Some works also seem to intermix the two. What is your perception of the role of humor and tragedy in your work, as well as the relationship between the two?

KB: I think it's a matter that is close to meditation, of getting in touch with my mind, involving a mix of the cognitive and gut instincts that expresses themselves without censorship from the cognitive side of the mind. The results range from absurdist humor to extreme sadness. Where do these ideas come from? It's a question of the self. I believe that the universe is a vast mind, and that our conscious mind and our unconscious mind combine as a receiver. One has to trust his/her own intuition.

JD: **Your work has employed toys that are like those created and sold during the era of your own childhood. When did you first start collecting these toys, and why?**

KB: The toys I use are from periods both before and after my childhood. They are from the so-called "golden era" of toy manufacturing, and date from about 1900 to the 1940s. I started using them in my creative work in 1970.

JD: **Did you envision using the toys in your art works when you first started collecting them?**

KB: No, the collecting process had its own life.

JD: **While realizing that your home is literally stuffed with collectibles, I wonder whether you still adding toys to the collection. Are you?**

KB: Yes, but at a slower pace, and only if it is something rare. However, I'm always on the lookout for something that can be used in my work. There is an on-going problem of adding new things when they have to compete for space with the things I have already collected. All of these things also must compete with the large number of archival binders and other, related things that are part of my working process as well.

JD: **Freud stated that play serves as a means for the young to experiment with and learn methods necessary for survival in an adult world. In a related vein, your work employs toys that were originally created before and during your own childhood, yet you use them to construct environments in which a frightening adult world off decay, death, destruction, and selfishness is emphasized. The resulting works seem to represent a vision that is paranoid in its extremes. Do you feel that your work accurately reflects the nature of the world, or is it a paranoid exaggeration of it?**

KB: I try to keep myself informed, am aware of history, and I'm a news junkie. I try to keep an open mind and maintain a world perspective outside our own culture. I see most of the actions of the so-called adult world as insane. I also try to maintain a balance by having a strong sense of humor. I like the way Mose Allison (the jazz musician) says it: "I'm not disillusioned yet, but I'm getting there."

JD: **Thinking of the world as a wine bottle, do you think it's half-full (optimism) or half-empty (pessimism)?**

KB: The only thing I can deal with is my personal life. Dealing with the world is becoming harder to do.

JD: **Do you feel that we are at a point in history when we have more control over destiny? Or more?**

KB: The only control we have is within our own personal life.

JD: **In a related vein, your work seems to have consistently possessed a considerable emphasis upon social commentary and political satire, somewhat in the traditions of the French Realist painter Honoré Daumier or the American political satirist Thomas Nast. Would you agree?**

KB: Yes, I have always felt an affinity for the work of these artists.

JD: **Your work has also frequently focused upon the underbelly of society, somewhat in the manner of artists such as the American novelist John Steinbeck or the German Expressionist and Dada artist George Grosz. Among other related topics, Steinbeck realistically traced the struggles of the working poor during the Depression era in America, while Grosz incisively exposed the blatant decadence in Fascist Germany under Hitler. Your works aren't any prettier than theirs. Because of this, I realize that your photos haven't sold in the way they might have if they were closer to the softer and more palatable images produced by most blue-chip artists working in related ways in recent years. I really respect the way you have stuck with exposing the ugly truth despite the way this brutal honesty may be considered distasteful and frightening to many individuals. Your work is never about mere entertainment or fluff, nor is it a distraction from the ugly truths of life. Do you ever have any second thoughts about continuing this focus upon the dark side of society and life?**

KB: Yes, my gallery tells me that I challenge the viewer too much. But at the age of 69 I seem to be stuck in following my own path. And I prefer the ugly truth to the palatable lie.

JD: **Does the act of creating works that reflect a hopelessly paranoid view of a decaying world depress you more than you might experience otherwise? Or does creating such works reduce your anxiety?**

KB: The latter is right. Sometimes I interject my anxiety onto the viewer. But I hope that this registers and rings true. I want my work to continue to have something to say and to continue resonating rather than sitting comfortably on its ass looking pretty.

JD: Is the attention you direct toward the underbelly of life a product of you Catholic up bringing? If so, how?

KB: The church taught conformity, middle class values, and materialism, while using mind-numbing dogma and church authoritarianism. But then, again, the church does give one something strong to rebel against! I also was very fortunate to have had two great art teachers who were nuns, and who encouraged my artistic interests. One of them also encouraged me to go on to art school. Due to this I went to California College of Arts and Crafts (now called California College of the Arts). While at CCAC I was encouraged to expand my awareness through study of history and a liberal education, and especially the Eastern thought that was prevalent in the Bay Area at that time. I have come to realize that the church (as we know it today) represents a relatively new religion, while older religions were part of ancient archetypal myths.

JD: Your small-scale works seem to represent an underlying chaos in art and human behavior, as much as it reflects out society's underbelly that we already discussed. Are you attempting to reveal the chaos that is in what appears to be order in the real world? Or are you trying to find order within chaos?

KB: I feel that I need to inject some kind of energy into inanimate object, to give them life. I believe that these objects then come to represent a comparable meaning to that manifested in human behavior. This parallels the animistic view that Buddhists have toward all objects in the universe, as opposed to the more anthropocentric (human centered) religions. The Native American peoples similarly look upon all objects as animated by an internal spirit or energy.

JD: Your work also seems to bear a relationship to at least two literary sources that I am aware of: Don DeLillo's fiction work entitled *White Noise* (1985) and José Saramago's *Blindness* (1997) and *Seeing* (2006). Have you read any of these fiction writings, and what parallels do you see between what you do and what these stories are about?

KB: I have read DeLillo's *White Noise*. The author had seen my work entitled *Fort Winnebago* at the Peter Galassi curated show called "Pleasures and Terrors of Domestic Comfort" at the 1991 New York Museum of Modern Art show and asked his publisher for the Italian version of his book whether they could use my image on the publication of *White Noise*. The publisher consented and this work appears on that version of the book.

JD: What similarities do you see between what you do in your art and what DeLillo described in his book?

KB: I was already on my own path when I read *White Noise*.

JD: DeLillo's book describes a black toxic cloud of imminent death and toxicity that roves the countryside, forcing people to confront a fear of death that they otherwise tend to deny. The people in the book also seem to develop a rather demented fascination for this specter of death. Are you attracted to death?

KB: (laughs) I am attracted to death. I also think our conscious and unconscious minds survive us after death, and go on.

JD: Delillo's characters show a fascination or death, a concern for it, as the cloud awakens their interest in it.

KB: I've just had a very close friend go through the process of dying from cancer. Watching her go through this made me realize that we really don't die. We simply leave our present form. We survive as some form of energy after our death.

JD: We live in a youth-based culture in which the ideal of remaining young permeates our magazines, TV, movies, advertising, newspapers, and almost everything we encounter. You seem to emphasize things that are the opposite of this: decay, death, and destruction. How do you relate what you do in this sense with the culture in which you live?

KB: I'm more influenced with Eastern thought that doesn't deal with a false obsession with youth. They seem to be much older culture, and seem to have gotten beyond the materialism and concern for appearance that characterizes Western culture.

JD: I have know you a long time, and have noticed that you don't like to talk about things that are debilitating or that remind you of the gory details of death and decay. Yet your work seems almost obsessed with these attributes. Do you employ your art as a means to confront your own mortality, and as a substitute or surrogate for such matters in your real life?

KB: I just don't like to talk about such things.

JD: In *Blindness* and *Seeing* Saramago emphasizes the blindness of people and sets up the government as capitalizing on this blindness. In the latter work, a main character is a police superintendent who begins investigating the people for the government in order to find the cause of a form of blindness that had suddenly appeared without apparent cause in the first of these two books (the two books are interlocked thematically). The superintendent then comes to realize that "not only are those within the government never put off by what we judge to be absurd, they make use of absurdities to dull consciences and to destroy reason." Sound familiar?

KB: I'm not familiar with Saramago, but it sure reminds me of the gang that is running the government today in America, especially in light of their ubiquitous predatory nature.

JD: Saramago also described the government in *Blindness* as deploying and even nurturing "cultural blindness" and in using deception as instruments of coercion to do things the way they want rather than to serve the needs of those they "represent." What do you think of this cultural view?

KB: That's what's going on today, and it's been going on for quite awhile except we are getting more adept at such deceptions. In fact, the current government doesn't even bother trying to cover up what they are doing, but just seem to be saying, "I'm going to lie, but what are you going to go about it?"

JD: In the more recent work (*Seeing*) Saramago sets the story during an election in which the votes of 70% of the ballots cast end up blank for no apparent reason. Does this sound familiar? Or perhaps like votes not being counted, or "hanging chads"?

KB: It sounds like recent elections for the United States presidency. It could happen again if we can't get a tighter voting system established. As Joseph Stalin put it: "It's not who votes that counts, but who counts the votes."

JD: **In a related vein, are you familiar with a book by the French philosopher named Jean Baudrillard called *Simulations*?**

KB: Yes, I did read it at one point.

JD: **Baudrillard discusses a world our culture has created that has increasingly come to represent a new form of reality compared to previous eras. This new reality is characterized by simulation. He stated that there have three successive orders (modes) leading to this condition. The first was what he calls the "counterfeit," a mode that was dominant during the "classical" period from the Renaissance to the Industrial Revolution. The second he terms a "production, with this one dominant during the industrial era. The third is identified as "simulation" and it dominates at present.[16] Do you feel that the current, simulation characterization parallels your own use of miniaturized worlds that run parallel to, and comment upon, a broader external reality?**

KB: It sound right on the money to me.

JD: **Another writer who seems germane to your work is Georges Bataille, who presents death itself as erotic. The eroticization of death may seem like a contradiction, yet, when one really think about it, one does annihilate all rational thought and existence in a state of complete sexual orgasm. Do you agree that there might be a parallel with your work here?**

KB: Oh yes, Bataille had an enormous influence on me, as did Hans Belmer (visual artist), and both for similar reasons. The relationship between death and eroticism was an idea that I grew up with.

JD: **Do you think that whatever order we perceive in our world is an illusion that we impose so that we might remain (or become) sane?**

KB: (laughs) What is order? What is sane? What is reality? It's all an illusion within an illusion. They are different faces of the same thing.

JD: **As small, staged, though inanimate, dramas, your works seem to inquire into a realm between the tangible ordinary reality and an**

entirely imaginary world. This sometimes results in the works seeming like mini-docudramas. Would you agree with this?

KB: I try to make my small, stages, imaginary worlds believable in their own right, in spite of how they are made and what they are.

JD: **Your more recent works deal with depictions of live people and/ or human-scaled mannequins, occasionally occupying a small environment like the older work (see _Enfant Terrible_). The newer work is also increasingly inhabited by real humans, or their human-scale equivalents (the mannequins), while the older works were entirely miniaturized. I think this is one of the strengths on the newer work, but it is more ambiguous in terms of a particular space being either miniature or real. Are you trying to compare real and imaginary worlds?**

KB: Most of the recent work focuses on the interplay of dolls or mannequins doing the exact same things that real people are doing in the equivalent photograph in each pair. It is important to bear in mind that I do these works in pairs, with one photo featuring mannequins and the other stressing real people. Yes, sometimes the mannequins actually seem more real than the actual people. When a normal scale figure (the baby in _Enfant Terrible_ for instance) appears in a miniaturized environment, this does disrupt our expectations and forces one to wonder which is the more real: the contrived space or the actual figure within it. The boundaries between surrogates and real humans are, indeed, blurred.

JD: **How would you compare the two worlds of the humans and the mannequins?**

KB: This method challenges and questions the believability of both through the absurdist nature of the comparison. The dolls are more real in some ways because they have a greater freedom, and fewer moral restraints than their human counterparts.

JD: **Does the pairing of real humans in their own, larger environments with toys or mannequins in their own environments both humanize the toys and mannequins, or does it dehumanize the humans?**

KB: The humans remain human, and the dolls or mannequins remain inanimate objects. But due to their similar stiff poses, and related body language and gestures, the mannequins obtain a dramatic presence that

challenges the viewer's way of thinking. Both worlds are questioned and, in some ways, interchangeable.

In summary, we have been able to examine several significant aspects in the development of Ken Botto's work. We considered his use of micro-worlds in which the focus is upon both the tragic and ludicrous of our cultural incapacity to constructively address the crumbling social infrastructures and the assumptions that have contributed to this condition. We also compared the artist's experimental use of constructed small environments in terms of their parallels with the small spaces used by medical researchers called petri dishes, in which "cultures" and materials are modified so that they may later be introduced into our "real" world in the form of implants, cures, or embryos. From this, we continued with a consideration of reasons why socially critical works, such as those by Botto, challenge the status quo, and are consequently often ignored by writers on art today. We then enumerated a summary of the various stages in the development of the artist's work, and acknowledged relationships, as well as significant differences, between his work and those of Laurie Simmons and David Levinthal. We also inquired into the methods and materials used for constructing the mini-worlds that the artist then photographs. Parallels with the "fictional" (but vividly real) toxic world described by Don DeLillo in his book entitled *White Noise* were discussed. We also inquired into Botto's use of what he terms "urban archeology," a method of social-environmental inquiry that he has developed within his art works. Finally, relationships between the artist's work and the "simulacra" described by Jean Baudrillard were discussed.

Above, all, we have noted that the deployment of human figures in most of Botto's works were in the service of constructing a hypothetical, separate domain that comments upon our own world, with both worlds being on parallel trajectories. In the next chapter we will shift to an examination of an artist whose work exists between worlds, and, by occupying this "hyphen-space," addresses unique ways in which one can come to understand each world. The multiverses perceived from within this new kind of space provides a hybridic perception as if we are within the membrane separating realms, or worlds, with which we normally don't, or can't, associate. This includes interest also includes entry into the "space" between differing modes of expression (such as between video and painting), and also measures the impact such shifts might impart in our perceptions.

HYPHEN–SPACE:
Spaces Between Places in the Work
of Gail Dawson

The space could be to the place what the word becomes when it is spoken:
grasped in the ambiguity of being accomplished, changed into a term stemming
from multiple conventions, uttered as the act of one present (or one time), and
modified by the transformations resulting from successive influences...

– From Jean Merleau-Ponty,
Phenomenologie de la Perception

We are entering a new era for which new metaphors are needed to accurately portray the changes in prevailing scientific theories and cultural assumptions. This is as true in matters of the depiction of space in the visual arts and it is in other areas. The "window" has held sway as the prevailing metaphor for visual space since the Renaissance, and, one could argue, even since the Romans. But the depiction of images as if they are seen through a window seems to be wavering in terms of its former position of reverence. By extension, the spatially integrative alternative to the window that evolved as the ultimate criterion in pictorial modernism–that is, a singular and unified surface in which all parts are holistic and coextensive–that first emerged with Cubism in the early twentieth century is also fading in its pertinence. Similarly, the pictorial conventions dominating the evolution of photography and its extensions in related forms of media continue to deploy the rectangular window as the dominant perceptual framework for expression. The later introduction of "real time" imagery within the frame added an element of motion illusion to the later tradition, providing a dynamic element through its use of time, but, even with the advent of the extended moment, the dominant framework continued to operate within a fixed perceptual rectangle as the basis to visual expression. The new art forms were now like sitting in a moving car while looking out the window, as opposed to sitting in a stationary car while looking out the window. Nonetheless, all of these alternatives are situated in terms of a fixed window, regardless of what is seen within it and whether that which is seen is still or appears to move due to the presence of a rapidly presented sequence of stills.

But new notions of space are emerging within this evolution. In contrast to the window-based perceptions, many of these new forms of perception are mediated by non-architectonic features, or at least those that are less dependent upon architectonic principles. Released from the ideal of a single, fixed frame within which images are

presented, these alternative forms of visual space are frequently driven by a variety of new possibilities. These include anthropological, ideational, and interactive concerns.

For the purposes of this chapter, one form of these new concepts of space will be introduced and emphasized. We will identify it by the term "hyphen-space." This hybrid word is chosen to indicate the meditative and conjunctive roles that this form of space might entail. The term also accounts for existentialist and phenomenological factors that are conferred due to its unique attributes. While the above mentioned, older concepts of space that had prevailed since the Renaissance (and earlier) had relied on a construct that was bound by fixed spatial/geometric and sequential temporal prototypes, our new concept–that of hyphen-space–is the product of inherently dynamic features, and also engages the viewer's imagination (thought) to a greater degree. While the old system tried to "tell all," the information that was provided was limited to a single vantage point. The old spatial construct accounted for events and perceptions of events in ways that were definable within or in terms of the confined notion of space in which they appeared, and specifically within a single geometric territory. In contrast to this, hyphen-space tends to focus upon events themselves and subsequently is more phenomenological in nature. While the old system selected a single slice taken from the "pie" that constitutes the panoramic totality of events and tended to claim that the slice represented the entire pie, the new effort attempts to actually account for the pie more in total. Of course, goals and achievements are two different things, and it's easier to claim a complete victory than to achieve it. But the goal certainly has changed.

In linguistics, a parallel may be found in the word "and," given its role as a conjunction between thoughts or ideas. The conjoining of things (and concepts) through the intervention of "and" aspires toward the same goal as the new prospects for a hyphen-space. It also provides a link where the dynamics caused by intersecting ideas is made possible, and serves as an acknowledgement of the potential for inclusiveness as a function of thought. The conjunctive serves as an instrument for release of the many elements that are entertwined within complex ideas much as it does with the resident perceptual modes that comprise the complexity of real space.

Using a wall (the membrane) between two rooms as a metaphor for our new kind of space–rather than one of the rooms (a rectangular space) taken alone as has traditionally been the case before–we can now account for a multiplicity that wasn't available through the old method. If the reader can imagine for a moment being within, or of, a wall, and being able to sense (both see and hear) the events from both sides, this might convey the essential nature of our new kind of spatial relationship. From this new vantage place, one would experience the two (or more) worlds enfolding herself or himself on all sides, and in a way that is entirely unlike the system provided by linear perspective along with its various reinterpretations. From within the membrane, one is between worlds, and thus encounters a multiverse rather than a universe. In this new situation, less emphasis is now placed upon the isolated vantage point of the individual and singular perception demanded in the old perspective sense, and more emphasis is now also placed on the new experiences formed. Similarly, if one could imagine

being within a drumhead (the membrane on a drum), from within this membrane the person would be able to simultaneously experience the striking of the drum (on the "outside") and the manifestation of the sound itself (on the "inside"). From here, one is between cause and effect, and, again, experiencing through multiple senses. Here too, one could come to know the spaces on both sides of the membrane as one, rather than as mechanically separate as is required when using the old system. In the old form of space we must distinguish events as separate based upon their role in the cause and reaction relationship. And, in this in-between-place, the experience is one of vibration and pure energy. The cause and the effect are like bookends with the place of experience being the books themselves. In another way, it would be like being the body that is between the head and tail of an "animal-event," but all three parts being experienced at once.

An additional trait of our new hyphen-space is its capacity to attenuate experience beyond a physical level alone. In this respect, one is reminded of Robert Irwin's commentaries on art being something we take with us, not something embedded within a fixed construct such as a painting, and that gains its optimal meaning within a museum or gallery. If taken seriously, the experiential aspect of art-experience is internal to the perceiver–rather than merely external to the work–and it is also reflective (more than simply reflexive) in nature. Otherwise it wouldn't be something that can be carried with us, and this is why it is not something that is left behind (in the art). In Irwin's words:

> What we're really talking about is changing the whole visual structure of how you look at the world. Because now when I walk down the street, I no longer, at least to the same degree, bring the world into focus in the same way. My whole visual structure is changed by the fact that I'm now using an entirely different process of going at it.[1]

And:

> Allowing people to perceive their perceptions–making them aware of their perceptions. We've decided to investigate this and to make people conscious of their consciousness…(and)

> If we define art as part of the realm of experience, we can assume that after a viewer looks at a piece, he "leaves" with the art, because the "art" has been experienced.[2]

Similarly, our introductory quote from Merleau-Ponty implicates notions of space that are both anthropological (lived in) and dynamic, thus demanding both reflection and thoughtful participation. Such a space cannot be defined only in fixed and geometric terms, as Euclidian and post-Euclidian art has tended to do. As such, dynamic (anthropological) space cannot be defined by its own measurements and traits, but by the experiences and thoughts of those who have experienced

and been transformed by it. To be sure, a corollary form of art experience may be invoked to engage our own responsibilities within it. It is the "lived in" and "thought about" nature of such anthropological space that energizes and lends meaning to it.

As the next stage in this discussion on hyphen-space, we will now encounter the art works of Gail Dawson. In her work we are faced with the necessity to reconcile the dilemma presented by Irwin's above observation on the mobility of experience as something within us rather than something within a work. With Dawson's art, one must either pay attention or leave the room. Her work will raise more questions than it answers. But questions inspire thought more than answers anyway, so that shouldn't be a problem, unless one prefers rote experience. And, if one adequately sticks with an engagement with this artist's work, and bothers to really look, s/he will very likely gain a lot. And it will stay with this person longer than what is most likely provided through experience with most other works that one encounters today. The reason for this is simple: her work provides insight into the ways we think about, and come to know and understand, things in new ways. This kind of experience takes time to grasp, and it continues after one "leaves the room." It's not art for lazy people or those who want a quick "fix." It isn't based upon a passive window onto a world intended to entertain or distract us.

The condition of being between two or more conditions that we have been discussing–a hyphen-space–is an important and major characteristic of Dawson's work and one's experience of it. Being at the intersection of a multiverse occurs in several ways and on several levels as we shall see from our discussions of four of her works below, three of which will be reproduced.

9. Gail Dawson, *One Second at the Rijksmuseum*, 2002-03. Comprised of 90 pieces (30 are oil on board; 60 are watercolor on paper), each piece 8 in. x 10 in. Photo courtesy of the artist.

Dawson's piece entitled *One Second at the Rijksmuseum* (2002-03) is an installation comprised of ninety 8 X 10 inch paintings, arranged in three rows. Each row contains thirty individual paintings, with each representing a different approach to the perceptions of the subtle movements of a person standing in front of a seventeenth century painting by Frans Hals. The thirty paintings in the top row collectively represent the sequence of movements of the figure within the short span of one second "video time." The figure in this first group of thirty images is depicted in oil paint, using representational conventions, with somewhat painterly applications. These thirty frames are presented as individual stills, with each stage representing but a tiny fraction of time (one thirtieth of a second). The time lapse encompassed by the entire top tow is brief, and, according to the artist, encapsulates one second. As one consequence, the overall span that the thirty paintings represent is an extreme distillation, with the resultant subtleties of movement within each frame being barely noticeable, even if jumping several frames. This perception is truly a close-up of a close-up of both time and space.

The other sixty paintings represent a break down of the above original thirty oil paintings into pixel-like dots and geometric circular shapes. The additional sixty works are executed in watercolor paint. These shapes are like the dots on a video or TV monitor if one were able to radically zoom in on these and get an extremely close-up view. In the first thirty of these watercolors, the original image is still discernible; the last thirty show an even more compressed sense of time and space. The perception in the top row provides an experience in which the viewer seems to enter the tiny fractures of time provided through a video camera in which the unique version of an event that occurs within each fraction of a section is isolated and individualized. Taking the top row as a whole, one gains the feeling of how time contains far more than we normally are able to perceive with this kind of break down into miniscule moments within the moments that our limited minds and eyes are able to interpret through ordinary perceptions.

The top row provides entry into the fabric of a second, but, through its provision of depictions of thirty segments within this very limited timeframe, the experience of perceiving the middle and lower two rows is almost like entering the molecular structure of the perception itself. In short, the middle and lower rows provide entry into the fabric of space, while the top one provide access into the membrane of time. While examining the middle row, one notes that the proportions of the generalized shapes within it correspond to those in the top row where the perception is relatively intact as a more or less typical figure-ground relationship. This image is comprised of a human figure as it appears within a museum gallery room. Behind the figure is a Frans Hals painting shown as tilted on the wall, thus serving as an anchor for establishing the ground in the figure-ground relationship.

When moving from the top row to the middle one, and from the middle one to the lower one, one moves dramatically into a network of the pixel-like shapes. The pattern of shapes is highly reminiscent of the dot paintings of Roy Lichtenstein. As with the Lichtensteins, Dawson's pattern motivates one to stand at varying distances from the work since the pixel-like shapes break down the façade of the image,

dematerializing it from its former condition as an intact singular material object. And, in place of the illusion of a cohesive materiality, one "enters" the subject. On another plane, Dawson's approach bypasses, and even penetrates, the normal notion of materiality as something solid and fixed. One obvious consequence is a sense of displacement, and a unique kind in which one is transported into the space within the subject. Some readers might recall the old sci-fi film *Fantastic Voyage*, in which a space ship was miniaturized and injected into the body of a human. Most of the movie was comprised of navigating the numerous biological avenues and rivers within the human body. Each part is perceived in an entirely unique way when one is within it, in contrast to the way one perceives an organism as a total from the outside. Others might feel that Dawson's "penetration" into the fabric of materiality evokes Alice's entry through a rabbit hole beyond where one encounters the magical, miniaturized world described in *Alice's Adventures in Wonderland*. The significant issue, of course, is that, in these cases involving entry into the body of a human or into the world within a rabbit hole, the entire cosmos may be perceived in a new way.

After completing the sequence of small paintings in the Rijksmuseum work, the artist then digitized the images. The thirty panels in each row come to life in the video in animated form, although the entire sequence only lasts for 38 seconds. In terms of a related work entitled *First Take Off*, the artist states:

> I work from a television monitor, which combines the challenge of working from life and working from a photograph. I concentrate on capturing the specific qualities of electronic color and transmissive light, dividing mimesis between a description of the image and its format. The painted and drawn images retain a recognizable reference to their original technological format. Unlike a television monitor, however, their surfaces are open and worked. Touch and vision are linked; the optical experience of video becomes tactile—a material equivalent of video distortion.

> The circle is complete when I digitize the paintings and drawings and edit them into brief video clips, where 30 frames equal one second. Thirty paintings represent one second of video. As videos, time compresses multiple paintings into the tiny space of a monitor...Seen as paintings outside of the video, they occupy space, and require a different kind of time to be viewed—a traditional, more contemplative looking where the viewer is the editor and decides which images are seen and for how long.

> The result is work that unites a newer way of seeing images with a traditional way of making them. My hope is that the viewer moves from a position of consumption of images to one of contemplation of them.[3]

From the above, it is clear that Dawson moves first from a perception gleaned from television media to one enacted through relatively traditional paintings. The

paintings are very small, and done in sequence in order to provide a sense of time. In the case of *One Second at the Rijksmuseum*, the artist moves even further from a media-driven image by producing it in the three forms that we have discussed above: a relatively ordinary figure-ground perception, a view in which this perception is broken down into pixel-like fragments, and a final one in which one gains the sense of entering into the fabric (or membrane) of the space within the subject. She then digitizes the various stages, and translates these digital images into a video form in which one then experiences the same sequence, but now in animated form. Even when animated, however, the subject still retains the sensation that one is entering the molecular and sub-molecular fiber of materiality itself, dissolving its former illusion of solidity into the suspended dots and other pixel-like shapes. When played back in the animated, final video form, these sequences gain a humorous and dance-like quality.

In *Race* (2005), the artist uses the theme of a horse race, and employs the racetrack as the outer spatial limits of the work. Like many of her works, this piece is extremely large: three by thirty feet. Although the dimensions are large, the intricacy is minute. The image tracks the entirety of a horse race from beginning to end. The horses are shown in full gallop, and are repeated multiple times, as if caught in a massive stop-action photograph encapsulizing the entirety of the event. In this case, however, the work is not converted to a video form. But this isn't necessary anyway, because the depiction provides a cohesiveness–an "all at once" perception–that wasn't available in other works by the artist in which a sequence of small paintings chronicle a larger event.

Dawson works from a huge roll of watercolor paper as the ground for the painting. The painting is approached in a distilled and minimalist manner, with only the most essential aspects of the images provided. The horses are depicted in simplified form, and the building of the racetrack is even more reductive. The amount of white paper left unpainted is enormous, giving an almost blinding sense of illumination to the entire work.

One must stand relatively close to the piece to clearly analyze the nature of individual images and their localized relationships. But when stepping back, the entire work becomes a condensation of many moments in time, all occurring within a panoramic space. This perception is unlike the sequential way in which time was

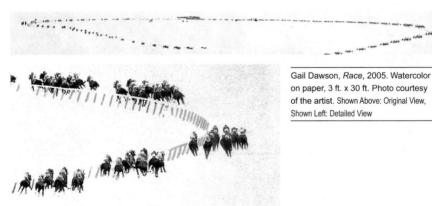

Gail Dawson, *Race*, 2005. Watercolor on paper, 3 ft. x 30 ft. Photo courtesy of the artist. Shown Above: Original View, Shown Left: Detailed View

approached through many rectangular paintings done in chronological order in *One Second at the Rijksmuseum*. Now the sense of time is coalesced into one large, single event: the race. But one can still identify its constituent moments by standing close and examining any given local sub-event within the larger event.

The challenge of compressing a hyper-scaled event in real time into a single perception that we find in *One Second at the Rijksmuseum* closely parallels another work by the artist entitled *Fischer v. Spassky, 1972* (2005). The latter piece involved a condensation of the lengthy performance that occurred in a chess game between Bobby Fischer and the Russian champion, Boris Spassky, in 1972. The match was an internationally televised event, elevating chess to the level of spectator sport. To make the piece, Dawson translated the entire sequence of moves into a single watercolor painting measuring 4 X 4 inches. Though the overall work read on a visual level like the pixel-pattern of shapes that we encountered in the lowest row of the *One Second at the Rijksmuseum*, the painting is not literally a "figurative" one. The artist did not wish to make a literal representation of a chess game, but to use a time-based sequence to create form. Structuring a painting by translating the sequence of chess moves necessitated inventing a system to represent the stages within the game. Each player was assigned a color, and each chess piece was assigned a circle, with its size corresponding to the relative strength that the given piece represented (e.g., queen = large; pawn = small). The work was digitized as it was made. For example, each time a circle was painted, but before the next one was added, the image was shot, using a classic stop-action type of animation. The three hundred and twenty images that comprise the entire game were edited into a video, as occurred with the Rijksmuseum series of images. A sound track was added, and it became an extremely humorous animated version of the famous chess game. The sound track was created using one of Bach's two-part inventions, and was played by the artist on a midi-keyboard that fed directly into her computer. The video portion was then modified somewhat in length to conform to the length of the musical portion, resulting in the final piece.

In Dawson's *Hurdles* (2006) we find a new, though closely related, dimension in the artist's working methods and results. The work, again, confronts the notion

Gail Dawson, *Hurdles*, 2006. Watercolor on paper, 21 in. x 52 in. Photo courtesy of the artist.

of an extended time experience with the successive stages of a sequence within an event being simultaneously visible. Except, instead of the historic patterns or facets of evidence of prior events as a sequence of units that collectively represent the whole, we now find linear "tracings" of the past events over an extended period, but no direct visibility to the actual event itself.

In this case, the work shows a track meet stadium where runners conventionally run "laps," and conduct competitive races. However, no runners are visible. In the Rijksmuseum piece we found the figure in the top row of 30 pictures that subtly rotates in space, showing the minor (and subtle) changes that occur in the form of the thirty stages that would happen within a second. And in the *Race* work we found the many stages of horses as they completed their circuit around a horse track. The first of these stressed an expansion of subtle and minute change within a brief moment, and the second stressed the many changes occurring within a broad sweep of a horse track.

Our new example of *Hurdles* shows the many hurdles around a track, and that would constitute the challenges that the hurdler faced in the past. And, with this, we also encounter the linear "tracing" that following the paths that the hurdlers accomplished while completing their circuit, but, as actual perceivable events, these all have already happened and we are only faced with a residue of these. The marking ("tracings") are reminiscent of those stop-action photos that we've all seen taken in the dark of a highway and in which the headlights of the cars are recorded as sweeping lines of light, but with no actual cars visible in the end product. Due to this, the work is understood more as memory of an event than as a record of the event itself. Or perhaps this could more accurately be stated to say that what we encounter is the memory of movement, but not of the bodies that moved. The work is stripped of it bodily recollection, and thus we are reduced to the purity of movement itself. And, because the movement is reduced to the light colored lines that track the directions of the path that the bodies had followed, the work is further characterized by using light as the vehicle of movement.

This dematerialized perception of the tracking of movement from a past event represents a highly mediated form of recording an event. And, as a record, the reductive manner in which the past movements are presented lends an extreme form of ambiguity that the viewer must "complete." Most of our readers are familiar with examples of art in which the viewer is called upon to "complete" the image. This work falls into that category of gesture and suggestion. It is an art of intimation, rather than full exposure. But compared to most suggestive art works that this viewer has experienced, this example is considerably more reductive; it doesn't indicate a partial image but only a memory of the trajectories of past images. This suggests a prior presence most definitely, but not in a material way, or in a way that tells us what had been there before. We have no indication that the objects that produced the "tracings" around the track were humans, horses, or other possible entities. Because of this, we are forced to draw conclusions based upon the environment itself (the track), and, by know that humans normally run on tracks in stadiums, we tentatively come up with the idea that the beings must have been humans. But this is still only a guess.

The artist strongly feels that perception is a key consideration in her work. She has explained in a direct phone discussion with the author that her work is concerned more "with making a painting," than in "painting an idea." The obvious emphasis upon perception within unique frameworks of time and space leads one to conclude that both the phenomenon of experiencing the work and the perceptions of it are more important than ideational goals in themselves. While there is an ideational side to both phenomenology and perception that have to do with our understanding of our world and our experiences within it, these experiences, and the unique perceptions gained through them, are more important in our relationship to Dawson's work than any preconceptions we might have of what the works might mean in a purely ideational way.

Not everyone will like having to fill in the gaps to the extent that this kind of work demands. But, in doing this, the work invokes the participation of the viewer to a dramatic degree. This is why this author cautioned the reader that Dawson's work is "not for the lazy." This work requires an active imagination, and a willingness to reflect on the subtleties of what is being provided.

INTERVIEW[4] - GAIL DAWSON

JD: As a form of hybridization, your work seems to join real-time media and still-image traditions, yet still retain something of the traits of both. Would you agree? How would you explain this interest?

GD: Yes, I agree. My initial interest in making paintings from video was purely visual. I was interested in the differences between a non-mediated subject, and its mediated image. Video artifacts—scan lines, halos, and low resolution—were as interesting, if not more than, the subjects or images of the videos. I began this process at a time when I was asking lots of questions about the possibility of making a painting. Working from a video still was a way to make a painting. In the seven years I've been working this way, my interests have expanded and evolved into making videos. However, my deepest interests are founded in painting practice.

JD: Your work seems to be readable on different levels simultaneously. Would you concur? Is so, what levels do you perceive as most prominent? ,

GD: Yes, I hope it reads on multiple levels simultaneously. My process has a basic structure, but leaves enough to chance that I hope for the possibility that things occur in the work that I can't foresee. It is only in reflection that I begin to see the different levels. What I see as the most prominent varies over time and from piece to piece. Right now, I am

most interested in the overall structure of the painting, using temporal sequences to create form, so for me, this is the most prominent aspect of the work. However, most people seem to read images first, so I think the subject of the paintings is most prominent to viewers.

JD: Your work also seems to provide entry into both time and space. In terms of time, you work from real-time video/film/TV expressions (such as the Triple Crown races or human sporting events such as track meets) and encapsulate a broader scope of time than still works normally do alone. Is this a fair assessment? Can you give examples of how you do this and how such works relate to time?

GD: Yes, I hope the work encapsulates a broader scope of time than most still works do. I have a hard time selecting a single moment for a painting. I'm not sure why, so I've developed this practice where I take a familiar event, like the ones you mentioned, and pull it apart temporally and spatially. Take a horse race for example. A televised race, once it starts, focuses on the participants as they make their way around the track. The camera tends to move in and out on the participants, showing their progress in relation to the course. Still, even if the camera is pulled so far out that the entire track is seen while the race is on, it's only one of many framings of the event as it unfolds in time and space. On television, we watch the race, part to part – one frame to the next. (It is rare during the real time running of the race for the producers to pull out so far we see the whole of the course.) So when we watch the Belmont Stakes, for instance, as we watch the horses run, we unconsciously rely on our concept of the racetrack oval to create a context for the frame-by-frame sequences. Space is compressed through time, so that despite the distance being traveled by the participants around the racetrack ovals, we are watching just one spot: the television screen. What I've done with the race paintings, for instance, is take the part-to-part sequences of the race, and link them together into a whole as you might string pearls. Showing the parts and their whole simultaneously is only possible in painting. (Television now has screen inserts that can show the whole and the parts together, but those are not integrated wholes; they are separate parts.) The space of the painting replaces the time of the video. Multiple sequences of time create the form of the painting overall.

JD: Can you comment on ways that your work deals in comparable ways with space?

GD: In terms of the original question, about how my work might "encompass a broader scope of (space) than still works normally do," I don't think there's much difference.

There are lots of space questions at stake in the work. I'm most interested in two aspects. One is the issue of space and its relationship to time as noted above. The other is how "realizing" the whole from its parts directs pictorial space in relation to the continuum of say, Renaissance to Greenbergian, space. In those terms, in all the work, there is some form of representational space following the conventions of spatial representational on a two-dimensional picture plane. For example, what is nearer is larger and stronger in color and value, and what is farther away is smaller and less intense in color and value.

In all televised races I've taped, the producers at some times pull out for a wide view (showing more of the course and the runners); at others, they close in for a tight shot of the participants, often cropping out all but a few. Sometimes I manipulate the given video frames to emphasize spatial conventions. The *Human Race* watercolor is an example. In that painting, I made the runners at the start the farthest point away from the viewer. To create the painting I changed the frame size from the video standard of 720 x 480 psi, to whatever was necessary to make the runners appear to grow larger as they run the 100 meters.

The *Race* painting of the Belmont Stakes, on the other hand, uses the frames directly from the televised race. Each is 720 x 480 psi. Sometimes it's shot wide and sometimes it's tight, changing the scale of the horses in each frame, from large to small. I didn't attempt to apply pictorial spatial conventions to any of the images to make them "sit' in a believable representational space.

JD: Another way in which your work seems to possess a hybrid quality is in the references to other artists' works. Specifically, some of your multiple and sequential images seem to evoke aspects of works by a number of artists. Among these are certain examples of Chinese landscape paintings that come to mind, in particular those in which the same figure appears several times, and resulting in a merging of disparate moments from within an extended journey. Others, in the Western tradition, include Masaccio's *Tribute Money* (1427) in which St. Peter is simultaneously shown at three differing moments in time, Monet's serial studies of *Haystacks* and *Rouen Cathedral* (mid-nineteenth century), Eadweard Muybridge's sequential photographs (late nineteenth

century), and Duchamp's *Nude Descending the Staircase* (1912). What correlations do you see between your work and those by these artists?

GD: In terms of the multiple and sequential images of Chinese landscape painting, there is great similarity, since every part of one of my paintings, is just the same image at a different moment in time (and space). With respect to narratives in the Western tradition, there is a previous understanding on the part of the viewer about what s/he's seeing that contributes to her/his understanding of the painting. This is why I've chosen to use sequences from broadcast television. In relation to Muybridge, other people have noted that his work creates a context for what I'm doing. Though if you make his images into a motion sequence, the galloping horse seems to run in place, not creating space. This isn't true of all his sequences, but I think the questions driving his work were entirely different. The same is true of Monet, whose interest was in light. I think you could say that my initial interest in the transmissive light of video could be a relationship between our works. I think there's a strong relationship with Duchamp since he's using motion as a way to make a painting.

JD: Another reference seems to be Degas' horse race paintings and drawings. What is your perception of his work and its relationship with your efforts?

GD: I have been interested in Degas' paintings since I began painting. I think there's an analogy in that his race paintings were made possible through photography, and photography affects the paintings through its essential qualities such as cropping and composition, and the sense of potential movement. In a similar way, the temporal and visual qualities of video make my paintings possible. Also, Degas was working with subjects that were part of his life and social circle's interests. Watching sports on television is part of my culture.

JD: Are there any other past or present artists who have influenced your work? And, if so, how?

GD: Richard Hamilton is a big influence because of the way he works from one medium into another. He doesn't seem as concerned with subject matter as much as he is concerned with process and how images change as they are translated. Gerhard Richter is also an influence for similar reasons.

More recently, Benjamin Edwards and Tom McGrath are people I'm interested in. Benjamin Edwards for his constructions of pictorial space and Tom McGrath for his interest in modulating space and time through painted form.

JD: Your work treads the line between contemporary digital and real-time media, on the one hand, and expression of still images, on the other. How do you perceive your relationship to each?

GD: As I said above, I began using video as a way to make a painting. Though I veer, rather recklessly between the two, my first allegiance is to painting. Amid all the experimentation I undertake, and I experiment a lot, the roads I ultimately choose are those that foreground painting.

JD: While your working process draws upon images and processes central to real-time expressions in video, film, and TV, the final form in which the work appears is a still image (watercolors). Could you comment on this phenomenon?

GD: I am most interested in making a painting. I try to show my paintings and the videos I make from them, together. In this way, I hope the viewer, switching between watching a video made from the painting, and looking at the painting itself, will come to recognize the different stances required to look at each. The videos, I think, lend themselves to consumption of images, while the paintings lead to a more contemplative stance.

JD: I have noted that your academic background includes a B.A. in art history from UC Berkeley, as well as your later studies in studio fine arts. Has your earlier study of art history had an impact on your work? If so, how?

GD: When I studied art history my concentration was architecture. I also managed to avoid studying any art beyond the 19th century. I wrote my Senior Thesis on tracing the work of anonymous artisans of the Western School of Masonry in English Gothic Architecture. The relationship between what I do now and that art history degree, is to be found more in reflection than in instigation, and my conclusion, as of now, is that like Gothic architecture, which created large structures from multiple, small parts, I make big paintings from multiple small pieces.

JD: Your image of the Kentucky Derby track and the human version

of the same kind of racing, except that it's in the form of track meets, shows "tracings" that following the paths taken by the horses during earlier moments in time. This is intriguing. The tracings are like memories of events in the past, and also evoke those photos we've all seen of car headlights on freeways taken with long exposures. The horses have vanished from the picture and only the linear markings showing their movements in the past remain on a visual level. What were you after when making these pieces? What stages were involved?

GD: Those pieces were made by taking linear, temporal sequences and putting them together to make a whole. Sometimes I include the tracings and sometimes I don't. Those decisions are directed by my primary interest in making a painting, rather than making a painting of an idea.

The paintings, whether or not I decide to show the tracings, are made when I determine how I am going to build a form from the source material. I begin with a taped event, like the Kentucky Derby. I input it into Final Cut Pro, a video editing program, and break it into various sequential configurations. I import stills into Photoshop and play around with possibilities. Sometimes, I use the NTSC standard of 30 frames per second; sometimes I create my own 'rule' for the number of frames per second; and other times I'll use visual relationships to determine the temporal distance. In the *Hurdles* piece I chose the frames by the information they showed about the track. In this video segment of the race, the camera was in a fixed position. It followed the runners, as they ran toward, passed in front of, and ran away from the camera. I took the frames, which had just a small portion of the racetrack ellipse, and extrapolated the entire ellipse of the track. What's shown are the "tracings" of the track as the camera followed the runners.

JD: There seems to be an aspect of your work that is also about that good old visual artist concern of perception, that is, how we see. Do you agree and, if so, could you discuss this aspect of your work?

GD: As I mentioned above in response to the question about time, I think that perception does play a part, but it is incidental. I do not set about to make a painting that "deals" with perception as I have reflected on it in answer to that question. I think when making images or paintings, it is a question that naturally occurs. A directive I've given myself in relation to this question is to consider the continuum of information necessary for representation – how little and how much.

JD: Another element that seems to enter into what you do is the element of light. Your process seems to combine both artificial light, such as the luminous dots on a TV screen on the one hand, and natural outdoor light on the other. In some ways you seem to be a latter day impressionist in this respect. Could you comment on this, and refer to specific works as examples for the varying ways you deal with light?

GD: The question of light is one that first interested me in painting from video. After a few initial pieces where I worked from a printed video still, I began painting from a still playing on a video monitor. I chose to do so because the printed still was just a particular type of photograph, so it seemed that I was just making photo-realist paintings using a specialized class of photographs.

It was my interest in two systems of light, that you mentioned in your question, that drove me to work from video monitor: one, the transmissive light that presented the image; and two, the light represented in the image.

The electron gun that shoots stuff to the TV raster, breaks up the image in particular ways that provided a painting vocabulary I hadn't explored. It gave me ways to see how to paint, forgetting what the image was, and allowing me to focus on how it was being shown. All the distortions of video, including black and colored halos, bleeding color, and scan lines became ways that I laid down paint, and, through following the color and value of the screen, "inadvertently" created an image.

The painting, *Race* uses the way watercolor bleeds to recreate the blurs and bleeds that occur in video, where distinguishing between rider and mount is sometimes impossible (this is another example of how perception is a part of the work – we use our understanding that there is a rider on the horse to distinguish her/his form, even when the video image distorts this beyond all recognition).

JD: What kinds of response do you get from people who see your work?

GD: 1. Dealers' concerns center on the scale and saleable qualities of the work. No one seems to know what to do with a thirty-foot watercolor, and gallery spaces that can accommodate it are rare. There is an element of confusion about why anyone would be concerned with the relationship between video and painting; this association seems completely foreign to most people.

2. People like the videos.

3. People respond to certain images. For example, the bird paintings are attractive as a subject, over any sense of "hybridization."

4. People are curious.

5. I've had interesting conversations with physicists about the time/space aspect.

JD: Are there any other ways in which you feel your work embodies qualities that are related to hybrids or the process of hybridization?

GD: No, I think you've covered them very thoroughly with your questions.

In our discussion of Dawson's work, and in the interview, we have encountered several things. We have found that her work demands an extended period of time to understand, and that it is based upon our capacity to perceive, and also to fill in the gaps when our perceptions don't provide us with complete information. Her work both compresses and expands time and space, and we gain glimpses into the space within the spaces, and the time within the time. While her art borrows from the familiar events of a world we know, it represents these vistas in ways that are unfamiliar to us. In so doing, Dawson provides doors through which we can learn about how we come to know and how we see. We have also seen many ways in which her work dissolves the materiality of things, and, in its place, provides new worlds where we haven't looked before. Many of her works are drawn from images found within our common media, such as TV and movies. The artist then breaks these down into sub-units, and then reconstructs them in video format as a real-time expression. This multi-staged process allows the artist to examine relationships of the components in visual perception in ways that are both analytical and magical. The results tend to transport us outside of our ordinary notions of materiality, into new worlds where we seem to float within an imaginary place where divergent moments and spaces are mediated.

The forms of hybridization that we have encompassed in this chapter involved the interlocking ways in which the elements of perception can form new landscapes of perception, and our subsequent understanding of them. Through combinations of images drawn from television and movies, combined with direct manipulations in traditional painting processes, followed by the synthesis of the works in dynamic animated videos, we have encountered many transformations and reconstructions of images. Our next chapter will address a totally different form of hybrid: a kind that results from assembling things to form an entirely new "body" as the resultant image within a work.

ASSEMBLY REQUIRED:
The Constructed Body

It was on a dreary night of November, that I beheld the accomplishment of my toils. With an anxiety that almost amounted to agony, I collected the instruments of life around me that I might infuse a spark of being into the lifeless thing that lay at my feet. It was already one in the morning; the rain pattered dismally against the panes, and my candle was nearly burnt out, when, by the glimmer of the half-extinguished light, I saw the dull yellow eye of the creature open; it breathed hard, and a convulsive motion agitated its limbs...by the dim and yellow light of the moon, as it forced its way through the winder-shutters, I beheld the wretch–the miserable monster whom I had created...one hand was stretched out, seemingly to detain me, but I escaped, and rushed down stairs. [1]

> – From the thoughts of Dr. Victor Frankenstein,
> in Mary Shelly's *Frankenstein: or The Modern Prometheus*

A conflicted, yet obsessive, love/hate relationship with both life and death has persisted in Western culture for at least two centuries. At one extreme, there is an exaggerated fear of aging and death that is acted out through countless forms of denial and cosmetic fakery. In opposition to this, there is an equally fanatical resistance toward creating or altering life forms, even when there is clear evidence that the research will likely result in cures for highly debilitating and widespread illnesses such as Sickle Cell Anemia or Parkinson's disease. In one of those blatant instances of hyper-hypocrisy, the latter group opposes such research based upon the reason that science "should not intervene with nature" while also insisting that intervention into nature in other, and highly destructive ways, is totally acceptable, even refusing to recognize or prevent the countless forms of corporate and government intrusions that have clearly led to destruction of the earth.

Nevertheless, the love/hate relationship with life and death has evolved into an either/or mind-set that has shaped recent debates on the potential development of biomedical capabilities to improve opportunities for prolonged and healthier lives made possible though genetic research. The amplitude of the conflict seems to increase exponentially with each significant advance in research involving cures for previously lethal diseases, organ transplants, laser surgery, cloning of animals, clever and highly functional prosthetic devises, and even creation of life in the petri dishes in research labs.

The origins of the fascination for creating and dramatically altering life forms in Western Culture might be traced to the Greek Myth of Prometheus. The most common version of this myth states that Prometheus stole fire from the gods, and gave its power to humans. In so doing he was punished by being chained to a rock where he endured an endless repetition of cycles in which his liver was alternately eaten by an eagle during the day and reconstituted at night, only to face the same cycle the next day. Another version—one more important for our purposes here—states that Prometheus formed humans from clay, and used the energizing heat of fire to animate the inert beings. Although this version of the myth isn't the best-known interpretation of the original Greek myth, it is the version possessing a strikingly close similarity to the theme of constructing bodies emphasized in this chapter. By stressing the creation of human life, this version also more closely parallels our contemporary obsessions with creating, cloning, improving, and altering life forms, and especially human life forms.

We can find additional roots for the present cultural interest in the animation of inert matter in medieval alchemy. Following this, perhaps the most prominent post-Greek version of the Promethean creation myth comes to us in the form of Mary Shelly's famous story of the activation of lifeless body parts attached together to form a quasi-human constructed by the character named Victor Frankenstein. This version, of course, is described in *Frankenstein: or The Modern Prometheus* that Shelly began in 1816 and finished a few years later. After its initial publication, Shelly's story was rewritten in 1831 to comply with the conservative demands of her society. The earlier version was considered too radical in its connotations, which included acknowledgement of a non-material mind or spirit rather than a divine creator, allusion to a theme of perverse sexual "selective breeding," and references to public morals, health, and behavior.[2]

Despite the revisions that Shelly made in her story in order to conform to expectations within her society, the influence of Vitalism (a theory emphasizing the infusion of life within inanimate material) was an obvious component in the author's motivation when inquiring into the theme of animating that which is inert. Specifically, the vitalist theories of Erasmus Darwin (not to be confused with the other Darwin) were particularly germane for the Shelly in her formation of the book's ideas. Darwin claimed to have observed self-animation within single cell parasites, as well as regeneration of a corpse using electricity. The scientist also claimed to have developed methods for the reconstruction of human bodies that could be brought to life.[3] Additional inspiration for Shelly even came from Benjamin Franklin's famous experiments with electricity. Electrical energy had come to be considered an activating and transformative form of energy in early nineteenth century scientific thought (and a more modern parallel to the fire early used by Prometheus to enliven his clay figures to create humans). The ultimate physical goal contained in Shelly's book, of course, was the animation of the lifeless bones and other body parts that Victor Frankenstein had joined into the semblance of a human body as described in Shelly's narrative.

While the many movie versions of the Frankenstein story radically wandered from the sequence of events that one actually finds in Shelly's story—usually resulting

in an almost hopeless detachment from the original narrative—the only parts of human bodies that are mentioned in Shelly's description are the bones from "charnel houses," with additional organic parts being taken from a "slaughterhouse."[4] The latter reference even suggests that animal parts might have been used in addition to the human bones, which, in itself, is a rather startling matter to consider. Notwithstanding these facts, however, we have developed a false image of arms, legs, skulls, torsos, and even brains, being hacked and otherwise removed from the bodies of demented criminals, to be later crudely sewn together in a way that resembles a lumpy football. Of course it might be argued that Shelly opened the door to such deviations by never being entirely clear about the source and nature of the body parts beyond the rather generalized statements made in the story.

The schism between science and religion was even more pronounced during Shelly's era than it is today. The physical world was considered to be at complete odds with, and even a barrier to, the spiritual realm. In contrast, many cultures of the world (both then and now) perceive the worlds of the physical and spiritual to be interwoven and interdependent. In fact, it seems clear that religion and, by extension, bioethics in Western society haven't not advanced to a degree that corresponds to the rapid developments in science and medicine. Despite the countless ways in which discoveries have provided constructive methods for prolonging and improving healthy lives, religion and the prevailing cultural-ethical assumptions continue to employ the same basic arguments in opposition to many of these life-sustaining opportunities that prevailed in previous eras. Thus, the Frankenstein story continues to provide at least as much relevance and potency today as it did when it first appeared.

An informative parallel issue in Shelly's book focuses upon the sad fact that Victor Frankenstein rejected his own creation almost immediately after creating it. He very quickly considered it to be a "miserable monster," and, upon seeing it, was compelled to "escape" and "rush downstairs" in response to its mere presence. The inevitable and eventual change in the monster as a consequence of this rejection—so opposite to the way the "monster" would have reacted if he was actually treated as a miracle of creation—should be no surprise, and serves as a classic example of pre-Behaviorist conditioning, one in which the monster's views toward others is shaped through human relationships rather than any inherent mental, psychological, or genetic inclinations. After repeated rejections by his creator (by the person who was, instrumentally at least, his "parent"), the monster eventually gives up on any aspirations for a positive life as a caring being. After all, his own creator had repeatedly demonstrated an utter lack of interest in fulfilling any responsibility toward his own creation. Based upon these rejections, the monster even comes to prefer Satan to God when saying, "Satan had his companions, fellow-devils, to admire and encourage him; but I am solitary and detested."[5]

Related to the above, the main thrust of this chapter is intended to direct our attention toward processes of fabricating and constructing images of humans in art. The title, "Assembly Required," takes its cue from the countless ways in which we have increased alternatives for constructing things in our lives, in the ways we live,

in the things that surround us, and even in the ways suggested above and that are increasingly deployed to reconstitute our bodies. Just as we can buy a bookcase from Ikea (or over the Internet), and assemble the parts at home, resulting in a fairly high quality product at a reasonable price, we can also choose to have our bodies altered and enhanced through changes in science and medicine. As we know, those who have lost or damaged body parts while at war, through accidents, or through the anomalies of mal-structured DNA, can now acquire and attach new body parts, sometimes with even greater capabilities than the original parts might have possessed. This is entirely similar to the combining of body parts to create a new life described by Shelly, but with one very important exception: we make the choices ourselves and Frankenstein's monster didn't have such a choice. Instead, the monster was forced to live with the consequences of the decisions of another (his creator). In this sense, above all else, the resulting new life form was, indeed, the offspring of an ambivalent Doctor who chose his own role as an uncaring parent.

Just as our bodies can be transformed through additions, subtractions, and reshaping, the arts have represented an increased interest in constructing expressions from new materials. When creating images that reflect what it means to be human, artists are now faced with a vast array of emerging alternatives. For this reason, there are some who refer to our era as being "post-human" or "super-human."

A related phenomenon, sometimes referred to as the "Arcimboldo Effect," identifies a method for constructing the human image in a way that is totally unlike the norm that was dominant during the sixteenth century when works created by the artist who is the effect's namesake first appeared. The idea is named after Giuseppe Arcimboldo (1527-1593). The artist's works were notable for their novel method of forming human heads through a combining of objects that are not of human-origin, such as animals, plants,

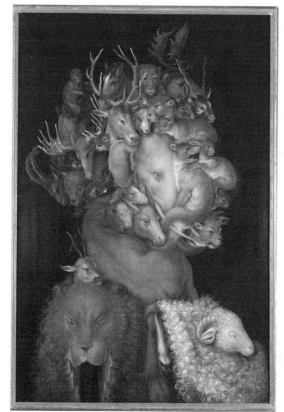

Giuseppe Arcimboldo, *Earth, allegory*, 1570. Oil on wood, 27 ¾ in. x 19 in. Private Collection, Germany. Photo Credit: Erich Lessing/Art Resource, NY.

or other objects. This system obviously deviates from the normal manner of painting a face, both then and during the four centuries that followed. Through that period, the expression of a human face would be created by basing its appearance upon the way the human flesh is normally perceived as an outer surface, using light and dark shading, and with suggestions of the structure of the skill that lies beneath this surface.

While the methods used by Arcimboldo to depict the human face fell outside the dominant trends during his own era, they might also be considered to represent a perception of what it means to be human in ways that is also in advance of his own time. During the ensuing twentieth and twentieth-first centuries, the construction of human images have come to include many experimental processes, and Arcimboldo's efforts may not seem nearly as unusual as they would have during the Italian Renaissance. It has become increasingly apparent that the attributes of this artist's work have also been borrowed and reshaped into many parallel methods of portraiture during the modern period. These new ways of expressing the human image have extended to new ways of depicting subjects other than people as well. It is significant to note that, despite it Renaissance origin, Arcimboldo's work was included in the celebrated *Fantastic Art, Dada, Surrealism* exhibition curator by Alfred H. Barr, Jr. in the 1930s. The inclusion of the Renaissance artist's works in this show indicates the extent to which his work had come to be associated with the unique forms of expression in the modern era even though the artist had been dead for three hundred years. With the countless new ways of forming images of the human face and body that appeared within the Surrealist movement that was in full swing at the time of the 1930s Barr show, it is hardly surprising to find what the Renaissance found to be highly illogical images now fit the new perceptions of what it means to be human quite well. This is a clear example of being ahead of one's time.

The first reference to the term "Arcimboldo Effect" appeared in connection with a 1987 exhibition with the same name formed by Pontus Hulten, curator of the Palazzo Grassi Museum in Venice. The show included the first retrospective exhibition of works by the Renaissance painter during the modern era, but also included many works by relatively recent artists, such as Dali, Picasso, Redon, and Dubuffet, all of whom have been indebted, in varying degrees, to the innovations of the painter. Like the Barr show fifty years earlier, this one delineated ways in which the artist's influence continued to impact creative ways of depicting images of the human face and body in art during the decades following the earlier show.

In his essay portion of the book published with the Venice exhibition, Hulten proposes three ways for us to interpret the Arcimboldo Effect: (1) as an amusing work of fantasy; (2) as an allegorical exposé of the Hapsburg Empire and sixteenth century science; and (3) as a metaphysical statement on a new vision of what it means to be human, specifically as a complex and composite being.[6] Hulten accurately argues that, while the first purpose leads to little more than a puzzling curiosity, the second framework invokes a range of symbols to be found in sixteenth century texts, and is thus considerably more informative. The third criterion–clearly the most applicable to modern life and art for our purposes in this chapter–reflects a new and more realistic

perception of the condition of being human.[7] It is in the latter where we find the key relationship with the complex nature of the human psyche and mind that eventually found its most fruitful creative manifestations through Surrealist art and its offshoots. It has further been found that such complexity is not just a matter of the human mind alone, but is also imbedded in the inherent complexities of the external world as well (see Chapter 5 on "The Rashomon Factor" for an extensive discussion of this aspect).

Another, and equally plausible basis for the relevance of the Arcimboldo Effect was articulated by René Thom in a later chapter in the above book. Thom's premise is based upon the tension one finds between parts and wholes in Western culture in general, and in its arts in particular. He refers to this condition as Catastrophism. This condition rests upon a scientific assumption borrowed from the far earlier speculations of the Greek theorist named Heraclitus.[8] No doubt we can all agree that there is a fundamental tension between and parts and the whole that is central to the Arcimboldo Effect. In fact, this is the essential thrust of the idea in the first place. We are often advised by aestheticians to pay less attention to the parts in a work of art because the parts are "in the service of the whole." Instead, we are to focus on the overall expression, as if the parts must always be entirely sublimated by the whole. Yet why must this always be the only way to "read" a work of art? Deep down, we all know that perception of both the parts and the whole are essential for the understanding of a work. Being attentive to both may not as damaging to one's experience as such theorists might think. In fact, awareness of either can enhance the other, including those instances when they contradict each other, which, in fact, is one of the common attributes in contemporary expression and, most certainly, as an characteristic of the Arcimboldo Effect. If one thinks of the parts/whole relationship in social terms it might be clearer, with the "part" being an element of anarchy when considered alone, and the "whole" as tyranny when considered alone. A part can be thought of as anarchistic when considered alone because nothing can exist in a vacuum, and a blatant disregard of all that surrounds that given part results in a jeopardization the whole. And, conversely, in the opposite extreme, a part being entirely subservient to a whole becomes a tyranny of the whole, because the individual importance of the part may easily be considered inconsequential. One obvious conclusion is that it seems more advisable both when viewing art and when evaluating social systems to consider both the parts and the whole as significant, and not force them into an either/or context. As we already observed, in some art works the energy of the work flows from the contradiction between the parts and the whole. Accepting this as an alternative is simply another way to "think" in terms of hybrids.

In addition to the two major kinds of hybrids that we have discussed so far in this chapter—namely, the animation of life from within an assembly of inert body parts represented by Shelly's monster, on the one hand, and the Arcimboldo Effect as an expression of tension between parts and wholes, on the other—we have one additional major force to consider before examining recent examples of hybrid expressions in art relating to these. This third framework involves the use of found materials, with transformations of these occurring when they are introduced and combined in works

of art. Needless to say, this is a widespread methodology within the modern era, and it includes such processes as collage, ready-mades, assemblage, and other forms of combines. The increasingly combinative character of the materials and processed used in the arts parallels, and complements, the combinative (hybrid) nature of images in many of the same art forms. This is an important aspect in our examination of the hybridized nature of the arts because artists have increasingly tended to think of images and materials, along with the processes used to combine and manipulate both, as inseparable elements in their expressions.

Synthesis of seemingly disparate materials from traditional and non-traditional sources became a major factor in the formation of art works during the very early twentieth century. At this time, re-contextualization (transplantations) of both media and images became a dominant force. One of the best-known early examples is to be found in Picasso's painting called *Les Demoiselles d'Avignon* (1907). The work embodies images of African masks depicted as the faces of three of the female figures in the painting, with the remaining two being depicted in an early cubist style but based upon the features of an ordinary face. The intermixing of masks and bodies accompanies another new interest the artist was developing in this work: the construction of images from geometric faceted parts. This later trait, of course, served as the basis for the rapidly approaching Cubist movement, with this work representing a seminal example. The geometricization of organic images presented a kind of hybridization in itself, with the process of forming images from an accumulation of geometric facets—as opposed to the modeling (shading) of color and light and dark that had dominated Western painting since the Renaissance—embodying a radical break in art-making methods. Of course, we know that Cezanne had already pursued similar interests in his earlier Post-Impressionist works done during the late nineteenth century. We know, too, that Cezanne's works served as principal prototypes for Picasso's Cubist works. Equally important, however, is Picasso's introduction of the African masks, which opened the door for art as a process in which images are relocated and implanted (much like a transplanted organ used in a surgery), rather than constructed from scratch. It also reflected an exodus from the established goal of creating an illusion of a three-dimensional world as if seen through a window, in which one depicts a space based upon linear perspective that had dominated most art since the Renaissance in Western culture. In essence, the modern era would now focus more upon a kind of space that is constructed rather than illusionary, leading to art works as entities unto themselves, rather than images that are dependent upon perceptual parallels and connections with the external three-dimensional world.

From Picasso's bold introduction of actual masks—along with their transplantation from an entirely distinct cultural context—the trajectory of combining elements from outside the world of paint and brushes into visual art opened a new world into which artists would now enter. This, in turn, led to new forms of related hybrids, such as the collaging of two-dimensional fragments from newspapers or magazines, or fabrics and related materials. The Synthetic Cubist works by both Picasso (as in his *Still Life With Chair Caning*, 1912) and Braque are excellent examples of this, and were followed

by an explosion of experimental expressions combining materials from a multitude of sources in the work of the Dadaist and Surrealists. The appearance of college, in turn, was followed by the transference techniques in the form of rubbings (frottage), and, considerably later, the transference of inks from magazines using lighter fluid and other methods.

The isolation and relocating of common objects found in Picasso's early Cubist works led, in part, to the Readymade sculptures of Marcel Duchamp beginning in 1913 with the artist's relocating of the *Bicycle Wheel* from its ordinary environment to the context of the gallery and museum. The Readymades were not exactly combinative hybrids, but, through the process of relocating the images from their prior, ordinary context to the new environment of the museum or gallery, and with the subsequent interaction of one's perceptions of the object now applied in terms of the new space, the result was a new, hybrid perception that inter-joined recollection (of the old) with direct perception (in the new context). Duchamp was acknowledging that we understand things according to their context. When the context changes, so do our perceptions. Duchamp, of course, wasn't interested in the intrinsic aesthetic nature of the Readymades, but in the new ideas that the transplantation process evoked. In fact, he perceived the role of found objects in his work as "a reaction of *visual indifference* with a total absence of good or bad taste …in fact a complete anaesthesic"[9]:

> I wanted to put painting once again at the service of the mind. And my painting was, of course, at once regarded as "intellectual" "literary" painting. It was true I was endeavoring to establish myself as far as possible from "pleasing" and "attractive" physical paintings.[10]

Several additional stages occurred in the evolution of art images emerging from a framework in which dislocations and re-combinations of materials and objects was the driving force. One of the related Dadaist desires was to fuse art and life, a combination that was most fully realized in the *Merzbau* constructions by Kurt Schwitters. His approach to the combinative process included any and all materials that were considered useable in the development of new constructs, with the artist even fabricating his own home using the same principle. The *Merzbau* was the ultimate merging of art and life through its combination of found materials in the creation of a living environment in which the artist lived. Schwitters comments that:

> (He) could not, in fact, see the reason why old tickets, driftwood, cloakroom tabs, wires and parts of wheels, buttons and old rubbish found in attics and refuse dumps would not be as suitable a material for painting as the paints made in factories. This was, as it were, a social attitude, and artistically speaking, a private enjoyment, but particularly the latter …[11]

The confluence and mergence of materials previously alien to each other and to the art process continued to evolve into the so-called "combines" of Robert

Rauschenberg in the late 1950s. These works conjoin a wide range of objects and materials, as well as paint. Some were created in a way so that they could be placed on the floor (like sculpture) while others spilled off the wall, with both being somewhere between painting and sculpture. The artist believed that his works "relate to both art and life …Neither can be made …(I try to act in the gap between the two)."[12] Alan Kaprow extended this idea by furthering the links between art and life in his performance works, and recently described in his book entitled *The Blurring of Art and Life*. In this book, the author presents his extensive knowledge and experience with the phenomenon of hybridization between art and life from the 1950s through 1990s.[13]

The conjoining of existing and frequently common materials into new creative perceptions continued in the work of Niki de Saint Phalle and Jean Dubuffet in France, the Fluxus movement of the 1960s in Europe, America, and Japan, and Arte Povera in Italy during the 1960s and 70s. The idea didn't gain as strong a foothold on the East Coast in America as it did on the West Coast, most likely because the Eastern United States tended to lean more toward a theoretical and analytical orientation that has been dominant in its art scene. Furthermore, the inclination toward theory was an outgrowth of the various "isms" that developed in Europe prior to the transfer of the center of the art world to New York in the 1940s and 50s. Even the "found-material" felt sculptures of the 1960s by Carl Andre and others–though seemingly informal in their use of ordinary materials–were predominately structuralist and formalist, and tended to depend upon lengthy analytical treatises to be understood. This seems evident in terms of both form and content. On the West Coast, by contrast, the work by artists such as Edward Kienholtz, George Herms, and Bruce Conner were noted for their rustic materials and methods, as well as visceral and psychological orientations. These concerns stood in stark contrast to the comparative formal, intellectual, and theoretical tendencies in the work of their East Coast contemporaries. Perhaps the absence of a prevailing rationalist underpinning, along with blinding changes in the landscape, cities that rapidly filled with mixed cultures (leading California to become the first state in the nation that is not predominantly white), constant reminders of impending destruction through massive earthquakes, a perpetual love for experimentation, and a location poised between the extremes of Western materialism and Eastern mysticism, may have collectively led toward a stronger affiliation with the more malformed and psychologically introverted orientations of Surrealist and Dada art. While European-derived expressions and conceptual art have dominated the trajectories of art forms evolving in the East, uncertainty, spirit-driven art, and a psyche gone wild have prevailed in the West. Of course, no matter how one defines the dominant traits of any highly populated region, such characteristics tend to coexist with tendencies that run in opposite directions. In the case of the West Coast, a laid-back se la vie detachment is counterpoised with the edgy, try-anything-new, psychologically inquisitive, and alternative lifestyle traits that are most dominant.

The juxtapositions of raw materials that are common in the art of Kienholtz, Herms, and Conner are similar to what we find in the work of Ken Botto. We had already encountered Botto's work in the earlier chapter called "Art in the Petri Dish"

(see Chapter 2). His work entitled *Séance* (2005) shows two closely positioned figures leaning forward, while intently peering at a ten-inch flame flickering before their eyes. The flame rises magically from the center of a plate that rests on a tabletop placed between them, like an altar dedicated to fire. The figures appear to be mesmerized by the amorphous dance of light and heat that is performed before their eyes. The figure on the left is one of the famous "dummies" of American TV culture named Danny O'Day. The figure on the right is a cloaked sculptural construct with its head being a skull from a human skeleton. In our previous discussion of this artist's work we encountered related work from a sequence of pieces done between 1999 and 2006 collectively called the "Conversations" series. The example previously discussed from this series was titled *The Blind Leading the Blind*. Both that work and the one being discussed here employ the same two figures. In both cases, the two figures are intended is to convey the idea that we (those of us in the audience) are privy to a private "conversation" that is occurring between the two figures. In the earlier discussed work, the implied dialogue pertained to a spectacle that both figures shared and upon which they seemed to meditate. In that case, the subject was war and death, along with a blindness that seems to "inform" the "justifications" for such war, suggesting the ways in which poor judgment and obliviousness to the consequences of one's actions can lead to devastating results, such as a needless lose of lives.

Ken Botto, *Séance*, 2005. Ecktachrome print, 24 in. x 20 in.
Courtesy of the artist and Robert Koch Gallery, San Francisco, CA.

Séance involves a dynamic, ever-changing element (the flame). Because of this, the work had to be photographed several times in order to establish a range of images of the fire from which the artist could select those that work best with the two figures. After looking at several versions of the flame image it became clear to the author that some worked better than others. In its maximal form, a flame is like a mini-performance art event in itself, and the figures seem to come alive, in part, as an interactive response to the excitement "expressed by" the flame and through the unique kind of lighting that is projected onto the two figures as they witness the event. When the shape of the flame and the shadows that it produces are less interesting, the figures seem less "involved" in the event due to the need for a dynamic relationship to

be established between the mannequins and the flame.

As in the example of *Blind Leading the Blind* that we previously discussed, two figures again appear to be at least as meditative as conversant, most likely because they are comprised of the mute dummy and the constructed pseudo-person with a skull for a head. The fact that the artist chose to use a Danny O'Day dummy is quite interesting in itself. Such a figure originates from the traditions of Edgar Bergen and his cohort, Charlie McCarthy. In the case of Danny O'Day, the dummy was an extension of ventriloquist Jimmy Nelson, who was popular during the 1960s and 70s, and appeared several times on the highly popular Ed Sullivan Show on television. The dummy presents us with a new form of hybrid: an artificial being that serves as a prosthesis (extension) for the humorist. It has been well documented that Danny-the-dummy served to compensate for the comedian's extreme shyness that prevented him from interacting with others throughout his childhood. Once Jimmy Nelson discovered that he could "throw" his voice into the body of Danny, he was able to overcome his verbal reticence, but this only occurred through the presence and assistance of his sidekick. One might even say that the use of the dummy as an oral prosthesis brought Jimmy "back to life" (revitalized him) as a communicative member of the human race. This kind of hybridization involves transference of the personality from the "real" person into the "unreal" dummy figure. Of course, when observing an accomplished ventriloquist, one's attention immediately focuses upon the surrogate figure of the dummy, not the real person who is throwing his/her voice. Therefore, the viewer becomes complicit in the act of transference and its consequent hybridization.

The being on the right presents the same *vanita*-figure that we encountered in the earlier work by the artist. And as discussed earlier as well, the *vanita* is borrowed from the seventeenth century North European and Spanish traditions for the skull to be included in a work of art as a reference to the perpetual presence of death. In the European traditions, of course, the skull was placed in the context of a half-eaten meal that represented sustenance.

Another source for the figure on the right side of *Séance* may be found in the concurrently developed Driftwood series that Botto produced between 1999-2006. This latter series established the use of found objects and other materials in the construction of life-size figures in the artist's work. The artist attributes a significant influence from the 1930s works by Hans Belmer on this series (see comments concerning Belmer in the interview below). Belmer had constructed human images from doll parts and each was referred to as *Poupée*. Belmer states that this term was rooted in his study of "variations on the assembling of an articulated minor."[14] Belmer did photographs showing each stage in his construction of a human-like child using parts that he fabricated from wood, metal, and paper maché. His process was almost like photographing each stage in the construction and animation of the monster in the Frankenstein story that we have already discussed, but was in the form of a distorted child who's body parts appeared to be rearranged and distorted. The *Poupée* also made numerous later reappearances throughout the development of Belmer's photographs, and thus serves as a primary character in his unfolding panorama of

transmuted human-like bodies documented in photographic form. In the work of Belmer, of course, there are obvious roots in a Freudian fetishism as well. In contrast, such aberrations are not to be found in the work of Botto, although the latter's work is clearly oriented toward the nightmarish kinds of expressions that have been common in West Coast art mentioned above.

Another notable trait in Botto's work is the unique kind of lighting that is cast onto the two faces from the flame. Though of small scale, there is an intense drama that is reminiscent of works by Georges de La Tour, a seventeenth century artist whose paintings are notable for their use of dramatic, localized lighting in which candles illuminate the flesh of a hand or other object. It is known that La Tour was highly influenced by the deep contrasts of light and dark in the work of Caravaggio, but his own work moves into areas of mystery that are relatively rare for his period in history, though they became fairly common during the Romantic movement of the nineteenth century.

A second discussion occurred between the artist and the author in May of 2006. This discussion stressed issues related to the idea of a hybrid as a composite of parts previously associated with different contexts, but now transformed in their new roles when relocated and joined in a work of art. This conversation is included below.

INTERVIEW[15] - KEN BOTTO

JD: Your recent work has shifted from constructing small environments made from toys and other found materials, which were then photographed, to using larger, life-size scale live people and mannequins. Some of these works also combine found driftwood parts that are combined into large-scale figures. After arranging the mannequins or driftwood parts into images resembling humans, you then photograph them. In your work entitled *Enfante Terrible* (see Chapter 2) you employ a life-size, real human baby placed in a small-scale environment. The work possesses a dramatic shift in scale due to this. What kinds of unique spatial relationships were you trying to capture?

KB: When combining conflicting scales, the shift from one to the other is absorbed on a psychological level, and I attempt to instill both with credibility by giving them the same look. In some of my recent works, such as in this example, the humans are living and full scale, but here (though an infant and thus relatively small) the figure is placed in an environment that is somewhat smaller. In most, however, I place the live figures in settings that are comparable to their own scale. This work is an exception. The combinations between figures and other

figures, and between figures and environments, in my works are actually quite varied. They include small surrogate images within small settings, full-scale humans in small environments, mannequins or driftwood-constructed images of people in human scaled environments (see *Séance*, 2005), mannequins with humans in full-scale spaces, and mannequins combined with driftwood/constructed human-like images in human-scaled environments.

JD: When did you start using found driftwood and constructing life-size human images?

KB: This was about 1999, right after I had been hospitalized. During the convalescence, I spent a lot of time on the beach and starting finding lots of provocatively shaped driftwood that had floated up from the ocean. This was like discovering body parts! (laughter) I then started fabricating figures from these "body parts," and mixed them with Barbie-doll heads or ceramic heads that I already had.

JD: Were the figures that you constructed based upon specific people as portraits, or were they generic figures?

KB: They're not specific people; they are ideas about people or what people represent.

JD: Were there any influences upon these works?

KB: Oh, yes. Hans Belmer definitely came to mind. He was a master at combining body parts into new configurations evoking unique forms of human experience.

JD: They also evoke the works by the proto-Surrealist Renaissance painter named Arcimboldo. Do you agree?

KB: Yes, they are certainly quite similar.

JD: Arcimboldo's works were distinguished by combining many objects together into a portrait of a head or upper torso of a person, and, after these images were combined in the final artwork, they came to gel into a gestalt, or total (larger) image that resembles a person. As a consequence, his works are readable on multiple levels: the specific and the general, as parts and wholes. A more recent artist whose work is often readable on multiple levels simultaneously is Salvador Dali. I especially recall a work in which he combined multiple readings

in which one can perceive a dog, a human portrait, a landscape and a still-life simultaneously. Would you agree that some of your own works are readable simultaneously on multiple levels?

KB: Arcimboldo's works combine related images, such as fruits or animals, while mine combine more disparate ones, such as a ceramic head with driftwood pieces.

JD: How about parallels between Dali's multi-image paintings and your multi-meaning works? In other words, such works seem paradoxical and enigmatic. Do you agree?

KB: Yes, this true. My works can and sometimes do work on different levels at once. And sometimes, when I have finished making and photographing them, I have one idea of what they imply, and then, when I get the photos back from being processed, they carry an entirely different set of references and implications. This is another set of multiple levels (the intended and the unintended), and I like such complexity and multiplicity in the "readings" one might get from visual work.

JD: In your work entitled *Séance* (2005) there is an element of a macabre event and mood, perhaps even one that is frightening or nightmarish. The two figures, though seemingly placid in their meditations on the flame that is flickering between them, are rather horrific as figures. They remind me of images of people one sees in the old Vincent Price horror movies, or in Romero's *Night of the Living Dead.* The horrific aspect of being human–aging, becoming ill, rotting, dying, going insane–seem imbedded in this, and in others of your recent, related works. I note that many of the recent images include a figure that is a skeleton. In Spanish and Dutch art of the seventeenth and eighteenth centuries the use of a skull located in a still-life of food or other living materials came to be referred to as a *vanita*. The *vanita* signified the transience of life, materiality, and even art. It was an idea that is related to the Buddhist desire to transcend the material in its implications. We can find similar images of skeletons in the *ex-voto* tradition in Mexican art, as well as in the work of Frida Kahlo.

KB: Yes, one sees these elements in much Spanish art especially, as in the work of Picasso. He did an entire series during WW II stressing the presence of the skull in the works.

JD: Your recent work all seems to be moving more consistently toward

an emphasis upon life-sized human works. Do you see this as where you are now headed?

KB: Yes, this seems to be the case, and has been evolving in this direction through the most recent two phases in my work. Moving away from miniaturized scales has given me a whole new set of circumstances to work with. These include new problems with lighting for the photographic phase too, since I'm no longer predominantly shooting in a fixed outdoor location. I'm now inside, or in any other number of environments where the people or mannequins can logistically be placed. The shift to life-size environments also brings with it new meanings for my work that can be associated with real life-scaled situations.

In summary, the above discussion provided insight into several aspects of the artist's recent works. These include the mixing of the micro-worlds common in the earlier works with human-scaled environments, a shift to new kinds of materials used to construct life-size figures during a period of convalescence and that continue to the present, relationships with the works of Hans Belmer and Arcimboldo, and the psychological implications of paired inanimate figures intended to be engaged in "conversations."

While this chapter has examined various ways in which images may be assembled to create a new, overriding configuration and meaning (or life, as in the case of the Frankenstein story), our next foray will explore a phenomenon we shall call "Corpus Transitus." This new inquiry will focus upon ways in which our bodies may be altered through laminations, grafts, or other shape/surface modifications, with the new hybridized form reflecting a combination of the previous condition of the self with new changes or elements that have been introduced. Through this transformation, the body may be perceived somewhat like a landscape (as a world within itself). This examination will include consideration of ways in which changes to the human body also provide new insights into understanding of individuality, socially constructed ideals of beauty and appearance, and personal freedom.

CORPUS TRANSITUS:
Orlan's Metamorphology

*When Gregor Samsa awoke from troubled dreams one morning, he found that he
had been transformed in his bed into an enormous bug.*[1]
> – Franz Kafka, *The Metamorphosis.*

*The grotesque body, as we have often stressed, is a body in the act of becoming.
It is never finished, never competed; it is continually built, created, and
swallowed by the world.*[2]
> –Mikhail Bakhtin, *Rabelais and His World*

*I have also wanted to show that beauty can take on appearances that are not
reputed to be beautiful. This idea is truly very important for me; it is the reason
I created the digital photos for the pre-Columbian and African series (called)
Self-Hybridizations.*[3]
> –Orlan, in Interview with Maxime Coulombe

In our last chapter called "Assembly Required" we focused upon the prospects
for constructing images of the human body from combinations of previously discrete
parts or elements. Upon construction, the final amalgamation formed a kind of hybrid
that we referred to as the "Archimboldo Effect," a term named after an artist of four
hundred years ago who formed images of humans by combining objects that one
would normally consider unrelated and alien to the human body. In the discussion
we also envisioned a new definition for what it means to be human based upon new
forms of DNA control, prosthesis, and reconstruction methods that medical science
has provided.

We will now turn to a related alternative: hybridizations of the human body that
integrate an existing body, or image of the body, with new elements that have been
laminated or grafted onto it. The result is a transformed body. Our general term for
identifying this kind of hybridized body is "Corpus Transitus." When literally translated,
this phrase means "the transient body," which is to say, a body that is not fundamentally
perceived as fixed or static. Above all, the term refers to the processes involved in body
changes even more than to any "final" product as a kind of appearance, since the
form of the body at any given moment is always subject to further change (hence the
inclusion of the "transitus" aspect). In stressing the process of change as a significant

factor in itself, we will also be attempting to acknowledge the increasing emphasis that individuals within contemporary society have assumed in order to implement changes falling within the scope of their own legal and moral jurisdiction, in terms that are bodily, conceptual, or psychological. On the physical level, such changes frequently occur to and within one's own body, and, by logical extension, the behaviors enacted by the body when these are taken being within the sphere and control of one's own personal life. In short, the Corpus Transitus is a condition of personal freedom, involving both body and behavior, and the possibilities for enacting such changes may be the result of applying one's imagination and thus fall within the realm of art.

Historically, of course, art has been defined as ultimately focusing upon the creation of images external to the artist's own body by resulting in physical objects, such as painting, sculptures, or other such products. However, within the modern era, artists have increasingly turned to an option of art being a form of personal action (performance), or as directly involving the structure, surface appearance, or activities of their own.

Few would argue with the claim that body alterations are among the most pervasive forms of human behavior to be found within recent culture, and especially in America. The high level of public interest in body alterations as the content for popular entertainment was confirmed when a TV program called "Nip/Tuck" won the Golden Globe Award for Best Television Drama Series. The program was but one of many forms of TV docudramas that focused upon cosmetic changes in human appearance. Others have included "Scrubs," "I Want A Famous Face," "Extreme Makeover," and "The Swan." A parallel set of programs have also been established to address prospective changes one might instill within their homes, which might thus be considered as an extended body.

This kind of programming assumes the presence of a cultural discontent with the existing condition of one's appearance, with this awareness leading to decisions to cosmetically alter physical attributes to more closely conform to idealized forms of beauty. One might easily argue that such an interest reflects a relatively superficial concern for conforming to an externally determined kind of appearance, with these often being established by marketing forces well beyond the scope of influence of any one individual. In contrast this, our discussion will ultimately culminate with consideration of the use of body alterations as an art form by the French artist named Orlan, along with some of the unique ways that self-instituted changes within her own biological structure have resulted in a sequence of powerful forms of self-expression concerning both herself and her surrounding world.

As many readers are no doubt aware, body alterations are historically common among most cultures in one way or another, and not just those considered modern industrialized societies. Such bodily changes have existed worldwide for centuries. One thing that seems to distinguish those most common during our own era is the emphasis upon a desire for superficial changes that address an obsession with maintaining one's youthful appearance, as we encounter in the "Nip/Tuck" phenomenon mentioned above. Localized definitions of beauty of what constitutes the norm vary considerably if one examines the differing forms of body alterations that have appeared in

worldwide cultures over the centuries, and it is clear that interest in the enacting of physical changes is not an entirely new idea.

There isn't time here to discuss the entire scope of the complex roles and forms of body changes within global cultures, as interesting as these are. But it would be helpful here to mention a few examples in order to shed light on common cultural practices that have been lost to recent generations due to shifts of priorities within modern Western societies from those common within traditional cultures, and, perhaps more important, to become acquainted with some of the significant purposes that these traditions have entailed. Hopefully, this brief discussion will assist in shedding some light on why there is such a high degree of interest in body changes in present society.

One of the better known of the vast array of body alterations among world cultures would be the impressive and intricate tattoos deployed by the Maori people of New Zealand. These tattoos have historically included visual images serving as a kind of "identity card," while others provide information on the individual's ancestral history. The inscriptions on the front portions of the face, for example, include designations of rank, role, work, marriage, and birth. Tattoos on the sides of the face are devoted to images describing the person's family history. The tattoos were typically inscribed as a stage within a broader sequence of events comprising the rites of passage from childhood to adulthood. Very similar tattooing practices are also common among cultures in Japan and the Philippines.

Equally well known are the numerous forms of scarification and related body alterations practiced in rites of passage among traditional societies of sub-Saharan Africa. In these, the scars were created during one of five stages commonly included in rites of passage. Taken as a whole, the rites signified the transition from childhood to adulthood. As an inherent attribute of the process, it is significant to note that these cultures designated the communal space inhabited by humans (society) as distinct from that of nature (the bush). While the space and structures of society were defined as orderly and within the realm of human control, the space of nature, conversely, was perceived as comparatively chaotic, a place where uncertainty and ambiguity prevailed. Roy Sieber has described the five steps commonly comprising the initiation processes in these sub-Saharan Rites of Passage.[4] The same basic stages were employed in parallel sets of rites for male and female members of the community, but the rites for each gender occurred separately, and the specific kinds of body changes employed in the Third Stage described below were distinguished by gender. The Five Stages are:

1. *Separation from the past.* The young people were first removed from the familiar and orderly social structure of the village. It was only through a dramatic and clear disconnection from the old, familiar patterns of life that meaningful changes and a subsequent re-definition of the self in order to become an adult would be possible;

2. *Entry into a zone of unfamiliarity and ambiguity (a liminal zone).* The adolescents were then moved into a region of unfamiliarity within nature, which is often referred to as a liminal zone. A liminal zone is a space of

unfamiliarity, but also of ambiguity, where the unknown prevails. The cultural view was that the changes into adulthood could only occur within a space that is characterized by ambiguity and unfamiliarity;

3. *Death of the child/ birth of the adult.* While in the liminal zone, the initiates' bodies were permanently altered in some fashion (circumcision, tooth removal, shaved hair, scarification, change in structure of the hair), with this change signifying the death of the child and the emergence of the adult in the new, altered form. The body change was melded onto/into the physical self as a signal of transformation from child (old self) to adult (new self). This physical change was typically to remain a part of the young person's body attributes for the remainder of his/her life as a sign of the transition into adulthood;

4. *Learning adult ways.* In the same environment, an educational process also occurred. The adolescents were taught the secret ways (behaviors) of adulthood by elders from the village;

5. *Reincorporation into the former community.* As the final stage, the youths were returned to reintegrate into the familiar order of the original community, but now as adults.

Carl Jung has noted that Stage Three in the above (the symbolic death of the child) is especially essential for a youth to emerge anew as an adult, since it establishes in formal and concrete ways that the prior person (the child) no longer exists and that a new person (the adult) has taken its place. Jung also felt that the main point of the rites of initiation was to reconnect the personal ego to the "true self." He felt that one's ego disengages from the true self after infancy and leading up to adolescence. In his view, the necessary reconnection to the true self that has been relinquished could not happen without a visible and concrete (though symbolic) "death" of the old self. Without this concrete and visible change, the individual's self-perceptions would be unable to advance to the next level, and others would also continue to perceive the young person as the same as when s/he was a child.[5]

Many observers of contemporary Western culture have noted an absence of multi-staged rites of passage comparable to the five stages listed above and found in sub-Saharan societies. Older traditions in Western society had some equivalent processes for youth, as in the form of youths assuming the dress habits and jobs of ancestors, apprenticeships, learning from an uncle, or the like. These assimilative stages have long disappeared as society has modernized and industrialized. Industrialization and mass-production resulted in increased specialization in jobs, and thus discouraged the comparatively quaint and personal that one finds in traditional societies in which one assumed the roles of their fathers because these fathers' occupations no longer existed. Similarly, the nature of the new forms of educational and training systems tended to parallel and support the traits of mass production and, with this, the increased assumption of individual professional roles became increasingly dominant. In recent decades, the mechanical models that prevailed during the Industrial Revolution have disappeared, and, in their place, we find

attributes paralleling the dominant global methods.

In the absence of anything resembling the five stage Rites of Passage found in an agriculturally based society like that found in sub-Saharan Africa, youths in modern culture have taken it upon themselves to compensate through their own initiative by independently implementing the Stage Three as an independent ritual of their own during recent decades. As many readers know, there has been a widespread increase in the various forms of body alterations practiced by young people within each generation during recent decades. Such alterations have encompassed changes in the attributes of body, clothing, gesture, and the elements and patterns of speech. The selection of each form of fashion has been accomplished, in part, to establish a personal identity for each emerging generation as it approached adulthood. During the 50s, for example, at least four divergent personas gained great popularity, and might even be considered to represent four distinct types, tribes, or groups. The beat generation was inspired to pursue mystical and creative goals, and, in so doing, donned the bohemian guises of dark glasses, black turtleneck shirts, goatees, and adopted language borrowed from jazz traditions ("Dig it, man," "Far out"), and ideas from Eastern mysticism. Conversely, those oriented more toward the business world or the comparatively up-tight image of the singer, Pat Boone, gravitated toward the more rigidly attired looks of button-down collars, peggers (narrow, straight peg-legged) pants, white suede shoes, and Eisenhower politics. A third tribe gravitated to Marlon Brando's image of the rough and tumble individualist motorcyclist in "The Wild One," that introduced leather jackets, buckled shoes, blue jeans, cigarettes dangling from the lips, and slouching postures. A fourth group identified with the massive pop phenomenon one might call the "Elvis movement." The latter was attracted to up-turned collars, ducktail hairdos, Hawaiian (or western) shirts, big and ornate belt buckles, and smirking smiles. During the same period, women's choices seemed more limited, and included bobby socks, layered petticoats under billowing skirts, huge falsies, and cashmere sweaters. The 1960s had its own forms of youth signifiers, including bell bottom pants, long hair, blue work shirts, green military jackets, "back to nature" clothes ("Little House on the Prairie" look), rainbows, and sequins sewn onto fabrics. The 1970s continued much of the fashions from the 60s, but now in a more populist and pervasive (rather than politically symbolic) vein. Toward the end of the 70s the disco look, with its massive collars, bright colored shirts, and the strutting walk found in John Travolta's film, *Saturday Night Fever*, became an all-encompassing look. The 1990s turned to various combinations of retro looks, high contrast (black and white) gothic make-up with black clothes, piercings, tattoos, and punk hairstyles. More recently, another group has derived its inspiration from black hip-hop culture, and has assumed the "grunge" guise of baggy pants, bent wrists with downward gestures, and lots of finger pointing using the index finger. The inventory of pop body changes and clothing styles have continued to evolve since the latter phenomena.

While any of these changes might be argued to represent a perpetual state of rebellion among youth against the status quo, this line of thought, alone, simply doesn't provide an adequate explanation of the complexities involved in the individuation

and maturation processes involved. While the above body changes have been shared attributes used by adolescents to announce an individual's emergence into the adult world (or an opposition to it), the other four of the five stages that we found in the traditional rites of passage recounted above simply don't exist in Western culture to any significant degree. If they do exist, this isn't visible on a visible and acknowledged level, and certainly isn't experienced in the far more integrated and integrative manner that we saw in sub-Saharan society. The alteration of the body in the traditional African rites was but one of the five stages, with all five being considered necessary to assure a significant transition into the adult realm. In isolation, any one of the five stages alone didn't and couldn't represent the entire process of transition into adulthood. The body alteration stage gained much of its impact through the physical displacement into an environment (the liminal zone) where no direct ties and familiar, old habits would serve to pull the young person backwards in time. The combination of the new environment with the learning of new ways of defining the self from the elders was integral and coincident to the symbolic death of the child enacted through body changes. Furthermore, the final (Fifth) stage of reintegration back into the community represents a final, public acknowledgement of the youths in terms of their new roles through reintegration back into the group. In contrast, the tendency in Western culture in recent decades has been to reject the youth at this same equivalent moment, instead telling them they must "be independent" from family and community and "strike out on their own." While one might try to argue that the teachings of parents has substituted for the teaching of elders (Stage Four), parents has actually tended to increasingly withdraw from this role in recent decades at least, leaving only the media, the educational system, and peer influences as the remaining sources of "knowledge" in preparation for an adult world. At the same time, educators have been incapacitated in their efforts to meaningfully contribute to adult citizenship by being told they can only convey quantifiable facts that, in turn, can be tested too prove "accountability." Awareness of the complexities of the contemporary world and successfully solve problems are probably the two most important things a young person can obtain in the educational system, yet both are increasingly inhibited and even prohibited through the emphasis upon regurgitation of rote facts as the ultimate goal of learning. The other two components in the present system (the media and peers) seem to provide little to fulfill the significant knowledge for confronting a increasingly complex, diverse world in which an adult is, by necessity, defined as one capable of understanding and constructively contributing to it.

Connected to our discussion of body alterations, a distinct, but closely related, form of physical change common in many global cultures is enacted through the use of masks. This form of body change is temporary and often part of cyclical events (planting, harvesting), or associated with resolution of a specific social need (resolving a social dispute, curing an illness, ending a famine, assuring plentiful crops for food, mediating the weather).

Perhaps the most distinguishing traits of masks in non-Western societies is that they are generally donned for the purpose of revealing new meanings and bestowing

new capabilities upon the wearer that weren't there before the mask was worn. The specific new meaning(s) infused into the figure wearing the mask in non-Western settings varies considerably, but the essential condition has been that new traits in the meaning and capabilities of the wearer were enhanced through the wearing of the mask. One example might be the use of a Janus-faced (double-faced) mask in the Okpi village of Nigeria. In this case, the figure is called the *Egu Orumamu*, a figure who assumes the dual task of adjudicating social dispute and overseeing the annual agricultural plantings and harvest. This dual set of tasks is why a double face is used. Within each of the two tasks is a duality as well: social judgments require insight into two or more points of view that requires creating a fair balance between the conflicting views; and the planting and harvesting off crops are two equally important stages in the cycles of nature with the *Egu Orumamu* assuring an equilibrium between both in order to assure a plentiful crop.

In contrast to the above revelatory roles of masks in non-Western settings, those employed in most Western cultural environments tend to be for purposes of concealment. The phrase "to mask" connotes hiding what is under the mask (the self). Examples of such concealments include the hiding of one's identity when robbing a bank by wearing a ski mask, or assuming a mask-like behavioral or speech pattern to accomplish one's ulterior motives (as opposed to serving as an extension of one's true inner self), or employment of camouflaging devises to hide what are ultimately considered as flaws in one's appearance, by using a facial make-up such as mascara. The meaning of the word "mascara," itself, is derived from the same root word as that of "mask" in Western languages.

As we have already discussed, the tendency to idealize select forms of beauty has become dominant in contemporary culture in recent decades. This has come to pass, to a significant extent, as a result of increased mass advertising efforts from pharmaceutical, cosmetic, clothing, and related corporate interests that are dependent upon marketing based upon perpetually changing fashion. Young people, and especially young women, are continuously subjected to a flood of images and mantras in print and TV media attempting to convince them that their present physical appearance is inadequate no matter what the truth of the matter is, and that they must alter that appearance in order to assume the traits of an idealized image of the self. The norm varies almost infinitely, with recent common stereotypes stressing youthful features and slender bodies. One is made to feel inadequate if s/he doesn't fit the prevailing ideal, even though it is often unclear what this is. If one has dark skin, they are urged to lighten it. If they have a light complexion, they are urged to darken it. If they have curly hair, they are encouraged to straighten it. If they have straight hair, they are exhorted to curl it. If they are tall, they are prodded to do what they can to appear shorter. If they are short, they are compelled to appear tall. Enough is never enough.

Another motivation leading to body changes in contemporary culture is to introduce physical attributes that one didn't originally have, along with the recovery of youthful appearances that have been lost during one's thirties and forties. We have already suggested the latter aspect in our comments on the pervasive presence of a

"Nip/Tuck" culture. The phenomenon has a particular impact upon older individuals who are dissatisfied with changes in their bodies as they aged, including the appearance of flabby skin, drooping breasts, increasing weight, unresponsive penises, and countless other attributes. One might say that these phenomena are the counterfoils to the body alterations enacted by youth in order to fulfill their own triadic goals of establishing an appearance of individual identity, thumbing one's nose at the status quo, and enacting a transition from childhood into young adulthood. Significantly, however, the motivation of the older group is in an opposing direction from that of the youth. Rather than gaining a new appearance and revolting against the status quo, they desire to regain the appearance of youthfulness. Botox treatments, breast enhancements, penile implants, liposuction, and other forms of body enhancements/changes introduced through both surgery and the ingestion of various chemicals are all among the arsenal deployed to turn back the clock.

In defiance of common reasoning, Michel Foucault has claimed that these isomorphic tendencies to normalize appearance, or to conform to a single, universal, or idealized look, aren't entirely devoid of value. As he points out, normalizing certain traits may, indeed, lead toward an inevitable homogeneity, but it also individualizes by making it possible to measure gaps, determine levels, fix specialties, and render differences useful by fitting them into another. In short, one can frequently come to measure the most specific features of attributes when attempting to assimilate it. For some this might entail a relatively mindless process; for others it involves a highly conscious one. Foucault's optimism resides in the latter more than the former. As he points out, the quest for obtaining a result that is ideal actually ultimately results in discovery that individuality (with all of its inherent variations) is the rule–the prevailing and unavoidable condition–rather than the exception.[6] In effect, the process employed for inquiring into changes that individuals might instill in/on their bodies has the potential to invoke a greater awareness for these same individuals to increase control over their own lives. In a related vein, Celia Lury made the following observation in her book on *Prosthetic Culture*:

> In prosthetic culture, what have previously seen as relatively fixed social and natural attributes of self-identify are reconstituted as modifiable by deliberate transformation, opening up new spheres of decision-making and choice.[7]

While instilling greater individual control over personal attributes and identity, Lury also cautions us to remember that exercising such choices while pursuing changes of our identities might also offer new grounds for the denial of individual responsibility, and thus pose new ethical dilemmas.[8] In these terms it might also be advantageous to again consider the Bakhtin quote found at the beginning of this chapter:

> The grotesque body, as we have often stressed, is a body in the act of becoming. It is never finished, never completed; it is continually built, created, and swallowed by the world.

Since the ideal (perfection) is ultimately unattainable anyway, the process of change itself becomes the framework within which one may most convincingly measure the presence and importance of appearance and the inherent value that it can embody. The contemporary artist named Orlan has appropriated the potential for a variety of changes that exist strictly within the domain of her own personal biological landscape as the area within which her art has evolved.

Few artists generate the extreme responses from a variety of viewers that one encounters in the case of Orlan. She is the only artist who has employed surgery as a principal artistic methodology—comparable to a paintbrush or sculpture chisel—with manipulation of her own body as the primary subject of her art. From dialogues that this author has had with many people concerning her work, it appears likely that those who are most comfortable with what she does, and who even admire it, are those who perceive it as a product of individual human will, and especially as an extension of a woman who has assumed full control of her own body. That she does so to create her art is fully accepted to such people. But to those who like it the least, including those who are repelled by it, Orlan's work is a narcissistic and sensational form of expression, one in which she is attempting to create shock as an end in itself through the use of melodramatic physiological changes that she surgically implants into her own body. For the latter group of viewers, it appears that the grotesque appearance of the artist's body, especially when she documents the act of surgery itself, as the most abhorrent. Because the artist has videotaped and photographed the surgeries, and exhibited these acts as works of art in themselves (though they are actually best understood only as stages of the process), may have drawn more attention to the procedure of change than its results or significance. Also, those who are among the most appalled by Orlan's art are also among those who appear to generally accept body piercings and tattoos. Such individuals also seem to accept surgeries that are for life preserving purposes, but not changes in which an artist physically uses his/her own body as being comparable to the malleable clay from which Prometheus formed the first humans that we described in the last chapter when discussing the construction of bodies.

It is important to note that Orlan's use of surgery as a means for body alterations occurred long after she had already employed her body as the main subject of her art. As such, the surgery is but one stage in the evolution of her work. In fact, her body has served as her primary vehicle for expression throughout her career from the early 1960s to the present. Her first surgery came later, and was due to a physical emergency (ectopic pregnancy) in 1979. As of that moment, the notion of deliberately using such a method had not occurred earlier in her work at all. And, equally important, she began the transition from surgically altering her body to using digital methods as "virtual" alterations in the mid-1990s.

Beyond the relatively sensationalist presence of surgery as a method during about fifteen years within the approximately forty-five year of work, what are the broader attributes and tendencies in Orlan's art?

Like Frida Kahlo before her, Orlan has primarily focused upon self-portraiture throughout her career. Her first works in the mid-1960s were notable as formal

photographic self-portrait studies in the tradition of the female nude, but with both conceptual and humorous connotations. One finds such humor conveyed through the interplay of body positions that she assumed and other kinds of imagery, as in *Body Sculpture called "Frog Against Black Ground"* (1964) and *Body-Sculpture No. 3 called "Shiva, or Many-Armed Tentacles"* (1965). Her interest in parodies of famous works of art in Western culture began about this time as well, with take-offs on Duchamp's *Nude Descending the Staircase*. In fact, it is clear from most of her work, that Orlan is acutely aware of and engaged with the images, iconographic meanings, and modes of perception embodied in the methods and subject matter in art throughout history. In stark contrast to the claims of some critics, it is equally obvious that her work represents more than a stereotypical or superficial flaunting her own body through surgical intrusions as an end in itself. Instead, her work embodies a complex and probing inquiry into cultural perceptions of the human body as a static phenomenon, or as something to deny or control through the strictures of society.

By the late 1960s she was exploring the chiaroscuro (atmospheric) effects examined by Leonardo and other Western artists, as seen, for example, in her work entitled *Documentary Study No. 1: Plaisirs Brodés (Embroidered Dissipations, or, Chiaroscuro Couture)* (1968). This work has a strong resemblance to works by Vermeer, when one considers the use of a shallow space in a home interior and with strong lighting that dramatizes a single figure engaged in a common domestic practice (sewing in this case).

Orlan, Documentary Study No. 1: Le Drape-le Baroque, or Sainte Orlan avec fleurs sur fond de nuages (Saint Orlan with Flowers, Against Clouds), 1983. Aluminum-backed Cibachrome, 47 ¼ x 63 in. (120 cm. x 160 cm.). Courtesy Fonds National d'art Contemporain, Paris. Photo: Anne Garde.

Orlan's recurring fascination with Baroque qualities, including an emphasis upon dramatic folds and high contrast lighting (ala Bernini's The Ecstasy of Saint Teresa, and perhaps even the Hellenistic Greek sculpture of Nike of Samothrace, which one must assume she saw in the Louvre) spans the fifteen year period of work she produced from the mid-1970s to around 1990. Within this sequence of studies, the artist includes her risqué appropriation and interpretation of images of the Madonna and also creates and photographs a persona of herself as a constructed feminist and erotic female saint (called Saint Orlan). These images, alone, have no doubt caused many to turn from her work, though usually with little inquiry into the central meaning of such transformations in the first

place. While creating such alternate perceptions of what might be properly defined as the image of females within religion, she has challenged traditional perceptions of women as figures under the control of men when defined in the extremes of "saints" or "whores." By rendering the Madonna (or "Saint Orlan") as sexual, the artist has been able to expand one's appreciation of the human within the mother of Christ, rather than the more conventional meaning as a vessel of purity alone. Conversely, by rendering a stripper as holy, she infuses more depth and richness into one's perception of an ordinary woman as well. Admittedly, these images typically seem appalling to those who wish to continue the traditional of limited definitions of women, both in religion and in daily life.

By infusing female saints with passion and rapture, Orlan integrates the emotion and sensual with the spiritual and mental. She is not the first woman to do so. In the writings of Saint Teresa (16th century saint from Spain) we find evidence of a distinction between a state of "union" with God and that of spiritual "rapture."[9] Through rapture (ecstasy) "...you feel and see yourself carried away, you know not whither."[10] But one is struck by the dramatic parallels between what the saint describes as her experience of spiritual ecstasy and that of sexual bliss. This parallel was not lost upon the Baroque sculptor, Bernini, when he sculpted the Saint at the height of this rapture. The artist's famous work entitled The Ecstasy of Saint Teresa (1642-52) is an accurate rendition of Teresa's own words that she used for describing the experience:

> Beside me on the left appeared an angel in bodily form...He was not tall but short, and very beautiful; and his face was so aflame that he appeared to be one of the highest ranks of angels, who seem to be all on fire...In his hands I saw a great golden spear, and at the iron tip there appeared to be a point of fire. This he plunged into my heart several times so that it penetrated my entrails. When he pulled it out I felt that he took them with it, and left me utterly consumed by the great love of God. The pain was so severe that it made me utter several moans. The sweetness caused by this intense pain is so extreme that one cannot possibly wish it to cease, nor is one's soul content with anything but God. This is not a physical but a spiritual pain, though the body has some share in it–even a considerable share.[11]

No doubt the reader can appreciate the similarity between these words by St. Teresa and the passionate dimension that Orlan attempts to infuse within the image of a female (and specifically herself) that also has spiritual connotations. Even if Orlan hasn't been aware of Teresa's rapturous testimony, we do know from her frequent comments on the matter that she does deliberately interpose her sexuality as a major feature within her self-portraits.

In confronting Orlan's numerous visions of self-transformation, we are reminded of a number of other, but more historical, creative works. Given the frequency of a broad range of historical references in her output, one must imagine that there may be

truth to the assumption that Western culture has provided more than a passing interest in her metamorphic imagery in general, and human body transformations in particular. To fully appreciate Orlan's interest in this theme, it is helpful to briefly consider the significant array of creative works, and especially those within the literary tradition, that have focused upon human and physical transformations as their primary vehicle. Among the better known of these is Ovid's Metamorphosis, which was written more than two thousand years ago and provided one of the most fruitful inspirations for later Western cultural writings on the transformation of the self (inclusive of bodily, psychological, and spiritual changes). Another obvious work that comes to mind is Franz Kafka's short fiction story entitled The Metamorphosis. This piece was written in 1912, and addressed the physical changes of a character named Gregor Samsa, who awakens from sleep to find that his body has been transformed into a "vermin."[12] Following the transformation, Gregor's family increasingly treats him in a distant manner, and eventually appear to forget about him entirely. Kafka's treatment is generally conceded to represent society's tendency to disregard those who's appearance differs from the norm. It also embodies a critique of evolving loneliness and isolation caused by the rejection, as well as the despair that life might ultimately be inherently a doomed venture, as one finds in the so-called Absurdist movement that stemmed from Kierkegaard. All of these traits, in turn, are quite similar to some of the major themes we already discussed when constructing a living body, and then rejecting it when it doesn't conform to one's expectations, as found in Mary Shelly's monster in Frankenstein.

Orlan chooses the term "carnivalesque" rather than "absurdist" in reference to her ever-changing mutant identities. In our earlier quote from Bakhtin, we found that the grotesque body "is a body in the act of becoming."[13] In this highly forgiving effort by Bakhtin to formulate a constructive way in which we might approach the infinite number of "in between" stages in which beings (or other entities) are not yet what they will become, by not having yet fulfilled their potential for achieving maximal beauty, we find yet another essential feature of Orlan's work. This is to be found in the simple fact that she has persistently pursued her vision of a constantly transmuted image of herself. To think of what and who she is cannot be separated from our vivid recollections of these many guises. A "guise" is very different from a "disguise," in that it represent but one of many faces of ourselves in a continuous panorama, rather than as a cover-up of our self. The distinction between the two is very important to this discussion. That many of the guises are similar to existing images that are familiar to us–both in Western and, given her more recent work, in Non-Western cultural settings–indicates the strength of her identity with others. This is especially true in respect to images that we tend to classify as classical representations, as found in the above image of herself as a fictional Saint Orlan who is experiencing the same transfixed ecstasy that we read about and could see in the image of Saint Teresa in Bernini's sculpture.

When considering the critical and historical significance of Orlan's work, one must inevitably consider its relationship to the images found in the well-known Film Stills series (1977-80) by Cindy Sherman. In Sherman's work, we find images of the artist dressed in varying guises, situated in a faux scene, and pictured as if the artist's

self-image has been culled from a movie (though a fictional one). By stressing the appearance of a person captured at moments of extreme vulnerability, Sherman presents her persona with a black eye and bruised face from what one surmises to be a beating by an angry lover, or as lying on a couch by the phone with a dim light over her head suggesting an entire night of waiting, or fulfilling one of the countless "provider" jobs that women have historically had to assume. The clothes, make-up, setting, and gestures that Sherman assume as attributes of her overall guise situate her within a specific kind of situation, alternately suggesting poverty, isolation, loneliness, and/ or dependency. The combination of conditions within each of these works instills a charged atmosphere that strongly urges specific experiential connotations in and about women. As such, the works reflect not only experiences that are unique to women but also those that imply women could be (and have been) "taken."[14]

Contrary to this, Orlan's works show little concern for celebrating or reiterating the conditions of vulnerability that area posed in Sherman's Film Stills works, and, in fact, are more frequently blatant expressions of female determination, regardless of the specific guise that she assumes as a persona in any given work. By lacking the number of environmental cues necessary for drawing fixed conclusions, the work tend to lead the readers in more disparate and conflicted directions, and are thus less monolithic in their meanings when compared with the Film Still images of Sherman. One will encounter entirely opposite reactions from viewers when interpreting the possible meanings in Orlan's works. Her works also go well beyond this by also addressing questions of cultural definitions of beauty, interpose the importance of female eroticism within all aspects of women's experience (including religion), and involve body transformations that are metamorphological and frequently permanent (or at least for awhile anyway). And, finally, physical changes in her body–whether this is through surface changes, surgery, or digital manipulation–have continued to characterize the nucleus of her work almost since its inception until the present.

One additional comparison should be made at this point. The collaborative photographic works of the French visual art team called Pierre and Gilles (and commonly billed as "Pierre et Gilles") represent additional similarities with the works of Orlan due to their methods for using alterations to the bodies of their models. Their works also involve the use of settings as faux environments, with melodramatic lighting, and a stage-prop look. The team constructs settings and themes of an archetypal kind, such as the Garden of Eden, Christ with the Crown of Thorns, or Saint Sebastian tied to a post with arrows in his body. While some of their works, like these, are biblical in origin, others draw from pop culture in a way that closely resembles the movie poster kinds of images encountered in Sherman's Film Stills. Orlan's works are quite different from those of Pierre and Gilles in that her work specifically engages her own body, and has done so in a consistent manner over a forty-five year span. In contrast, the collaborative French photographers lean more toward a saccharin vision of culture and imagery, and use the images of the bodies of others to create a melodramatic effect as an end in itself.

Orlan began her two series entitled Self-Hybridation Précolombienne and Self-Hybridation Africaine in 1998. Both groups of works involved deployment of

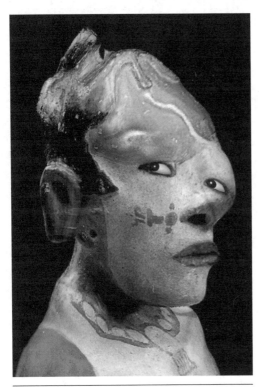

Orlan, *Defiguration-refiguration. Self-Hybridation précolombienne No. 4*, 1999. Aluminum-backed Cibachrome, 39 1/3 in. x 59 in. (100 cm. x 150 cm.). Courtesy Fonds National d/art contemporain, Paris.

digital alterations to photographic images taken of her head. Using computer manipulation, the artist was been able to fuse attributes from Pre-Columbian and African sculptures with features of her own face. In short, the result was photographic hybrids stressing bi-cultural imagery. She became the "other" and the other became "her." More recently, she has been creating similar amalgamations digitally combining her facial features with those of images of American Indians painted by George Catlin, again invoking her interest in integration images and ideas from the history of art.

In terms of the Pre-Columbian series, the artist inscribed onto her face signifiers of beauty originating outside Western culture (such as enlarged cranium, tattooing, scarring, an idealized age). She also instills facial features physiologically associated with the particular tribe or community from which the image was derived, such as a Mayan nose. In the words of C. Jill O'Bryan, the artist has approached portraiture in these works in a manner in which she becomes a "genie/genius by tampering with genetics, but now without blood."[15] With these works Orlan operates outside the boundaries limited through the prior use of her body approached as a purely physical entity, both sculpturally and surgically. In the Self-Hybridization works she is able to construct fusions in even more unrestricted ways. In the artist's words:

> Contrary to what I had attempted with the series of surgical operations, my self-hybrids do not inscribe the transformations within my flesh—my "phenomenological body"—but in the pixels of my virtual flesh, mixed with inorganic matter and my own representation after it has been reworked by surgery…

> …I make images of mutant beings whose presence is thinkable in a future civilization that would not put the same pressures on bodies as we do today. Such a future civilization could therefore integrate these beings as possible and sexually acceptable, and beautiful.[16]

Orlan's efforts are, in part, directed toward a form of rebirth, or recreation, that

results from mutation. To recognize and value the artist's pursuit, we must acknowledge that we, as living beings, are the sum total of more than our genetic and parental beginnings alone, and that all that we have seen, heard, worn, read, experienced, and learned are also among the fundamental attributes of our selves as well. Most of us could also agree that these constituent parts of the self weren't necessarily all "beautiful" or "normal."

Like Picasso's fusion of African masks on the bodies of women from Avignon in his *Les Demoiselles d'Avignon*, Orlan merges elements from differing cultural contexts in her Self-Hybridizations. Picasso's combinations of subjects that were otherwise disassociated–along with his breaking down and reconstitution of geometric shapes derived from the foreground masks and figures with the background in this work–serve as among the major innovations to be found in his work that is generally conceded to have served as the basis to much modern art that followed. In Orlan's case, however, the fusion of features of her own body with those of masks examines notions of what constitutes the self, and it also challenges conventional definitions of beauty. In her words:

> The Self-Hybridations (materialized by photographs) have been made by connecting works from past and lost civilizations that represented the norms of beauty at the time to my own face, meant to embody the criteria of beauty in our time with the extra irony of the two pigeon eggs that protrude on my temples like two volcanoes erupting against dominating ideology…People talking about these photographs have a tendency to describe me as a "monster" with a strange face, a distorted face; still these two pigeon eggs do not seem to produce the same effect when I am seen in reality.[17]

One of the fundamental features of beauty common in most African masks and sculptures is an emphasis upon what is often referred to as ephebism. This word denotes the emphasis upon a single ideal age that is "mid-point" in life, and is emphasized in depictions of the human figure. In the case of Africa, the idealized age is about 30 years old, which is an age that is coincident with the point in life occurring early in a marriage, when children were first born, and when one is fully mature. Interestingly, the Greeks borrowed this same ideal from Africa, and, in their own sculptural works of people, stressed the same age in almost all images produced throughout most of main periods of Greek history. One finds practically no images in Greek art of children or old people (or mal-formed people for that matter). Of course this wasn't the case with the Romans, who emphasized all ages and body types.

Orlan has created two sculptural images hybridizing features of her face with those of African faces, and combined the results with an Afro-body that is derived from sculptures. In this respect, these works are similar to her Pre-Columbian hybrids. In this case, however, the works are borrowed from Nuna images. One is shown above. In the work, the head is colored on one half as yellow and on the other as black.

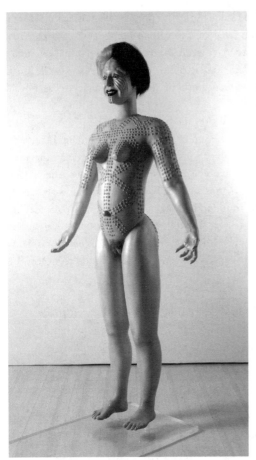

Orlan, *Nuna Burkina Faso Sculpture with Scarification and the Body of a Euro-Saint-Étienner with Facio-Temporal Lumps,* 2000. Resin moulding with whig on a transparent plexiglas plinth, 39 1/3 in. x 70 in. (100 cm. x 180 cm.). Collection of the artist.

These colors refer to the historical anthropological documentation of African tribes as the Western eye looks on. The figure portion is implanted with scarification bumps in the front of the torso, resembling those used by the Nuna (also called the Nunana) and also the neighboring Mossi peoples in the region now identified as Burkina Faso. In the tradition of these people, a woman who has recently given birth would have scars implanted into her flesh in patterns radiating outwardly from the umbilical region.[18] The scars are part of Nuna and Mossi rites of passage that only occur after childbirth occurs, and the scars signified her having given birth. In Orlan's version, the scar bumps are uniquely interpreted in the form of machine bolt shapes, giving the figure another twist that hybridizes the images with traits of machines.

The artist did two versions of the Nuna figure. Both were cast from the same body mold and appear identical. It is notable that the body torsos were not formed as duplicates of Orlan's own body, and are rooted in the same ephibist idealization of age found in the face. The trunk of the body was formed to achieve an approximation with the idealized images African sculptures of women, not as directly formed portraits of actual African women. The version illustrated above is painted with a lighter skin color, while the other version is darker and thus represents a truer Afro image.

By using the same body mold for both, and individualizing of the features in the extremities, Orlan is following the general methods employed by the artists who cast the more than two thousand surrogate soldiers cast in terra cotta and buried in the vicinity of the Emperor of Ch'in more than two thousand years ago in China. The fusion of a cast body with extremities that are formed to possess more individualized features (and especially in the case of Orlan's facial combine) is another form of hybridization. In this indirect discovery, we find yet another in the vast array of complex and varied art history references to be found within the artist's work.

One will inevitably ask whether Orlan's appropriation of imagery from other cultures, and the subsequent hybridization of these with elements from her own body, is not simply a new form of colonization. To answer this important question, one must consider the fact (as has always the case in her work throughout her life) that she never permanently dons the appearance of the "other" in her work. And in borrowing, she only selects some aspects over others from the array of possible features to be found in the source being used at any given moment, and through the act of fusing these elements with further visual elements drawn from her own body, the personas being constructed are in a perpetual state of transience. She (the central person to whom Orlan returns between the transformations) never really literally and wholly becomes the "other" in a fixed sense. She thus never really "possesses" the other in the usual sense of taking and holding something from its original context or culture, with the taken aspect becoming part of her biological ontogeny.

It also seems impossible to criticize someone for temporarily creating fusions of expressions that include elements drawn from external sources when this is one of the most common attributes of art throughout the modern era. This would be like telling Picasso he never should have used African masks in his Cubist work, or, for that matter, telling an African that they can never eat Chinese food. All cultures, everywhere, are now in a state of constant borrowing of attributes from each other due to the global nature of our world at present. We should be able to agree that cultural attribute as literally flying around the world and are being borrowed by virtually everyone, in all cultures. It would be extremely unfair to criticize Orlan for her temporary (and partial), though frequent, borrowings as being a form of theft, unless we also acknowledge that all of us are complicit throughout every day of our lives. She is only acknowledging through the nature of her art what is happening on a far broader scale everywhere, and she saw it coming long before most of us.

As we have seen, Orlan's art has encompasses a broad range of concerns. Through alterations of her physical body, she could be considered a sculptor. By recording the processes for these changes in real-time video format, she is a filmmaker and performance artist. By altering the surface of her body in countless ways, she is not only a portraitist but a landscape painter as well. In the words of Régis Durand:

> Orlan's forty-year career can be interpreted as a long take running from her self-birth to the invention of her own language and measuring systems, on to a kind of pseudo-mystical crisis with reincarnations in various forms, then to the controlled manufacture of her new faces, leading to total dissolution in the limitless euphoria of digital—and, soon, biotechnical—transformation. This tale is based, and demands to be considered, in its "narrative" dimension. Yet her oeuvre can also be seen as a limited number of variants that are constantly reworked and enriched through new techniques (performance, photography, video, surgery-performances, movies, computer technology, genetics, etc.). Synchrony, diachrony.[19]

The last chapter addressed fundamental ways in which the construction and

interpretations of the human body has gone through dramatic changes in recent decades. We stress the prospects for creation of the body from nothing, through combinations of discrete and seemingly alien elements. By comparison, in this chapter (Chapter 5) on the work of Orlan, we observed the important of both incremental and morphological changes, with each stage bearing a different connotation and identifiable as a "work" within itself. We will now turn to the presence of elements and meanings within works that initially lie hidden and may be perceived simultaneously within an overall complexity of given works. We will note that such images must be slowly unraveled and individually considered in order to accurately fathom the overall nature of the work. We shall term this new phenomenon the "Rashomon Factor."

THE RASHOMON FACTOR:
Hidden Meanings in Works by
Chester Arnold and Luna Topete

In front of me there was shining the small sword, which my wife had dropped. I took it up and stabbed it onto my breast.

> – Testimony of the "murdered" man who claims
> it was a suicide

I killed him...but I didn't like to resort to unfair means to kill him. I untied him and told him to cross swords with me....Nobody under the sun has ever clashed swords with me twenty strokes.

> – Testimony of the accused

I'm determined to die...but you must die, too. You saw my shame. I can't leave you alive as you are...I stabbed the small sword through the lilac-colored kimono into his breast.

> – Testimony of the wife who claims she killed the
> husband at his request

Above conflicting testimonies are from Ryunosuke Akutagawa's *In a Grove*,[1] which served as a basis for Akira Kurosawa's film of *Rashomon*.

The above three conflicting quotes are from a short story named *In a Grove*, written by the Japanese fiction writer Ryunosuke Akutagawa. Akutagawa's version of this story, in turn, was a re-written narrative borrowed from a medieval Japanese anthology called *Konjaku Monogatari* (Tales of Times Now Past). Akutagawa's story, along with another, briefer tale entitled *Rashomon*, form the basis to a film with the same title by Akira Kurosawa. This acclaimed film was the first Asian movie experienced on a popular level by Western audiences when it was featured at the 1951 Venice Film Festival. This work has become legendary as a study of the complexity of reality, and, perhaps more important, the vicissitudes of personal perceptions and testimonies.

The story in Kurosawa's film focuses upon radically varying testimonies of four people who were direct witnesses of what could have been a murder or a suicide, as well as what could have been either a rape or a seduction. That the testimonies could conflict to extreme degrees has been attributed to at least three major reasons. All three reasons intervene throughout Kurosawa's portrayal, and, through them, we are provided a framework for understanding how such divergent perceptions are possible.

The first of the three causal factors addresses the tendency for people to only

perceive what they are ready, or inclined, to acknowledge as possible. The old saying that "I'll believe it when I see it" is only applicable if one is both willing and able to see the totality of the truth provided through perceptions of events. But if evidence that one is not willing or able to accept presents itself–no matter how dramatic or obvious it might be–such a person will most likely be oblivious to it. Since we only see what we are ready to see, the act of "seeing," itself, needs to be understood in flexible terms. To truly "see," one must first shed as many expectations and inhibiting assumptions as possible so that perceptions are direct and unfiltered by prior indoctrination. Unfortunately, many of the teachings we are taught during our backgrounds make it almost impossible for us to perceive things that we have repeatedly been taught are impossible. Additionally, for us to truly see things entirely "as they are" requires an unusual degree of perceptiveness, in an of itself, as well.

The second determining issue is that our egos typically function as filters between our thinking about our perceptions and our descriptions of them when recounting these experiences to others. In simple terms, we like to present ourselves in a favorable light, irrespective of what our experience entails. Because of this debilitating habit, our testimonies tend to be as much about ourselves, or what we think others want to hear, as they are about the events to which we allude.

The third element that intrudes into the process of perceptions and the later recounting of them is an inherent and inevitable complexity, as opposed to a singularity, in the nature of events. Because of this multi-layered structure, many attributes lie hidden behind the comparatively simple façade that our first glimpse typically provides. Unlike the first two intervening factors, this one isn't about us as individuals as much as it is about the inherent complexity of the world as a multifaceted "reality." As a result of this, our initial perceptions are only attuned to the attributes that "face us" and are "on the surface." Most other attributes are partly or entirely hidden from our perceptions, and thus we may have little awareness of them. This condition also requires the use of inference when "reading" evidence since the perception of underlying traits must be accomplished through a combination of factors, including the recognition and interpretation of clues that are not obvious, including those that are read and acted upon subconsciously, and also the necessity for significant decoding in the process of interpretations. Decoding requires interpreting the underlying meanings of what we perceive as much as the surface traits.

Many forms of information are highly nuanced in these ways, and are understood as much through suggestion and symbolism as through their surface traits taken alone. And the elements serving as clues are not obvious and require "filling in the blanks." But this can only happen if one is willing and able to "complete the picture." We all frequently do this without even thinking about it. We wouldn't make it through the day without unconsciously employing our imagination and reflexes to interpret the ambiguous sequence of clues that we encounter throughout the day. An obvious example may be found in the subtle, yet complex, patterns formed by masses of people who walk down the sidewalk during lunch hour in major urban centers. All of these individuals are constantly required to "read" the innuendos suggested by tiny glances

and gestures so that they won't collide. The same happens while driving on congested freeways in Los Angeles, Atlanta, Washington D.C., or elsewhere. These interpretations and responses are all completed reflexively, and frequently on an unconscious level. But they involve interpretation and response nonetheless.

To compensate for both the complexity and stratified nature of events, we have to spend more time than we might be inclined to devote to see all the facets, to look again and again, to look at things from more than one perspective, and to be willing to question what we thought we saw at first glimpse.

Of the above three factors, it is the third one–the innate multi-layered and complex nature of reality–that is most significant for the underlying premise in this chapter. We will refer to this condition as the Rashomon Factor. The phenomenon is primarily a matter of complexity, along with the multiple meanings conveyed by the complexity. Many have noted that the presence and importance of complexity and multiple meanings within all things has increased considerably as our world has become increasingly complex. As a matter involving multiplicities within single experiences or objects within our lives, the Rashomon Factor must be considered as another common form of hybridization. When it appears as an aspect of art, one will often observe that select elements are initially apparent while others are only later noted on a conscious level within a given work. In essence, therefore, this chapter is about art that takes time to understand.

One might ask whether this kind of visual hybrid is truly unlike what we discussed in the earlier chapter entitled "Assembly Required." In that discussion, however, a single encompassing image (a 'body") was constructed from multiple parts that were all generally perceived at once and were thus relatively equal in dominance. The emphasis was upon how things were constructed or made, as bodies comprised of many physically discrete elements. In this chapter, however, the multiple aspects are more typically read in a sequence, as delayed perceptions, with each sustaining its own local presence, and thus its own differentiation, in a more pronounced manner. With the Rashomon Factor, we are also inevitably confronted an inherent complexity that characterizes both the localized part and the broadest reading of the work.

It will assist us if we begin first with a relatively obvious example in which multiple readings and delayed perceptions are principle features. Following this discussion, we will then proceed with our discussion of additional, and more subtly formed expressions by two contemporary artists whose work illuminates two entirely different ways in which the Rashomon Factor may be understood.

Historically, there have been many artists who have focused upon multiple meanings in their work. Among the best known and most obvious of these is Salvador Dalí. Dalí's *Invisible Afghan With Apparition of a Face on the Beach* (c. 1937) typifies many of the ambiguous expressions produced during the 1930s. During this period, the movement stressed not only the dream images for which the Surrealist movement was best known but also ones that required multiple kinds of interpretation. Many of the images in such works could be interpreted in two or more ways, and also included images contained "within" other images. The sub-images, in turn, were usually

Salvador Dalí, *Invisible Afghan With Apparition of a Face on the Beach*, © 1934-37. Private collection. © 2007 Salvador Dalí, Gala-Salvador Dalí Foundation/Artists Rights Society (ARS), New York. Photo courtesy Erich Lessing/Art Resource, NY.

contained within a landscape, with the landscape serving as an equivalent to a field of vision–the dreamscape so common in Surrealist practice–that could be understood as an equivalent to perceptions that we derive from unconscious sources.

In our example by Dalí we can perceive the largest context, or spatial environment, as representing this kind of landscape. Within this broadest spatial dimension, however, one finds the face of a woman that is resting on a quasi-table top (a still life reference) and that is also perceivable as the sand on a beach. If one looks closely at the head, the area where the eyes are located also form the heads of two very small figures. Both of these small figures are reclining on the beach and lurk within the same space that is occupied by the head, most definitely an illogical circumstance. As such, things are contained within other things, but also share a broader spatial environment with other images at differing spatial scales. When carried further, the forehead portion of the woman's head may be perceived to form part of the belly of an Afghan dog that is standing at attention like a hunting dog, with its head and body facing to the right. The dog may also be alternately read as a "positive" form (in art terminology, "positive" space refers to the images comprised of solid matter), but also opens into the sky (e.g., as "negative," or open space). The upper portion of the dog even contains clouds that associate it with the sky, so the dog isn't entirely a "dog" at its top portion any more than in its lower portion. In fact, the dog may be perceived as melting into the sky at

the top, and one must "complete" its upper contour largely through imagination, since the presence of this upper edge isn't actually present in a defined, physical way. Finally, in the central, right-hand area is a rocky premonitory, and in the water to the lower-right area are two figures who are in the water.

Dalí frequently referred to these kinds of ambiguous, multi-image visions as products of his "paranoid-critical method." He defined this method, in turn, as "a spontaneous assimilation of irrational knowledge based upon the critical and systematic objectification of delirious phenomena."[2] In his commentaries, the artist predicted that paranoic thought would be systematized, "totally discrediting the world of reality."[3] His use of extreme realism when painting his otherwise irrational images was for the purpose of increasing their believability—as a form of hyper reality—to "materialize the images of concrete irrationality with the most imperialist fury of precision."[4] The collection of seemingly unrelated images must be read accumulatively and totally in order to be perceived and understood. None of them exists alone, yet they are also evident only through extended examination. One cannot perceive all of the images within the painting instantly for several reasons: their large number, they do not have logical connections, and many are contained (and hidden at first glance) within others.

The juxtapositions of incongruous elements is parallel to the way dreams actually are constructed through combinations of fragments that do not individually become complete, but, instead, aggregate to become irrational extensions of each other. Each fragment of a dream builds upon the prior ones, eventually becoming a whole, but one that would very likely be considered contradictory, fragmented, and even irrational to the conscious mind. The conscious mind would want to explain everything according to its own dependence upon cause and effect methods for determining logic and truth. So, to fully understand perceptions that invoke our subconscious mind, or our imaginations in ways that are not rooted in rationalistic assumptions, requires consideration of other sources of knowledge and experience.

While Dalí's interests in Surrealism naturally gravitated toward the dream as his primary correlate, the work of our two featured artists—Chester Arnold and Luna Topete—focus upon significantly different realms of experience from those found in the Surrealist's work. Like the Dalí, many of the works by Arnold and Topete require multiple readings due to an inherent complexity. But the specific way in which the hybridization of images and meanings appears in works by each of these artists is as different when comparing them as the differences are if one compares works by either of them with those by Dalí.

In Arnold's works we find a unique blend of several kinds of complexity largely involving oppositional elements. A balancing of these oppositional factors is frequently found in much of his works. In an essay on the artist's work, Karen Kienzle notes that Arnold balances historical influences with contemporary themes involving social and environmental issues, and he also examines correlations between form and content, and pursues an on-going interest in establishing a balance between the minute details in his works with their general features.[5] One additional major hybrid element that

must also be mentioned–though it appears to have been ignored by others writings on Arnold's work–is the way in which individual works by the artist often contain densely clustered images and subjects. This congestion of multiple subject matters typically requires extended readings in order to perceive and understand the relationships between the parts. This is not to say that the detailed way in which the artist depicts individual objects within his works is the same as this density of imagery, what one might consider "highly populated" surfaces. In many of the artist's paintings the images are, quite literally, buried within each other, as countless parts of a vast, and frightfully filled, depository of discarded stuff. From this, the artist conveys the degree to which our modern material culture has endorsed a cultural addiction for pursuing never-ending cycles of obsolescence, featuring elimination of our most recently acquired toys with total abandon. As a result, the ratio of the landscape that is devoted to living in relation to that which is dedicated to serving as a garbage dump is rapidly reversing in dominance. There was a time when one had to drive for miles to find trash piles and garbage dumps, but one doesn't need to drive far to locate such places any longer. They are just down the street, or on the sidewalks in front of our homes.

In *Crossroads* (2006) we encounter all four of the above kinds of balancing of elements that are common in Arnold's work. In terms of historical influences, the artist's youth was spent in Europe, where he experienced works by several artists who had a distinct influence upon the themes and methods appearing in his art works that he produced later in his life. Consequently, many of the artist's works embody

Chester Arnold, *Crossroads*, 2006. Oil on canvas, 72 in x 87 in.
Courtesy of the artist and Catharine Clark Gallery, San Francisco, CA.

the technical methods, compositional traits, and underlying sentiments that one finds in the works by these artists. Specifically, we don't have to look far to find the tragic, earthly, and socially critical sentiment common in the works of Albrecht Altdorfer, Pieter Brueghel the Elder, and Casper David Friedrich. These are clearly major features in many of Arnold's works.

In terms of his painting method, Arnold employs traditional techniques for creating the ground (surface) for his paintings. The system used is laborious, and involves repeated reapplications and sanding of the sizing that seals the surface to be painted. As a consequence, the surface to be painted is both highly sealed and smooth. Both of these traits allow the application of oil paint in the highly detailed manner that serves as one of the distinct traits of the artist's work. The work has an obvious complexity in its array of subject matter.

This painting, like many by the artist, is depicted from an aerial view. This feature is borrowed from the works of Brueghel the Elder, and provides a feeling that, despite the complexity of what one sees, the scene is even more complicated than what is shown. In *Crossroads* the scene is actually more a close-up than a distant view. The method of depiction from above thus adds an element of intimacy, the way one peering closely at something that isn't very far away provides. In the composition we see two old, soggy tire tracks. Within or next to the tracks one finds discarded objects that are common to our culture or the era in which we live. These include a cell phone keypad, a fragment of a chain, a rusted auto muffler, a hand grenade, and a skull. The skull is reminiscent of the seventeenth century vanita paintings done in Holland, where it symbolized the transience of life (we also discussed this above in the chapter on "Assembly Required"). In Holland, however, such an image was more typically combined within a still life of half-eaten food. Here, of course, the image appears with what might be taken as a more modern meal: the "meal of consumerism," with the landscape aspect of the work, in turn, taken as the detritus of modern life.

Taken as a whole, the many "images within other images" that one finds in this painting is one of the attributes that is common in much of the artist's work. Among the many examples of this are the works in the "Accumulation Series." These paintings, done in the later 1990s and early part of the millennium, feature vast and highly complex aggregates of smaller objects joined into a larger shape, such as a ball or a pile. Examples of these include *Thy Kingdom Come* (1999), *Accumulation* (1998), or *Art World* (2000), all of which were featured in a one-person show at San Jose Museum of Art in 2001.[6]

The highly blended paint that is found in *Crossroads* is another of the influences from traditional European painting. This is another common trait in Arnold's works, and is made possible through the unusually smooth texture of the canvas that was created through the extended phases of sanding that occurred before the oil paint was applied.

In all of these works, one gets the impression that the artist perceives the wastefulness of humanity as something totally at odds with nature, and that, regardless of the extent of waste and abuse, nature will win in the long haul. For this to happen,

Chester Arnold, *Thy Will be Done*, 2006. Oil on linen, 72 in. x 84 in. Courtesy of the artist and Catharine Clark Gallery, San Francisco, CA.

of course, would require a natural disaster of cataclysmic proportions, such as the ocean rising twenty feet, resulting in the destruction all coastal cities. To date, humanity has not been particularly effective at reading and responding to the many clues that such changes will likely occur within a short time span. Consequently, Arnold's commentaries are very timely and provide critical insight into the follies present within the dominant (and the most wasteful) cultures concerning the world they inhabit.

One must acknowledge the spiritual dimension in Arnold's works as well. In *Thy Will be Done* (2006) we find the use of biblical wording to suggest the presence of a final cataclysmic response to humanity's persistent destructiveness. The title places the roles of individual humans in perspective, perhaps even suggesting an ultimate inevitability in the spread of decay and poverty that appears to permeate most First World societies. At the same time, this trait also seems to mirror the artist's own lower class upbringing as well as the prevailing rural conditions in his present living environment in an area of the California Sonoma Valley. In this region, enclaves of traditional lower class Americans have lived for many years. With the persistent expansion of urbanization into the valley, the lifestyles and views of the rural people increasingly clash with the more metropolitan personalities spilling into the region. Accompanying the urban sprawl is an increasing gentrification, a condition that is not always looked upon as a

positive improvement by those who have lived there for many years.

In this work, we again see the same aerial view that we saw in *Crossroads*. In the present example, we find that this spatial devise causes things to appear quite close and personally accessible that might otherwise be perceived as distant if they had been depicted using more conventional form of perspective space. There is an equalizing quality to this kind of space in Arnold's work. It is consistent with the otherwise egalitarian theme showing the varied activities of what are obviously ordinary people. The combination of the aerial view, the congested crowd of "regular folk," and the complexity of varied activities associated with these collectively remind one once again of the aerial peasant scenes (and showing feasts, parties, or weddings) found in Brueghel the Elder's works.

Arnold's elevation of the ordinary from the invisible to the sublime might remind one of the writings of John Burroughs, in his testimony on the grand importance of the ordinary in spiritual life:

> One of the hardest lessons we have to learn in this life, and one that many persons never learn, is to see the divine, the celestial, the pure, in the common, the near at hand–to see that heaven lies about us here in this world...

> It jars upon our sensibilities and disturbs our preconceived notions to be told that the spiritual has its roots in the carnal and is as truly its product as the flower is the product of the roots and stalk on the plant. The conception does not cheapen or degrade the spiritual, it elevates and celebrates the carnal, the material.[7]

From Burrough's words, we might conclude that an alternate place to find the spiritual in life is within the earthly and ordinary aspects of life. This is obviously quite different from that conventional Western notion of the spiritual plane, as a lofty ideal place symbolized by the sky, where a deity presides and cares for our eternal needs if we properly follow the rules for entry. In Arnold's work, we are provided access to the ordinary more than the ideal or lofty. Similarly, while we might initially find an apocalyptic vision as the most prominent force in the artist's paintings, as we look longer, we also find inspiration in the countless ordinary subjects shown engaged in their very human actions. It seems to be a complex mixture of horrors and visions drawn from Auschwitz, Kafka's novels, Hieronymus Bosch's earthly delights, Breughel the Elder's peasants, the conflict of economic classes in the Sonoma Valley, and the present world-wide clash between man and nature.

One could fairly ask why the complex, multiple subject matter and stratified readings required for the understanding of Arnold's work is of a higher order than (what this writer considers) the superficial and merely illustrative purposes found, for example, in M. C. Escher's multiple-perception art? The differences are considerable. Arnold's works are not singular in their themes the way Escher's works are. Once one

perceives the "visual trick" at work in each of Escher's work, there is nothing else to stimulate the imagination. In Arnold's paintings, one must continue to ponder the issues raised because the artist provides questions at least as often as answers. As in all works of serious art, life is not treated as something that is reducible to simple issues or simple answers. Unlike those by Escher, Arnold's works inquire into the depths of human experience and struggle. These works are not mere tricks that fool the eye, as we find in Escher. The represent a genuinely complex strata of themes, comprised of a rich combination of meanings that do not flinching in the face of our gravest fears, struggles, and failures as humans. Escher's works might look good on one's wall, and perhaps even inspire a laugh or two, but they certainly don't provide much insight into the human condition in the many ways that we find in Arnold's works.

We also find an equally challenging form of complexity and layering of meanings in the works of Luna Topete. While Arnold's paintings tend to focus upon the exterior environment as the site where human struggle is enacted, Topete's work stresses interior, psychological experiences, even when these are the product of prior external experience or uncertainties.

Among the writers and artists who have had a measurable influence upon Topete is Friedrich Nietzsche. The following comment by the philosopher seems especially noteworthy:

> What then is truth? A mobile army of metaphors, metonyms, and anthropo-morphisms—in short, a sum of human relations, which have been enhanced, transposed, and embellished poetically and rhetorically, and which after long use seem firm, canonical, and obligatory to a people: truths are illusions about which one has forgotten that this is what they are; metaphors which are worn out and without sensuous power; coins which have lost their pictures and now matter only as metal, no longer as coins.[8]

From this statement by Nietzsche, Topete derives a sense of multiple meanings underlying what we normally refer to as "truth."[9] Similarly, the artist perceives memory, like truth, as something embedded within its own history, a subterranean timeline that we carry within us both consciously and unconsciously. Such memories have provided him with the ideational material for much of his work to date. He states that he has been exploring "ideas of intimacy, vulnerability, and (sic) imagined realities," and that these are drawn from "my childhood and specific instances in my past that have shaped my most important relationships."[10]

In *We Never Talk Anymore* (2004), Topete provides an environmental setting within which repulsion and attraction are juxtaposed and inseparable, as elements specific to his personal history and memories. In essence the artist sees human relationships as requiring entry (commitment), but, with this, comes considerable risk. This sculptural work is a room construction in which the exterior is extremely simple but the interior is highly complex. The intricacies of the elements comprising the inside of the room draws one in, yet the 55,000 screws projecting from the floor, walls, and ceiling

provide a considerable challenge to anyone wishing to enter. If one does enter, however, they find that they can actually walk on the screws without the kind of pain that might be expected. Entry into this room represents the equivalent of access into a personal life, and is parallel to the transition into a relationship. The oppositional elements of attraction and separation appear as cohabiting dimensions within the work.

On an obvious level, the interior of the room is a bathroom. On a symbolic level the images presented within the space equate to entry into a relationship. As noted by the artist, a bathroom is a unique space that contains many elements representing our hidden lives. The artist's description of the work begins with identification of the elements and personal implications of a bathroom space, and evolves into a discussion of the constituent parts contained within this space as they mirror personal inter-social experiences:

Luna Topete, *We Never Talk Anymore*, 2004. Mixed media environment with video, 96 in. x 120 in. X 96 in. Photo courtesy Luna Topete.

I used the bathroom because it is a place of transformation…(where one can) alter themselves physically by putting on makeup, shaving, or combining their hair. A person can also alter his/her mood by (using) the medications kept in the medicine cabinet. It is a place where both the exterior and interior parts of the body are cleansed. The bathroom is also a place of privacy and solitude. The screws are representative of the personal baggage that one carries into a relationship. This baggage can keep someone from entirely immersing his/herself in a relationship (like a viewer who timidly puts one foot into the piece), or a person can accept the baggage in order to get the full experience of the relationship. One must make a decision for his/herself (by risking) injury, both physical and emotional, or (by) simply (walking) away (by risking) nothing.

The medicine cabinet represents our personal, inner selves. It contains those things we don't let the public see, including medications, ointment,

and other embarrassing products that we fear might reveal our true selves to the world. I put a small monitor in the medicine cabinet that shows several women having conversations and, ultimately, relationships with the camera. These women become ideal, unattainable. (These) images of lust and desire (transform) the medicine cabinet (into the equivalent) to the id, (representing our) unconscious desires of wanting, looking, and examining.

The bathtub is a place where one cleanses oneself. It can become a rebirth or the site of a religious baptism ceremony…one can also come out of a bathroom spiritually transformed. Projected into the tub (a video of) a wedding that starts out at regular speed but gets progressively slower as the ceremony continues… the bathtub is open and cannot be closed like the cabinet. It becomes the public persona. The wedding has a sense of conformity. It represents one of the rituals in which we, as a society, believe we should take part.[11]

While some viewers have found the layering of highly personally charged meanings resistant to easy access and understanding, such complexity does not necessary mean the work is of less value than other works by the artist that are easier to read or more impersonal. Nonetheless, the poignant interplay between what is ultimately a fascinating array of personal images in the interior space and the difficulty in gaining physical access to them due to the 55,000 screws poses a highly charged atmosphere for anyone interested in the unique tension that such a contradiction introduces. Furthermore, few could argue that the essential concern for layered meanings represented by what we have called the Rashomon Factor is not amply demonstrated by this work. Toward this end, the presence of various combinations of imagery related to personal human experiences, and by extension their psychological implications, are clearly presented both in the work and in the artist's underlying purposes, as quoted above.

Luna Topete, *Contemplating My Next Move*, 2006. Mixed media with video, 96 in. x 48 in. x 48 in. Photo courtesy Luna Topete.

The artist's Recollection Series continued the interest in the construction of box spaces as visual parallels to the nature of human relationships. The series is comprised of two works: *Contemplating My Next Move* (2005)

and *As Much as I like to Dream It* (2005). Both works draw upon personal recollections from childhood, though initially in an unconscious manner. Both works measure 8 X 4 X 4 ft. in size. The exteriors, again, are in simple box form, but the interiors, in both instances, involve a video projection of imagery on the back wall, covering the entire wall surface. The video is triggered after the visitor enters the box and closes the door. The illustration above is pictured with the video running and with a figure standing inside the box, but with the door open, in order to show as much as is possible of the work. The video used in *Contemplating My Next Move* is comprised of a dynamic image of wasps suspended in beeswax, and lit from behind.

By entering the box, the viewer is transported into a space comparable to a large hive. Childhood recollections and fears that one might have (as most of us do) about bee and wasp stings are forced into the foreground of one's thoughts through the total emersion within a community of wasps presented on a grand scale. The backlighting of the hive portion glows with an iridescence giving the appearance of an even greater lifelike presence than if it had been on the scale of an ordinary hive and unlit. For the artist, the similar imagery in *As Much as I like to Dream It* evoked memories of stings from his own childhood in Mexico while visiting his grandmother. The recollection of this memory, in turn, was inspired by Topete's reading the following comment by Carl Jung on his idea of the long-term role of memory in our lives:

> Forgetting, for instance, is a normal process, in which certain conscious ideas lose their specific energy because one's attention has been deflected. When interest turns elsewhere, it leaves in shadow the things with which one was previously concerned, just as a searchlight lights up a new area by leaving another in darkness. This is unavoidable, for consciousness can only keep a few images in full clarity at one time, and even this clarity fluctuates.

> But the forgotten ideas have not ceased to exist. Although they cannot be reproduced at will, they are present in a subliminal state–just beyond the threshold of recall–from which they can rise again spontaneously at any time, often after many years of apparently total oblivion.[12]

The following interview provides additional insight into the Topete's art works. It also gives us additional understanding of the complex layering of meanings that typically comprise individual works that he has produced.

INTERVIEW[13] - LUNA TOPETE

JD: Your work has evolved from a stress upon photography to include mixed media and environmental installations. What were your reasons for these changes?

LT: I felt that photography was limiting what I wanted to put forward and portray to the viewers of my work. Everything has to be so clean and neat in photography, and I needed to have more control over and creativity in my art. Mixed media was a natural segue from photography that allowed me to be more creative, but it lacked the spatial feelings that environmental installations provided.

JD: I am especially struck by your cubical environment that you entitled *We Never Talk Anymore*. Can you discuss this work? What general goals or content were you after in this work?

LT: The idea of the bathroom goes back to my childhood and my experience of having no privacy, because I slept in the living room. To me, the bath-room means privacy and isolation, and I would go into that room when we had company and I needed a quiet place to retreat. This was fairly often.

Because it was such a private place to me, and I spent such a lot of time there, it became a place of refuge during my times of conflict— a sanctuary as it were. While there, I examined the bathroom for hours and eventually this kind of environment morphed into an area were I began to examine my inner world. It became a room where I could meditate and find solace. In essence, it became a metaphor for my head.

I've been working with this metaphor for a few years, photographing bathrooms in different ways. Once I began to feel that it was time to let go of the idea, it became necessary to go to the next step and create this room as an actual environment.

We Never Talk Anymore was my closure. At the same time, the work was a sort of confessional. It represented a series of relationship crises in my life. I allowed the viewers a peek into my head to see how I viewed my own reactions to these crises. At the same time, the work allowed others to feel a commonality with how I felt.

JD: This work has nails projecting from the floor and walls. Why? Are you trying to discourage entry, or simply make it difficult for everyone except for yogis who might be accustomed to walking on nails?

LT: The bathroom is a metaphor for my mind and my reaction to relationships, and the nails represent the perils and obstacles we all face when we go into a new relationship. There's nothing that prevents the viewer from entering the space, and there is no specific encouragement

for them to do so. I leave it up to the viewer to enter the space in a manner similar to a decision s/he might make about going into a relationship.

I put 55,000 screws in the piece. I placed them one square inch from each other over every surface that was not covered by an appliance. I imagined it was a sort of penitence or atonement for the things I've done in prior relationships.

JD: What reactions have visitors to this piece expressed? Do they enter it? If they don't, what are their reasons?

LT: Most people have not entered the space. Many have been confused when viewing the it, and did not know if they could enter because there was no signage to direct them. I also believe that they did not know whether they wanted to enter, or whether they were even able to, due to the screws.

JD: The use of nails also relates to some smaller box sculptures that New York artist Lucas Samaras created about twenty-five years ago. He had first created box environments into which one could see due to transparent (and visually accessible) walls. But then, after making these for a few years, he created some with nails and other threatening objects projecting outwardly, seemingly to deflect one's experience of the image. Are you familiar with these works by Samaras? It is obvious that your works are life sized while his are quite small, but are there any relationships between his work and what you have been doing?

LT: Yes, I am familiar with Lucas Samaras. I believe that we both want to control the viewers in ways to make them interact with our pieces. There's also a sense of intimacy, with his boxes being so small and my boxes only being large enough to accommodate one or two people at a time.

JD: This piece has a video that shows on a very small screen inside the medicine cabinet inside the room. What is the general content and purpose of the video?

LT: Building on the idea of the screws, the video was used to further confess my infidelities to the world and contained images of women who represented the females that I was involved with when I was married. Like secrets, the medicine cabinet represents the private side

of a person that one keeps from the public and contains items that are not discussed, like deodorants, medicine, and ointments.

JD: I note from your website that your website Artist Statement mentions the deconstruction of symbols from your childhood memories. Can you share any of these memories, and did any of them relate to this piece? Also, were the nails on the inner surfaces of the above piece to protect your personal history and experience in any way?

LT: As already mentioned, the bathroom is a metaphor for refuge, a space where relationships and the dynamics with parents, siblings, lovers, and friends–as well as my experiences with the Catholic Church, and especially the confessional–are all deconstructed from memories. These thoughts resulted in the symbols and images that appear in *We Never Talk Anymore*. The purpose of the nails was actually the opposite of a form of protection of my personal history and experiences, as I've already explained. If anything, they exposed a lot of my personal baggage.

JD: You also mention in your website Artist Statement that your work "glosses over these youthful representations the way in which we all tend to polish the recollections from our less-than-ideal pasts." I find this to be an extremely honest statement on the way we, as people, change, polish, or even embellish our experiences when recounting them to others. The entire topic of this chapter of the book is called "The Rashomon Factor," and is derived from a Kurosawa film called *Rashomon*. The story feature four people who directly witnessed the same tragic events, but all of them give dramatically different accounts of what happened. In the film, the "testimonies" of these witnesses were ultimately more about the personal explaining their experience than about the events they purported to describe (the film involved a court proceeding in which there may have been a murder or suicide, on the one hand, and a rape or seduction, on the other, depending upon which character one believes). Your statement seems to parallel these circumstances. Can you comment on this phenomenon and also how it might relate to your art works?

LT: Growing up, I would observe things that happened and tell my mother. If my observations were negative, she would often contradict my interpretation of the events. This puzzled me greatly, since I was pretty sure of what I saw. As a result, at an early age I came to realize that truth was subjective and that everyone remembers things differently. I also realized that my mother chose to remember

events that were easier for her to accept, and that most of us also interpret our experiences more as ideals than as realities. I re-contextualize my past and recreate it to parallel my memories, while at the same time being aware of what I'm doing. For example, *We Never Talk Anymore* is presented in the way that I felt about the experience, but I'm sure my ex-wife would have a whole different take on what happened.

JD: Can identify any other important features in *We Never Talk Anymore*, and also address their purposes or meanings if there are any?

LT: The integration of the work into the gallery space was done so that the viewer could stumble across it and, upon finding it, become surprised by the piece. I did this because, as in relationships, we often come across social connections when we least expect to.

JD: In *Relation{ships}* your work appears in the form of an inaccessible, closed wooden box. When I saw the piece in the Art Gallery this spring, I asked the gallery attendant whether I could open the box (having remembered that you allowed people to physically enter *We Never Talk Anymore*), and she said "No." Should I have insisted? Could it have been physically opened?

LT: It was not meant to be opened. The intent was for the viewer to question what's inside. The boxes represent my family portrait, and, as is the case with most families, the true family is not accessible to outsiders.

The closed boxes allow the viewers to make up their own narratives as to what may be inside each crate. This is similar to instances when we look at a portrait of a family that we don't know and can't actually see for what it is; we usually draw our own conclusions about those in the picture based upon what little we do see. In the same way, I wanted the viewers of *Relation{ships}* to draw their own conclusions about the contents of the boxes.

JD: In *Contemplating My Next Move* the door of a similar box does open, and inside is a video image. Can you describe both the content of the video, how you made it, and how it was intended to relate to the structure of the piece? Does this video relate to the memories you mention in your website Artist Statement? If so, how?

LT: *Contemplating My Next Move* was the first in the *Recollection Series*. The structure was a 4' x 4' x 8' plywood box. The video was a projection of wasps suspended in beeswax and was 4'x8', covering the entire back wall. I also included a multi-layered, rhythmic sound that fluctuated so that it would float in and out of an individual's consciousness while in the booth. The smell of beeswax was evident as well.

The video of wasps, and the sounds and smell of beeswax were all recollected from my memories of being in Mexico as a child, running around and catching bees. Oddly, the piece was almost completed before I understood the references between the memories and the work.

JD: The video image in this piece is very large in relation to the size of the box, especially if compared with the very tiny video in *We Never Talk Any More*. The video covers the entire back wall of the box, almost as if was but a window onto a vast panorama. Was this deliberate, and, if so, what is your perception of the vast world that it implies?

LT: Yes, it was deliberate. In *We Never Talk Anymore*, I tried to coax the viewer in. In *Contemplating My Next Move*, the viewer was only able to experience the video in an overwhelming state. This is because when I was in Mexico, I was only three or four years old, and the event of catching bees was huge in my memory. As a grown man, the memories, as represented in *We Never Talk Anymore*, were not as intense to me. As adults we become desensitized to the world around us, so our memories are not as concentrated as they were when we were young.

JD: In *As Much As I like to Dream It* you continue to inquire into an alternate world that is alive with light and organic matter, similar to what we found in *Contemplating My Next Move*. What kind of imagery did you intend for the video portion of this piece to convey? Does it relate to the childhood memories, and, if so, can you comment on this too?

LT: Like *Contemplating My Next Move*, I was working instinctively on *As Much As I Like To Dream It*. This piece involves the encasement of bees within wax and has a rear projection of differing densities of light. It also refers to memories in their infancy. These memories are not yet formed. *As Much As I Like To Dream It* does not refer to one particular childhood memory, but to childhood memories in general.

This goes along with Bill Viola's idea of the "beginning of knowing" in his piece, *First Sight*, where he focuses closely on the eyes of a newborn infant. You can see the baby looking around for the origin of the sounds he hears in the nursery of the maternity ward. The baby knows there is something going on, but does not know what's happening. I discovered this piece by Viola after the completion of *As Much As I Like To Dream It* and realized the connection.

JD: Most of these box-environments seem to be done as a series, as does the videos shown within them. Can you comment on their cohesion? Are they intended to be collectively experienced as a complete narrative in sequence? If so, what would happen if one of the pieces was removed from the series? Would the overall theme be destroyed or significantly altered?

LT: These boxes are a set of childhood memories and do not have to be viewed as a linear narrative. In the same way one experiences a childhood memory, each box represents the way one can go into a particular remembrance at any time. The boxes do not have to be experienced in a particular sequence nor viewed in their entirety. These boxes can be interchangeable like our memories often are.

JD: Are you finished with the box series? If there are more to come, do you have any specific plans for the new ones?

LT: Yes, I am finished with them. I felt as though I came to the end of this particular exploration.

JD: Your environments all seem to possess layered meanings that require time and contemplation to absorb and understand. Even as constructions, this series is a physical layering that combines a relatively equal emphasis upon the exterior and interior spatial characteristics (even though each is obviously quite different from the other). In the case of *We Never Talk Any More*, there are many layers of materiality inside as well (first the inside, then the nails, then the medicine cupboard, then its medicinal contents, then the video machine, then the video shown within the machine, then the psychological worlds that the video enters through its inherent narrative, etc.). Do you agree, and can you address this?

LT: I do agree with your assessment of the layered meanings of my work. This is how I view the world. Each memory is not singular. We all bring

baggage into a situation, including our feelings of isolation and our fears of rejection and losing control, our failures and infidelities, and the conflicts we all have between our public and private personae. I used the best materials I could to represent the psychological nature of the ideas. These materials, therefore, became the remnants of what is left over from the process of remembering.

JD: Can you describe the layers of meanings in one or more of these works?

LT: While *We never Talk Any More* dealt with purely mental layers of my memories, *As Much As I Like To Dream It* encompasses memories of my senses: the aroma of the beeswax, the visual projection of pulsating lights, the rhythmic and atmospheric sounds, and the tactile texture of the actual bees encased in the wax. These all lent physicality to the layers of my memories.

JD: Are there any artists or culture theorists who have had a significant influence on your work? If so, who and in what ways?

LT: Bill Viola and ASCO both significantly influenced my work.

Bill Viola, in his videos, focused on circumstances that naturally occur (e.g., his implied self-portrait in the form of a newborn baby juxtaposed with a separate portrait of his mother on her death bed). His work affected me because he could look at an everyday event and really examine it. Certain situations affect us even though we may not know it at the time. Viola is able to pinpoint those conditions that make us turn corners, while the rest of us can only tell they are focal points in hindsight. He seems to have the ability to supersede the memory part and focus on important situations instinctively.

JD: Are there any further comments you can make on the purpose or nature of the box-environments?

LT: No. You were pretty thorough in your questions, and I can't think of anything else to add.

This chapter focused upon what we have termed the "Rashomon Factor." We traced this phenomenon to a film entitled *Rashomon* that was directed by the Japanese director Akira Kurosawa, and also to its origins in earlier works within the Japanese literary tradition. We defined the Rashomon Factor as a form of creative

hybrid that stresses complexity through the combining of multiple meanings within select works of recent art. We noted that the Rashomon Factor was also a characteristic within the world, itself, so that its appearance in the visual arts may be understood as an extension of experiences that we normally have in our daily lives. We then discussed recent visual art works by Chester Arnold and Luna Topete, and noted how both artists naturally lean toward a complexity and multiplicity of meanings in their work. Due to unique traits discussed in terms of works by each of these artists, we had opportunity to encounter ways in which these works are readable in several ways at once. With Arnold, these meanings are the product of destructive and ludicrous forms of human actions in the contemporary world. Conversely, we found a different form of complexity and meanings in the images combined in the work of Topete, with these reflecting the nature of personal thoughts and memories that are formed through our personal relationships.

While this chapter has stressed examples of works in which the images were derived from within the single lifetime of an artist, our next section will address displacements of images across the thresholds separating distinct periods of time. We will refer to such works as "Chron-illogical." Combinations of images from separate time frames will be approached as a distinct form of hybridization, and one in which a non-linear view of time will be a dominant feature.

THE CHRON-ILLOGICAL TIME:
A Woman's Take on Manet's *Olympia*

We have all some experience of a feeling, that comes over us occasionally, of what we are saying and doing having been said and done before, in a remote time–of our having been surrounded, dim ages ago, by the same faces, objects, and circumstances–of our knowing perfectly what will be said next, as if we suddenly remember it!

– From Charles Dickens, *David Copperfield*

There is nothing new under the sun.

– Old adage

Psychologist Arthur Funkhouser has noted that statistics indicate over 70% of us have experienced an event, feeling, or place that we feel we had encountered before, even when there was no evidence that the prior, "twin" event even occurred. Funkhouser also has concluded that such experiences of *déjà vu* actually appear in three different forms. In order to avoid the blurring of important distinctions, he proposes that we acknowledge the variants, and employ them to more precisely identify the nature of each, rather than lump them together. The three forms he identifies are: *déjà vécu* ("already experienced"), *déjà senti* ("already felt"), and *déjà visité* ("already been there").[1] The distinctions between experiences, general feelings, and places that these categories specify lends some clarity, although I'm sure most of us would agree that the entire notion of thinking we've experienced something before is still rather ambiguous.

No matter how we feel about *déjà vu*–whether we believe it really "exists," and whether our own encounters with it are legitimate–we must admit that many things do seem to "come back" in one form or another. Whether they come back to haunt us, or come back to enrich us, may be a matter of how one learns from experience. It's like the old saying that "things that go around come around." It's almost a given that we will confront very familiar people, events, and works both in life and in the arts.

In recent years the term "appropriation" has been widely used to identify works of art that borrow from prior works by other artists, especially those from previous historical periods. Some argue that such borrowings–along with other parallel methods, such as altered images, staged scenarios, and the like–are among the main traits of postmodern art and society. Such individuals tend to claim that appropriating the ideas of others is a sure sign of decadence, and that artists who employ images from the

works of prior artists, or others, must be devoid of any ideas of their own. In a book called *The End of Art*, one such critic, Donald Kuspit, states:

> The sense that one is watching the eternal return of the same, involving ironic apathy–the viewing of every new breakthrough and experiment as the latest coy fashion in the wardrobe of the emperor's new clothes–is the symptom par excellence of postmodern entropy. [2]

Of course, we do (or should) realize that not all art in recent years that has been mere "echoes" of the past. Nor have they been the vapid repetitions that Kuspit so clearly abhors (see the discussion of Kuspit's related fears of the blurring of art and life discussed previously in the "Art in the Petri Dish" chapter). In fact, many "post" expressions (that is, works that are responses to prior expressions) are built upon the visions of others. One could easily construct a case that both modernism and post-modernism have co-existed simultaneously throughout the so-called "modern period." And, if we look closely and honestly at the past (whether it be in modern or pre-modern eras), most artists have carefully studied the work of both their peers and their creative ancestors, and their subsequent work was informed in a way that derived from this dual awareness. Amidst the furor toward borrowing and altering prior ideas or images, one is reminded of Renoir's admonition that aspiring artists should "study and copy the old masters." It can equally be said that nothing–no work, no idea–has been produced within a vacuum, with no influence whatsoever. In fact, absolute originality is an illusion. Even memories are carried from outside the walls of thought and into the arena of creative speculation. Jean-Francois Lyotard observed an interchangeability between past and present, stating this with a perversely simple claim that:

> A work can become modern only if it is first postmodern. Postmodernism thus understood is not modernism at its end but in the nascent state, and this state is constant.[3]

By standing time on its head–like reversing dawn and dusk–Lyotard shows that the very conditions that are necessary for new ideas to emerge and flourish are at the heart of the postmodern condition as a reaction to the past. This, alone, can provide a basis for a future, just as they have in the past, even if one can't exactly predict what that future will be. For modernism to begin in the first place required someone to perceive a prospective condition of "post-something."

So why are borrowings from the past suddenly considered a sign of decadence? And why was it all right for Picasso to "borrow" the images of African masks, or the faceted geometric system for structuring a painting from Cézanne, while it's not acceptable for artists to borrow from prior artists today? What has changed?

It is doubtful that the mere act of borrowing from others is the sign of the "death of art" or, by implication, the downfall of culture as Kuspit insists. But it certainly is possible to claim that demands for superficial novelty have come to increasingly

dominate culture, including the arts. But even given this sort of decadence, are the borrowings from the past really any more frequent now than in the past? And is the reticence toward appropriations because these borrowings more frequently parody the "original" than they did in the past? If so, why is it bad to criticize the past, and especially if it is applied toward revisions of that past in order to create a better future?

This must be said: aren't those who are in denial about the existence of a post-modern current reminiscent of those who mocked art during past eras because it didn't conform to their own preferences?

One answer may be found in our far-too obvious addiction to newness that the entire modernist era has persistently demanded. Modernism essentially became an extension of material culture by mimicking its demand for constant newness. We became accustomed to new forms of art just as we came to expect new cars and new clothes designs, new computers, and new software that ran faster or with more flash (when they worked), new cell phones with new gimmicks in them, new everything. Fetishism for the new (read novelty here, rather than substantive new ideas) is as superfluous as fetishism for repeating the past. It seems preferable to take something old that can at least be counted on to work. And it also seems preferable to do funny things with our appropriations of these borrowings from the past.

Of course, even when things seemed relatively new during past periods, they actually weren't. Picasso's Cubism must have seemed quite new at the time it first appeared, yet, as we already suggested, it was also clearly an outgrowth of the faceted geometry commonly found in traditional African masks and sculpture, as well as a continuation in the refinement of the fusions of geometric facets to be found in the precedent of Cézanne's late nineteenth century works. And these same "new" works by Picasso seemed to also be establishing ways of perceiving reality in a way that was informed by hypotheses on "relativity" and "simultaneity" appearing first in the physical sciences and then in the social sciences during the same period. All of these things already existed, or were emerging, when Picasso "invented" Cubism, so we must concur that they all provided the foundation for it as well. Varying degrees of "borrowing from ways of seeing and knowing" have always been in effect–though not always on a conscious level–no matter how "original" works of art may have seemed when they "first" emerged.

One final observation on the topic of appropriations concerns the awkward choice of this term for use in critical dialogues on the arts in the first place. When first applied in the context of art criticism, the term was intended to identify the borrowings and subsequent transmutations of these borrowings by artists. But the term is actually a misappropriation in itself. Prior to its application in the sphere of the arts, the word was far more suitably associated with corporate takeovers, political power, government budgeting, and the like. These conditions are entirely distinct from the ways artists borrow images or ideas from other artists and always have. To be sure, taking ideas from others and using them as if they are one's own ideas can be considered a mirror of the taking over of other cultures or ideas from other peoples that has occurred throughout the ugly colonized past. But it is equally true that all artists borrow, and all

art is influenced to some degree at least by the work of others, both from within and beyond one's own culture. It is clear, too, that the process of borrowings increased during the 1980s. One wonders how much this phenomenon increased because of the increased awareness we have all had of others in our rapidly "shrinking world," and how much was due to some massive increase in artists capitalizing on this awareness for evil or selfish purposes. We must also factor in the matter that all things (fashion, food, music, everything) have become increasingly hybridized as the result of global mixings since the 80s as well.

The bottom line seems to always be the question of whether borrowings are for legitimate reasons or not. We all do it in countless ways in our thought processes, the ideas we consider, the food we eat, the ways we dress, the languages we speak. When adopting, and integrating, aspects of any ideas, inflections, appearances, or any other qualities from others in our own culture, or from other cultures, doesn't in itself make the person who is borrowing a criminal. Individuals within cultures from throughout the world are using the ideas and images of those from outside their own culture every day. Merely because this author lived for many years in Middle America doesn't mean I must only eat pork, corn, and mashed potatoes. One must always look closely at the result of borrowings, and carefully consider the quality and purpose of the resultant hybrid. Is it of high quality? Does it have inherent purpose? Does it express something meaningful in and of itself?

We will now turn to discussion of examples of works that employ relocations of images from prior contexts to new ones. We will find that, in the process of these transplantations the nature and meaning of the original image(s) tend to change significantly, and that this must be considered an essential trait for such appropriations to be purposeful and successful. Transplantation alone is not adequate reason alone; such purpose is found in the unique ways that new meanings emerge when the images have been relocated and redefined in their new contexts.

Jessica Walker's *Olympia Emerging* revisits a very well known painting by Édouard Manet similarly titled *Olympia* and created in 1865. Manet's work was based upon another, equally well known, Renaissance piece by Titian called *Venus of Urbino* (1538). The Titian painting, in turn, was based upon the even earlier reclining nude figure entitled *Venus* (1510) by Giorgione. This long history of thematic reiterations indicates the entrenched nature of the theme of the reclining nude in art history in Western culture. It is also notable that Manet, Titian, and Giorgione were all male artists, and all stress the figure as a reclining nude having almost identical gestures and positioning involving her arms and legs.

Most critical discussions of Manet's version of the reclining female nude have stressed the frank way in which the figure lies on her bed looking unabashedly out upon our world, thus challenging us to perceive her as a real person as opposed to a fictional one. However, the Titian and Giorgione versions are at least as risqué in their presentations of the nude female figure. Few writers have chosen to openly discuss their works in this way (an exception may be found in the writing of David Freedberg quoted below). The changes made by Manet, in short, are rather minimal

22. Jessica Walker, *Olympia Emerging* (general view with figure shown activating sensors), 2005. Interactive installation combining photo-projection, sensors, video projector, room size. Photo courtesy of the artist.

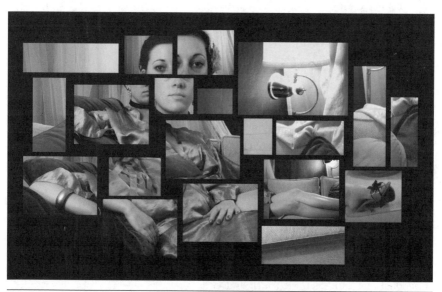

23. Jessica Walker, *Olympia Emerging* (close-up view of completed image of figure), 2005. Interactive installation combining photo-projection, sensors, video projector, room size. Photo courtesy of the artist.

compared to those made by Walker in her effort to take an even more dramatic step "away" from the much earlier versions by Titian and Giorgione. But before discussing Walker's significant departures from the established traditions constituting reclining nude females, it would be profitable to first consider some of what Freedberg says about the Titian work:

> A male description of what appears to be a main object of the picture, of what by any reckoning any describer would count as the main focus of attention and (one might suppose) the main focus intended by the painter, could run as follows: a naked young woman looks frankly at the beholder; her chestnut tresses fall over her naked shoulders; her nipples are erect; with her left hand she only half covers her pudenda–she almost toys with them–while the shadow around them suggests (if it does not actually indicate) her public hair. She is completely naked except for the ring on her little finger and the bracelet around her wrist. The sensuality of the representation would have been plain to many and may well continue to be so. But not many will admit to this–at least not if they are well schooled. The texts and monographs mostly avoid acknowledging the overt sexuality of such painting; the obfuscations are extraordinary.[4]

It's very hard to deny the blatant sexuality acknowledged in this accounting. This author has never heard of any critical statement about the Manet version except in glowing terms, even though that artist's version along with the two earlier ones by Titian and Giorgione, are actually far more similar to each other than the more recent interpretations by Walker is to any of the three works.

Walker's *Olympia Emerging* is an installation piece, and requires an entire room (or most of one at least) to be experienced. When one first enters the installation room, a video projector illuminates a grid of empty rectangles. Through the varied movements of the audience member(s), sensors respond to these movements, with select preprogrammed gestures resulting in the rectangles gradually filling first with fragmented line drawings, and later fully colored sections, that collectively will eventually form the total picture. As the audience members continue their movements in response to the emerging figure fragments, the line drawing transforms to a fully clothed reclining figure, one that is dressed in a bright green robe.

In Walker's piece we find at least eight major changes that significantly depart from the Titian and Giorgione versions, and their later counterpart in the Manet. These changes involve both the work's content and methodology. First, the female image and its environment are the result of the use of a photograph of an actual person reclining in a real space, not a fictional one. Secondly, the Walker version engages an entire room as an environmental installation, extending beyond the boundaries of the "painting" itself. This is totally different from simply being a picture hanging on a wall; it enters our space and we enter its space, again extending beyond the limits of a framed picture alone. Thirdly–and this is certainly one of the most critical departures–this

interpretation presents a dynamic perception of the reclining figure, one that evolves in many stages from an initial grid of empty rectangles suggesting no presence at all, to a completed figure that is readable as a complex array of completed rectangles. Fourth, and equally significant, is the requirement for an active interaction between the viewer and the work, which was totally absent in the two earlier works. In fact, this aspect deviates dramatically, from a perception of a female as a passive image deployed largely for titillation of a male gaze, to a dynamically engaged one, one that is inseparable from the active "dialogue" required to engage the process of its appearance in the first place. Fifth, since Walker invokes considerable collaboration with an audience through the necessary activation of the various parts of the work comprising the overall image, the work is not only dynamic but requires a group effort (work + audience) to be understood and experienced. Sixth, the work requires a considerable extended period of time to actuate, unlike the relatively instantaneous impression one can gain from looking at the still image of the figure found in the versions by Titian, Giorgione, and Manet. Seventh, the figure that eventually emerges is fully clothed; this further detaches the theme of a reclining female from its prior moorings as an exposé of female flesh. Lastly, there are no servants shown in the background, and the reclining figure thus assumes the role of ordinary person, with no aristocratic connotations.

These eight differences are clearly features that are consistent with the fact that the artist who created the work is female. It is also significant that the differences that we noted are both "feminine" and "feminist" traits. The aspects of gesture and tactility required to activate the various stages in the work, along with the extended period required to come to "know" the image, are both obvious feminine traits. The collaborative aspect, along with the presence of a dynamic (rather than passive) image, combined with the image's inherent complexity and spatial inclusiveness, all invoke further feminist ideals of equality, strength, and dignity of presence.

The "new" image of the reclining female presented by Walker is no longer the goddess that we find in the Titian and Giorgione, nor the flaunting woman of the street we find in the Manet. In place of these extremes we find a person, one far more human, one who was photographed and who we come to know in stages over an extended period of time. One could easily argue that, while light switches are male-like (abrupt and predominately actuated through relative "on" and "off" modes), gradients are female. Similarly, the collaborative aspect of the unfolding, the deletion of a colonized sub-strata within society that was featured through the background servants found in both Manet's and Titian's "male versions," the emphasis upon collaboration to complete the work, along with a focus upon sensuality more than blatant sexuality in the presentation of the figure, are all among the "female" features distinguishing Walker's version.

The re-making of this traditional theme of the reclining female figure is extremely justifiable given the extent and importance of the new attributes that Walker successfully infuses into the work. One cannot justify Manet's "extension" of the very similar sentiments that he continued from the earlier Titan work, and simultaneously

deny the Walker interpretation when, in fact, hers is not only more dramatically unique, but also more consequential in terms of the significant changes in the roles and perceptions of women that are manifested in her work.

The artist provides the follow commentary on her version of the work:

Olympia Emerging is an interactive installation that utilizes a gesture-based interface. The participant enters the space where they are presented with a projection of several white boxes arranged in a grid-like fashion. A red ball on the projection screen mimics the participant's motion indicating where they are within the virtual space. As the red ball intersects with the white squares animation sequences are triggered. Each animation develops into a drawing, a painterly representation, a photograph and finally a video. In this sense the image gains complexity according to the amount of time that the participant chooses to interact within the space. Each square develops independently which emphasizes multiple perception and simultaneity, themes often associated with Cubist painting.

Édouard Manet painted his controversial *Olympia* in 1863. It was not received lightly by the French Salon and had to be securely guarded for fear that it would be destroyed by a disgruntled art-viewing public. Manet intended to mimic Titian's *Venus of Urbino* but altered the themes of beauty and purity by replacing the goddess with a provocative, nude prostitute. Many art historians would agree that because Manet intended to provoke traditional notions of classical aesthetics that he is consequently one of the first Modernist painters. Manet emphasized the psychological intensity of the female through her provocative pose and curious demeanor. She peers outward in a deliberate and direct gaze initiating a dialogue between herself and the viewer.

In recasting Olympia as the subject of this installation it is my intent to further empower the female. Whereas Manet emphasized her stark glare through paint, I further articulate Olympia as the viewer through the function of the motion detection camera. Through the camera lens she gains intelligence and a sense of control over the participants, reading their movement and in turn gradually revealing her levels of complexity. The intersection of the participant's physical body with that of Olympia's virtual body suggests a corporal yet ephemeral experience. The image does not develop as a unified composition. It emerges in sectioned fragments much like a puzzle, but one that continually builds itself up only to break apart. Traditional artwork, especially that of the classical nude female, typically remains stagnant on the gallery or museum wall. My hope is that through the use of this gesture-based interface new dialogues will be initiated between the viewer and the viewed.[5]

As we can see, Walker's Olympia is activated in stages, not all at once. This is necessitated by the fact that the figure is constructed from a cluster of smaller, fragmented images. It is not so much that the fragmentation alone legitimizes the image, or that it somehow correlates to Cubism (and thus placing it in some modernist framework). Rather, the fragmentation adds an element of multiplicity, complexity, and hybridization to the image that neither of the earlier versions even pretended to possess. In this case, the grid structure that fragments the figure and its surrounding space operates less as a Cubist devise to integrate figure and ground, as one normally perceived in Picasso's or Braque's work during their Analytical period, but it introduces an element of anticipation and performance to the work. This never would have happened if the figure had simply appeared (as a whole) or disappeared (as a whole). Instead, one is drawn into the drama through an evolving process of appearance and/or disappearance. These stages are every bit as important as the final figure to the experience of the work because each stage continues to invite one's interaction as in a performance. If the work unfolded in totality all at once, that would not draw one into the process; it would, instead, be like a light switch.

Walker's version of the Olympia also reminds us of how the form of music referred to as jazz is almost always based upon the repeated use of standard (highly familiar) songs familiar to everyone, but does so through infinitely nuanced forms of interpretation that are never repeated the same way twice. Similarly, Walker's reclining female version of the Olympia theme is significantly different from other versions of the Olympia theme. While there has indeed been a long history of reclining nudes relating to this theme, the many examples all bear far more resemblance to each other in the terms we have been discussing here as male-produced images than they do to what Walker has instilled into her version of the same theme. Her work comes to life through a convergence of several features that include internal nuance, a female perception on the theme, and external audience interactions. The obvious fact that there is a reclining figure, taken alone, is but a minor matter when compared to the many new concerns that have been noted above.

We have seen in this discussion on Walker's work how the interpretation of a traditional theme–specifically the reclining female figure–can be utterly transformed to represent significant new meanings. These have occurred through the use of new media, collaborative interactions with an audience, a dynamic building of the overall figure image through sequential changes that employ localized constituent parts, the distinct ways in which a female might approach the depiction of another female when this is the subject in a work of art, and infusion of a performance dimension that is exposed when one experiences the emergence of the image within the piece over an extended period of time.

There are, of course, other purposes and methods used for the selection, transformation, and integration of images borrowed from past art works. This is not an unusual interest in contemporary art, and is frequently among the traits critical writers frequently identify as common within the postmodern era.

The underlying framework for this chapter has focused upon some of the general factors associated with the transplanting of images from works of art from prior historical periods, and the integration and transformation of these when they are combined with other images and ideas that are contemporary in nature. We stressed as our primary example a work by Jessica Walker that redeployed the theme of a reclining female figure, specifically from Manet's famous Impressionist work entitled *Olympia*. We also discussed unique ways in which Walker transformed Manet's earlier interpretation, by using methods that mirror her own perceptions as a female artist. These changes I perception and expression reflect some of the significant ways in which women perceive images of other women in ways that are entirely different from that of men. In the past, almost all images that depict the reclining female form have been created by men—with very well-known ones being by Titian, Giorgione, or Manet—with these works reflecting their gender's distinct tendencies in forming perceptions of the female body. In our next chapter we will now turn to a somewhat related form of hybridization, one that involves the rediscovering, combining, and resurrecting of images and/or materials that have been previously rejected by our society. We will collectively refer to work of this sort as "The New Salon des Refuses."

THE NEW SALON DES REFUSÉS:
The Phoenix Factor in Works by
Brian Goggin and Mildred Howard

As the waste piles up in the United States, above and below ground, contamination of America's fresh water supply from e-waste may soon become the greatest biohazard facing the entire continent.

> – Giles Slade, in *Made to Break: Technology and Obsolescence in America*[1]

If I seem to be over-interested in junk, it is because I am, and I have a lot of it, too—half a garage full of bits and broken pieces...I guess the truth is that I simply like junk.

> – John Steinbeck, *Travels With Charley*

Few people realize how simple it is to create the essence of the earth. Here's how: spread some straw on the ground so that the pile to be built may breath from the ground upward. Then apply a layer of leaves from the fall leaves, or cuttings from lawn. Then distribute a layer of kitchen refuse, plant cuttings and any other (non-meat) organic matter over the top. Next, sprinkle very thin layers of bone meal, blood meal, and raw natural lime over the surface. Flick a small coating of already existing earth on top of all of this to "seed" the materials with nutrients, like the bit of "culture" one saves from one batch of French bread and adds to the next. Then, lightly spray a small amount of water over the entire pile that you have created. Cover with a tarp or plastic sheet, and weigh this down with a rock at each corner so the wind will not blow it away. As more plant or lawn cuttings, or organic kitchen refuse, is available on a daily or weekly basis, apply additional layers of all of the same ingredients, and in the same order, until the pile is as high and of an amount that is desired. Periodically mix the pile like a giant salad using a pitchfork. This mix will miraculously transform into a pure and nutrient-rich earth within about six to eight weeks.

> – Traditional recipe for making compost (human made earth) from organic refuse

If a major purpose of art is to create new expressions that didn't previously exist, then surely another is to preserve what already exists and is of value. Having grown up on an "organic" farm, the author is able to approach our final theme on hybridization as an extension of his personal history. And, from this perspective, the idea of art being limited to "creating"—as a process that is singularly generative and only adds to the existing accumulation of artifacts in an increasingly cluttered world—seems ludicrous and contradictory.

It is appropriate that the concluding regular chapter of a book on creative works involving hybrids examine ways in which such works might contribute to our awareness

of the need for survival. In this case, the kinds of art that seem best for addressing this issue are those that recycle the refuse of our culture, or those that commemorate the need for redressing our tendency toward extravagance and endless production of cultural waste. There are many names for such art. Some call it "junk art," while others refer to it as "eco-art." I'm calling it art of "The New Salon de Refuse." The origin of this term is associated with an exhibition of art works by rebels who did not conform to the canons of the French Academy in the mid-nineteenth century.

As many readers already know, the original Salon des Refusés was held in France in 1863. It was an exhibition that was formed as an alternative to the annual juried exhibitions sponsored by the French Academy. As previously discussed in the chapter on "Art in the Petri Dish," the French Academy stressed works done in an academic fashion, and favored subject matter that was disconnected from ordinary life. Approved subjects included mythology, history, portraiture of the royalty, and religion. As an alternative show, The Salon des Refusés was formed in order to feature paintings that had been rejected by the jurors selected by the Academy. The art that was included in the Salon represented ordinary subject matter, in contrast to the impersonal topics acceptable to the Academy, and, equally important, new ways of perceiving the world and new ways of depicting images and forming compositions were stressed in the works as well. In short, the new approaches stressed in works in the show radically changed the course of art history. Featured artists included Manet, Courbet, Whistler, Pisarro, and Corot. Manet and Courbet, in particular, were among the artists at the vanguard and represented the new and radical directions in visual art.

In our case, of course, one will note that the words of "Salon de Refuse" are not plural and we do not use the French accent mark. This is deliberate, and is intended to reflect a revised meaning that is intended here: the "new" Salon de Refuse as focusing upon art forms that combine images in a hybridized manner and do so through recycling of discarded refuse (junk).

We have already traced some of the major phases in the use of collage, Readymades, and related composite forms of expression in our earlier chapter on "Assembly Required." In that instance, however, the evolution was intended to serve as a historic foundation leading toward works fulfilling what we termed the Archimboldo Effect, and especially in the form of images of people as "assemblies" from an aggregate of parts and objects.

Unlike the earlier chapter, this section will be more concerned with art forms deliberately created from discarded materials as a theme in itself. Such works infuse "new life" into that which has been considered useless and has been defined as junk or refuse.

The need for encouraging art to engage in the present and very important cultural dialogue addressing the increasing accumulations of toxic wastes and refuse in our world should be obvious. But such awareness hasn't yet translated into adequate alternative forms of behavior. In a recent exposé on our cultural addiction for constant replacement of technological products alone, Giles Slade points out several frightening facts.[2] One of these is that, as a direct result of the edict from one of our

own governmental regulatory agencies (the FCC) when it mandated a switch to high definition TVs to occur in 2007, we will almost instantly witness millions of junked but perfectly operable televisions. This event is reminiscent of the sudden discharge of debris that occurred when the music recording industry changed from cassette to CD sound, or when the film industry converted from video to DVD formats. Slade also points out that at least 90 percent of the 315 million still-functional personal computers discarded in North America in 2004 alone, as well as more than 100 million cell phones (200,000 tons worth) in 2005, were thrown away simply because they were considered obsolete by buyers who had been convinced by corporations and advertisers that the new gimmickry available in new models was something they had to immediately possess. The discarding of cell phones is particularly problematic since these devices have toxic components that are too small to disassemble and recycle. Cell phone obsolescence leads all other products in its frequency of replacement.[3] It shouldn't be surprising that artists have increasingly addressed these kinds of issues in their work.

Perhaps the most common works in American art history that involve the recycling of materials are to be found in the quilting tradition. Such works were constructed from scraps of fabric that were left over from previous fabric projects. Reusing the fabric pieces from such prior uses, the recombined pieces sprung to life using vibrant patterns. During the era of the Underground Railroad, many such quilts had the additional meaning of providing maps for escape from oppressive environments. Others were used as celebrations of life in which the resultant themes provided new life for the refuse from which they were constructed.

This is not the first instance in which the phrase of "Salon de Refuse" has been used to identify art works recycled from junk. In 2005, Lynn Becker organized an exhibition of this title in Chicago featuring art works constructed from rescued debris and other that commemorate the need for increased recycling of refuse. The exhibition was a festive, outdoor event, and was co-sponsored by the city of Chicago and the Chicago Chapter of the American Institute of Architect's Young Architects Forum.[4] The city had experienced an embarrassing 18% drop in recycling when since 2000, illustrating the tendency for people to expect others to take up the slack for them in such matters.

There have been many other comparable events and groups attempting to draw attention to the need for greater care in the disposal of waste and toxic materials. One of these is the "RECYCLED, RE-SEEN: Folk Art from the Global Scrap Heap" exhibition sponsored by The Museum of International Folk Art. This exhibition was probably the most exhaustive on the topic of recycling, and included separate sections on "The All-American Art of Conspicuous Recycling," "Recycling and the Aesthetics of Sound," "Recycling in the Global Marketplace," "Recycling on the Body," and "Recycled Chic."[5] Another example is the Norcal Visiting Artist Program at Recycling & Disposal Inc.'s Solid Waste Transfer and Recycling Center in San Francisco. In this location, artists compete with the large front-end loaders. In the words of Sarah Barsness: "It's stressful, even more than work I've done before–and I've literally waited

for the right object to appear at curbside. You don't know what you'll find."[6]

Another Bay Area location where are works have been produced by recycling refuse does so in a highly informal manner. The site is located behind the racetrack in Albany, California. The location began as a landfill, but, after 1984, nature and birds took over. Then the homeless moved in, and, during the mid-1990s to 1999, it became the site for artists who fabricated works using whatever the tides provided. The site has been known as The Bulb since it began to be used as an artist site, and the best-known artist-group working there was a five-member coalition that referred to itself as Sniff. The site replaced an even older tradition at the nearby Emeryville mud flats, where artists throughout the 1950s, 60s, and 70s constructed large-scale sculptures from the junk and driftwood that was randomly brought in from the sea with the high tides. The Emeryville mud flat tradition ended with a move to return the area to the birds and as an open estuary in the 1980s.

It is necessary to acknowledge that there are dramatic differences in the quality of art produced under the aegis of "eco-art." Among works done to "address ecological issues," there is a frequently and significant lack of conceptual depth, with many such works demonstrating a superficial understanding of the directions that art has taken in recent decades or even the potentials for thoughtful experimentation or skillful execution. While there are occasional eco works that are poignant and insightful, most others seem to be little more than clichés or formulaic quickies. This might be due

to the fact that found objects are frequently seen by the artists as ends in themselves, rather than as prospective elements within a significant commentary on the central issues in culture that are significant within the debates on ecology, environment, and survival. These issues are far too important to approach in superficial ways.

We will be discussing the work of two artists who employ the use of refuse that has been resurrected from its former discarded condition, and revitalized through displacement into a new context in which a unique expression has resulted. It is notable to add that the resultant work is at a much higher level of sophistication than the kind of eco-art suggested

Sniff, *Untitled Figure Sculpture*, 2001. Found driftwood, rope, c. 36 in. x 15 in. x 15 in. Photo courtesy Fletcher Oakes.

above. The high level of quality to be found in the work of both of our artists, in the view of this writer at least, demonstrate a very high level of fabrication skills, unique insights into environmental and cultural issues, and a capacity to formulate substantive creative concepts. The artists chosen for this purpose include Brian Goggin and Mildred Howard.

Brian Goggin has been creating sculptures that include combinations of ordinary objects since at least 1995. He is especially involved in site-specific work with urban connotations, and has produced pieces as far ranging as *Climbing Frenzy* for the San Francisco Art Commission Gallery, to *Herd Morality* for Yerba Buena Gardens (San Francisco), and *Defenestration* funded by NEA, Andy Warhol Foundation, and private funds in downtown San Francisco. The artist has also produced site-specific works for Palo Alto, Sacramento, Seattle, and San Antonio.

Herd Instinct is a piece that is attached to architecture, and which evokes images of organic or animal parts. The artist states that this work "alludes to the fundamental uncontrollability of nature in an urban setting, how people, objects and environment, regardless of construct, inevitably and intrinsically are tied to the mysterious, chaotic, and inorganic barriers between people and things, objects and intentions."[7]

Another work by Goggin that is related to our discussion is entitled *Metered Growth* (1994). This fabrication is a sculptural work designed for installation in an interior space. The piece combines unusually tall parking meters with tree branches growing from their pipe ("trunk") portions. Some of the meters are as high as fourteen feet, with others are somewhat shorter. In the artist's words, this work represents a condition that "will only, one assumes, give rise to a new crop of parking meters, which in turn will proliferate endlessly, eating up the remaining acres of cityscape."[8] The artist's measured sense of irony—as well as his concerns about rapid and endless urban growth—is clear. There is a sense of humor at work here as well, for Goggin continues by stating: "Ultimately, perhaps, the functional (aspect) returns to the purely aesthetic, as the passing years add charm and sap utility; and these meters rise just beyond the reach of anyone who would dare to feed them a quarter."[9]

On another level, this work embodies the physical clash between mechanical and natural environments. Big meters guzzle more (and, by extension, larger) quarters the same way that big cars guzzle gas. By integrating elements from the "natural" environment in the form of tree branches with the otherwise mechanical nature of parking meters that must be "fed" these quarters, two diametrically opposed elements are brought to bear within the work: the mechanical and the natural. On the one hand, we find the mechanical meter and its cohort, the automobile, and, on the other, references to nature in the form of tree branches growing from the meters. Similarly, we note that the parking site next to a conventional parking meter becomes the equivalent to the temporary "nesting" that occurs within a tree, though for mechanical creatures within an urban setting. Although cars aren't physically included in *Metered Growth*, we all know that they are complicit elements within the urban parking phenomenon nonetheless. In this context, we find that the concern of extreme growth represented by the fourteen foot tall meters implicates the parallel growths witnessed within the

Brian Goggin, *Samson*, 1998. Two pillars comprised of luggage, luggage carts, each pillar is 23 ft. x c. 8 ft. x 8 ft. Sacramento International Airport Baggage Claim Area. Courtesy of San Francisco Arts Commission. Photo: Florencia Aleman.

automotive industry during recent decades. The latter growth, in turn, leads one to think of our dependence upon limited resources to feed all these cars, just as the taller meters will require "larger" amounts of money to quench their increased "appetite." The more we feed them the bigger they get. There is both cynicism and the ability to laugh at our foibles conveyed by this work. And coupled with this, the tree branches attached to the mechanical "meter trees" implicate the simultaneous consumption of trees that has occurred within the same culture as further evidence of rampant consumption.

While *Metered Growth* represents a clash between organic and inorganic (parking meters as trees) often found in urban settings, another installation entitled *Samson* (1998) attempts to reconcile the contradictory ideas of movement (as in travel) and architectural immobility. This piece was created for the Sacramento international Airport Baggage Claim Area, and this setting was clearly instrumental in informing the ways in which the work simultaneously conveys both of these opposing notions. The installation is comprised of two twenty-three foot tall pillars made by combining 700 refurbished pieces of luggage dating from the beginning of commercial air flights to the present. Both pillars rise entirely to the ceiling where they are attached to the building using a concealed steel bracing system. Otherwise, each pillar appears like one could simply walk up and roll it off, as one would normally do with a luggage cart. In addition to our association of suitcases as mobile conveniences that accompany us on our travels, the bottom of both piles features a heavy-duty, mobile luggage cart,

like those used in airports for moving large numbers of check-in bags. Paradoxically, the otherwise precariousness stack of luggage appears to be literally supporting the roof above, since both pillars rise entirely to the height of the ceiling where they are attached. By combining contradictory conditions stressing mobility, on the one hand, and an architectonic stability, on the other, the work literally defies logical expectations. The encounter between these two opposite traits produces a powerful contradiction in one's mind when viewing the work.

Contradictions and paradoxes seem to be common traits in much of the work by this artist. In reference to the *Samson* installation, Goggin states that:

> Through luggage, we can see portraits of former travelers, the unique qualities of the bags seemingly imbued with aspects of their former owner's personalities...The simple act of looking becomes a point of departure for the imagination.[10]

The artist's *Defenestration* (1997-present) is perhaps the most significant work to date with particular pertinence to our primary focus on hybridization. This work involves the attachment of couches, refrigerator, tables, chairs, lamps, and other discarded objects to the outside surface of an unoccupied former tenement building at the corner of 6th and Howard Streets in San Francisco. At its "opening" in 1997 the work featured twenty-three such objects attached with steel to the building. The work continued to evolve after it's opening, and more objects as of this writing. The work

Brian Goggin, *Defenestration*, 1997-2006. Tables, chairs, lamps, refrigerator, couches, and other discarded objects, attached to exterior of building at corner of 6th and Howard Streets, San Francisco, CA. Courtesy of the artist. Photo: Florencia Aleman.

was created with the help of 100 volunteers, and is mind-boggling in its scale. The title of the piece ("Defenestration") literally translates to mean, "to throw out of a window." The neighborhood in which the building is located has faced harsh economic challenges in recent years, and has continued to exist for decades in a borderline skid row status. The work reflects the difficult lives of the residents of this community, as cast-offs and unappreciated people. By featuring the similarly cast-off objects that are attached to the outside of the walls, the artist reawakens public concern for the conditions of both the objects and, by association, the residents of the neighborhood.

Goggin describes a transformation of our perception of space and objects from one of improbability to one of plausibility when objects that we normally perceived in the interior spaces of architecture are transplanted and attached to the exterior of a building:

> By orchestrating everyday materials, I create works that make the improbable appear plausible. The resulting pieces, in effect, take on an identity, a personal history, until they seem complete and believable. Apparent animations evolve which are at once dream-like yet familiar, unleashing a hidden life in commonplace objects.[11]

It is notable, too, that the relocating of objects that we normally think of as being contained within interior spaces to the exterior surface of a building reverses the way a building is experienced. When standing on the outside of such a building, one's experience becomes one of exposure rather than containment or insularity. The structure, in essence, is converted into an exoskeletal space, reminiscent of insects that bear their organs on the outside of their bodies. It is also highly reminiscent of Gothic cathedrals, in which the exterior flying buttresses (literally the buildings' skeletons) and numerous external, sculptural fenestrations involving gargoyles and countless other attached sculptures resulted in a unique form of spatial expression seven centuries ago. Such space reversed the roles of inside and outside in architecture. On the inside, one would experience the dematerialization of the physical through the flood of light created by sunlight passing through the transparent stained glass walls and made possible by the exoskelotal approach toward architecture.

As a distinct form of hybridization, of course, Goggin's *Defenestration* work involves combinations on several levels. These include the conjoining of interior and exterior spaces so that these are simultaneously visible. Similarly, he also combines objects that we normally think of as autonomous to the building, though functionally experienced inside the rooms, with the exterior walls. As a consequence the exterior of the building and what would normally be though of as its contents are visible at once— with both visible from the outside. By being located this unique manner, the attached objects seem to laugh in the face of gravity. This is especially true since many of the externally attached objects are comparatively large and are of the sort that we know to be heavy. Finally, we also find the kind of paradoxical juxtapositioning of possible and impossible conditions that is so common in much of the artist's works.

While Goggin's works tend to integrate and present familiar objects and structures

Mildred Howard, *Salty Peanuts* (detail), 2000. 130 saxophones, silver coated steel musical notes, 29 ft. x 32 ft. x 2 ft. Collection of the City and County of San Francisco, commissioned for San Francisco International Airport by the San Francisco Arts Commission. Photo courtesy of the San Francisco Arts Commission.

in unfamiliar ways that challenge our expectations, the sculptural works of Mildred Howard reflect a combining of elements that inform our notions of memory, earth, race, gender, culture, and religion. These components are brought together in varying ways, and to varying degrees, within her work.

One such example is *Salty Peanuts* (2000). This thirty-two foot long wall-installation piece is installed at the San Francisco International Airport. The work juxtaposes 130 saxophones in a rectangular horizontal band. A central, horizontal strip of saxophones is flanked both above and below by two subtle, light gray colored bands of musical scores with notes and stanzas. The soft gray color lends a subtlety a the musical notes portion, that seems to refer to the secondary role of music in its textual (written) form if compared to the act of playing music itself as a direct experience. This view toward a secondary role for music in written form, in turn, evokes the far older oral tradition within black music that stretches back to its African roots. In many black form of music, such as jazz, the tendency is to play directly by ear with no, or little, dependence upon the strictures of pre-written sheet music. This, in turn, represents the tendency for jazz musicians to "live within the moment" through their spontaneous and improvisational methods more than repeat the traditions of performing music in a prescribed form that is repeated from the past. As we know, too, the saxophone is one of the most common instruments within the black jazz tradition. Taken as a whole, this work invokes hybridization on many levels, including living in the moment

combined with continuing a strong tradition from the past, and the more obvious one of the juxtapositions of the music with instruments.

In another work entitled *6639* (2004) Howard combines the numerous small bottles that form a miniature architectural structure, a home. The artist has done an entire series on the theme of homes comprised of bottles. The idea appears to go back to her reading of *Autobiography of An Ex-Colored Man* by James Weldon Johnson. In an interview with Richard Whittaker appearing in *Works+Conversations* Howard states:

> He writes about living as a child in a house which was set back 75 to 100 feet from the road. In the front were bottles stuck neck down in the ground. He thought the bottles grew as the flowers did…For some reason, the next morning I said, 'I'm going to make a house out of bottles,' and somehow it came to me, I need four thousand bottles. How that notion of needing four thousand bottles came to me, I don't know. It just came to me.[12]

In *6639* the artist employed commonly found small bottles that evoke the above story recollected by James Weldon Johnson suggested above. Not being intimately familiar with the origins of objects can lead to unusual perceptions, such as their growth from the ground like plants. In addition to the ways in which memories can distort and lead to imaginative new ways to seeing things, Howard is also interested in the ways that knowledge of plant growth and gardening can lead to self-awareness. One of her first forays into this interest was in a work called *Memory Garden* developed and installed at the Headlands Center for the Arts in 1991. After a period of working at the Exploratorium in San Francisco, the artist was offered the directorship of the Alice Waters "Edible Schoolyard" at Martin Luther King Middle School in Berkeley. This brought her into an environment in which young people grow the food from scratch, using only organic methods, and then learn to prepare the results as food. Experiencing the entire process, according to Howard, teaches young people how to connect things in their life, including those beyond the garden alone.[13]

Mildred Howard, *6639*, 2004. Steel, glass bottles, glue, 31 in. x 16.5 in. x 20 in. Courtesy of the artist and Gallery Paule Anglim, San Francisco, CA.

If the small bottles used as

building blocks to build the tiny homes may evoke memories of the past, such as the recollections of the past to which James Weldon Johnson refers, then Howard's series of thirty life-size portraits of her cousin, Ickles Rugley. She calls the series *In the Line of Fire*. The title refers to the invisibility of the many black men who have served and died while serving in the U. S. military. The artist created the thirty images by starting with a photograph of the soldier in his World War I uniform. The thirty figures were combined into a single, freestanding installation, and the viewer is able to walk through the informally located formation of figures, which collectively represents the many military contributions made by Cousin Ickles.

There is a target painted on the back of each of the figures in the installation, suggesting the always present danger of the "friendly fire" that targets black men in their lives when they are in their "homeland." The work represents a meld of the memory of sacrifice with the issues facing young black men today. In the words of Leah Ollman, Howard "pits the strength of personal memory against the totalizing efforts of the goliath history.[14] As depositories of both family and group (black) memories, the artist's work encompasses the overlaps between individuals and groups. In the words of Amalia Mesa-Bains, Howard's "memories are her community's memories, her family's memories, women's memories and racial memories, situated in overlapping residues.[15]

Memory serves as an essential component in the artist's creative vocabulary and motivation. She recognizes that our lives are the product of the on-going accumulation of residues from our pasts. The present as a reconstitution of the past might remind us of the Egyptian Myth of Osiris and Isis. This myth informs us that the body of a deity named Osiris was torn to shreds by his jealous brother, Seth. In response to this tragic event, the wife of Osiris, Isis, reconstituted his fragmented body, making him whole again. In respect to our concern with hybridization, it is particularly important to acknowledge that the renewal of Osiris's life was made possible through the recombining and reactivation of remnants from both his physical body and his spiritual past. As a consequence, the couple was able to make love once again, resulting in the birth of a new deity named Horus. This myth may be interpreted as a form of therapy–a way of making us whole again–after we have become fragmented through the many onslaughts and fragmentations frequently experienced in our lives. It also tells us that we can build a future through the reinvigoration and reconfiguration of elements drawn from our past. The African American writer, bell hooks, recognizes this creative power contained within the Osirian myth when she states:

> This glorious myth…reminds us that no matter how broken, how lost we are, we can be found. Our wounded souls are never beyond repair. Black females and males can use this myth to nurture the memory of sustained connection with one another, of a love that has stood and can stand the test of time and tribulation. We can choose a love that will courageously seek out the wounded soul, find you, and dare to bring you home again, doing what must be done to help put the bits and pieces together again, to make

us whole. This is real cool. This is love.[16]

When gathering the scattered pieces of Osiris, Isis was also garnering the fragments of his memory. While assisting in the process of bringing the pieces of her shattered lover together again, and in making him whole, she was expressing the ultimate act of love: the recognition and acceptance of all that he had been and all that he was. Similarly, the phenomenon of the rising Phoenix is the product of more than resurrection of the physical; it invokes a return and reconstitution of the spiritual dimension as well, and, perhaps even more significant, the rebirth of memory and hope. If she had selected only select parts or aspects of Osiris and ignored others, he would never have become who he truly was and he would have been doomed, if only as a fragment of his former self. It is this kind act of gathering and the subsequent infusion of recognition and importance of all the elements comprising our humanness—no matter how minor any of these might seem—that constitutes the potent vision of reunification that characterizes the work of Mildred Howard. One might even argue that this reconstitution of all of the parts that inevitably must be linked to make a person—or a work of art—whole is the ultimate act of hybridization.

INTRODUCTION

[1] One example is in my first such publication on the topic. My own work had come to include several forms of hybridization, including those involving disparate subject matters, combinations of differing formal elements, and other forms of combinations. See Chapter 4 on "Assembly Required" for more discussion on this. Otherwise, see James W. Davis, "Unified Drawing Through the Use of Hybrid Pictorial Elements and Grids," *Leonardo*, V/1. January 1967, 1-9.

CHAPTER 1: BORDER CROSSINGS

[1] Guillermo Gómez-Peña, *ethno-techno: Writings on performance, activism, and pedagogy* (New York: Routledge, 2005), 271-72.

[2] Alan West-Duran (ed.), in *Latino and Latina Writers* (New York: Charles Scribner's Sons, 2003).

[3] Néstor Garagía Canclini, *Hybrid Cultures: Strategies for Entering and Leaving Modernity* (St. Paul, Minnesota: University of Minnesota Press, 1995).

[4] Gordon Brotherston, *Painted Books From Mexico* (London: British Museum Press, 1995), 12.

[5] *Ibid*, 11.

[6] Max Benavidez, in "CHICANO ART: Culture, Myth, and Sensibility," in *CHICANO VISIONS: American Painters on the Verge* (ed. by Cheech Marin) (New York: a Bulfinch Press Book from Little, Brown and Company, 2002), 13.

[7] Gary D. Keller, Pat Villeneuve and others, in *CHICANO ART: For Our Millennium* (Tempe, Arizona: Bilingual Press at Arizona State University, 2004), 50.

[8] Guillermo Gómez-Peña, *Ethno-techno* (New York: Routledge Press, 2005), 16.

[9] Quoted in Gómez de la Serna, Ramón, in "Don Miguel de Unamuno," *Retratos Completos* (Madrid: Aguilar, 1961), 544.

[10] Otto Santa Ana, *BROWN TIDE RISING: Metaphors of Latinos in Contemporary American Public Discourse* (Austin: University of Texas Press, 2002), 319.

[11] This is the phrase used by Peter Selz in his discussion of this work in his book *Art of Engagement: Visual Politics in California and Beyond* (Berkeley: University of California Press, 2006), 180.

[12] Shifra M. Goldan, in "The Subversive Vocabulary of Enrique Chagoya," in *ENRIQUE CHAGOYA: Locked in Paradise* (exhibition catalogue for an exhibit with this title) (Reno: Nevada Museum of Art, 2000), 9.

[13] *ibid.*

[14] From Lewis Carroll, *Alice's Adventures in Wonderland* (Hertfordshire, England: Wordsworth Publishers Ltd.)

[15] The Kyle Ward NPR discussion occurred on "Morning Edition," NPR, on November 21, 2006.

[16] Gómez-Peña, *op. cit.*

[17] This codex has deteriorated through its passage from owner to own in Europe, and has been reconstructed using drawings by Giselle Díaz that are based upon the originals. To see the reconstructions, as well as some discussion on the narrative within the codex, see Gisele Díaz and Alan Rodgers, *Codex Borgia: A Full-Color Restoration of the Ancient Mexican Manuscript* (New York: Dover Publications, Inc., 1993), 25, 57.

[18] Friedrich Nietzsche, *The Will to Power* (ed. By Walter Kaufmann and trans. by Kaufmann and R. J. Hollingdale) (New York: Vintage Books, 1967), 539.

[19] This interview was conducted in several stages during August 2006.

[20] See Guillermo Gómez-Peña, Enrique Chagoya and Felicia Rice, *Codex Espangliensis* (San Francisco: City Lights Books, 2000), and Enrique Chagoya and Guillermo Gómez-Peña, *Friendly Cannibles* (San Francisco: San Francisco Artspace, 1996).

[21] This panel discussion was on the topic of "Conflict and Art." It was coordinated by Michael Krasny, and was presented at KQED in San Francisco on August 10, 2006. The panel was offered in connection with an exhibition with the same title at the Cantor Art Center at Stanford University.

[22] *ibid.* This quote, and all of the additional quotes from the panel included in this interview, may be traced to the above endnote.

CHAPTER 2: ART IN THE PETRI DISH

[1] Don DeLillo, *White Noise* (New York: Viking Penguin Inc., 1985), pp. 157-58.

[2] Robert Henri, *The Art Spirit* (New York: Harper & Row, Publishers, 1923), p. 166.

[3] Donald Kuspit, *The End of Art* (New York: Cambridge University Press, 2005), pp. 61-62.

[4] Rudolf Arnheim, *Art and Entropy: An Essay on Disorder and Order* (Berkeley: University of California Press, 1971), p. 52.

[5] See Allan Kaprow, *Essays on the Blurring of Art and Life* (Berkeley: University of California Press, 1993).

[6] *ibid.*, p. 89. The Baudelaire quote was from

[7] Paul Karabinis, "An Interview With Ken Botto," in *TELLING STORIES* (Jacksonville, Florida: The Jacksonville Museum of Contemporary Art, 1996). Reprinted in *Ken Botto in Heidelberg* (exhibition catalogue) (Heidelberg, Germany: Deutsch-Amerikanisches Institut, 2000).

[8] _____, *Past Joys* (San Francisco, CA: Chronicle Books, 1978).

[9] Anne H. Hoy, *Fabrications: Staged, Altered, and Appropriated Photographs* (New York: Abbeville Press, 1987), p. 47.

[10] Carol Becker, "Herbert Marcuse and the Subversive Potential of Art," in *The*

Subversive Imagination (Rutledge: New York, 1994), p. 114.

[11] *ibid.*

[12] *ibid.*, p. 115.

[13] Hoy also refers to a schematic study of the spatial structure of *Étant Donnés* done by Jean-Francois Lyotard that led him to conclude that the inner wall (the one with the second, fragmentary opening) represented the equivalent to the "picture plane" in a painting, and that all of the images placed behind it, within the three-dimensional interior installation part, are located in the ways necessary to reinforce this role. See Pia Hoy (trans. By John Irons), "Marcel Duchamp—*Étant Donnés*: The Deconstructed Painting," *The Marcel Duchamp Studies Online Journal*, 3, 2000.

[14] See Elisabeth Alexandre, *Still Lovers* (New York: Channel Photographics, 2005), and Alan G. Artner, "Documentary Photos Bring Unsettling Fantasy World to life" (exhibition review), *Chicago Tribune*, June 2, 2006.

[15] Interview conducted in stages between May 7 and 15, 2006.

[16] Jean Baudrillard, *Simulations* (New York: Semiotext(e), Inc. 1983), p. 83.

CHAPTER 3: HYPHEN–SPACE

[1] Robert Irwin, in Lawrence Weschler, *Seeing Is Forgetting the Name of the Thing One Sees* (Berkeley: University of California Press, 1982), 200.

[2] *ibid.*, 127.

[3] Gail Dawson, Artist Statement (used for exhibition at Salina Art Center).

[4] Interview conducted via email and finalized June 15, 2006.

CHAPTER 4: ASSEMBLY REQUIRED

[1] Mary Shelly, *Frankenstein: or The Modern Prometheus* (Oxford: Oxford University Press, 1993), 38-40.

[2] Marilyn Butler, "Introduction," *ibid.*, li.

[3] *ibid.*, xxi.

[4] Shelly, *op. cit.*, 36-37.

[5] *ibid.*, 105.

[6] Pontus Hulten, "Three Different Kinds of Interpretations," in *The Archimboldo Effect* (New York: Abbeville Press, 1987), 18.

[7] *ibid.*

[8] René Thom, "The Question of the Fragment," in *The Archimboldo Effect*, 319-20.

[9] Quoted in Hans Richter, *DADA: Art and Anti-Art* (New York: McGraw-Hill Book Company, (no date), 89.

[10] Quoted in James Johnson Sweeney (ed.), "Eleven Europeans in America," in *The Museum of Modern Arts Bulletin*, XIII/4-5, 1946, 20.

[11] Kurt Schwitters, in "Kurt Schwitters Katalog," *Merz*, No. 20. March 1927, 99-100.

[12] Quoted in Alan Solomon, *Robert Rauschenberg* (exhibition catalogue). (New York: The Jewish Museum, 1963), 11.

[13] Allan Kaprow, *The Blurring of Art and Life* (Berkeley: University of California Press, 1993).

[14] Quote from William Rubin, *Dada, Surrealism, and Their Heritage* (New York: Museum of Modern Art, 1968), 151.

[15] Interview conducted between May 7 and 15, 2006.

CHAPTER 5: CORPUS TRANSITUS

[1] Franz Kafka, *The Metamorphosis,* trans. by Stanley Appelbaum (New York: Dover Publications, Inc.), 1. The final words of this initial line to Kafka's famous short story in the original German are "ungeheueren ungeziefer verwandelt." These words literally translate to be "enormous changed vermin," rather than the more commonly used "enormous (changed) bug" that one encounters in most English translation. It is apparent that Kafka did not intend for Gregory's transformed body to be thought of as a specific being, such as an insect, but as a more generic form of being (and specifically "vermin," which connotes an entire range of possible entities, such as fleas, insects, or small animals, all of which are difficult to control). See David Wyllie, *Franz Kafka's Metamorphosis* (Online e-book: Project Gutenberg, 2005), 1.

[2] Mikhail Bakhtin, *Rabelais and His World*, trans. by Hélèn Iswolsky (Bloomington: Indiana University Press, 1984), 317.

[3] Orlan, "La Maïeutique du corps: Rencontre avec Orlan" (interview with Maxime Coulombe), in *ETC: Revue de l'Art Actuel* 60 (December 2002-February 2003): 15; translation of passage by Jill O'Bryan.

[4] Roy Seiber, "Introduction," in Seiber and Roslyn Adele Walker, *African Art in the Cycle of Life* (Washington D.C.: Smithsonian Institution Press, 1987), 24-25.

[5] Carl Jung, *Man and His Symbols* (New York: Dell Publishing Co., Inc., 1964), 120-23.

[6] Michel Foucault, *Discipline and Punish: The Birth of the Prison*, trans. by Alan Sheridan (New York: Vintage, 1979), 194.

[7] Celia Lury, "Introductory Comments," in *Prosthetic Culture: Photography, Memory and Identity* (London: Routledge, 1998). (unpaginated page)

[8] *ibid.*

[9] Saint Teresa of Ávila, in *Vita, XX (The Life of Saint Teresa of Ávila by Herself)*, trans. by J. M. Cohen (London: Penguin Books, 1957), 136.

[10] *ibid.*

[11] *ibid*, 210.

[12] Kafka, Op. Cit. See the discussion in the above note in which the actual German translation identifies the transformed body as "vermin" rather than the more common used "bug" or "insect."

[13] Bakhtin, *Op. Cit.*

[14] Lury, *Op. Cit.,* 104.

[15] C. Jill O'Bryan, *Carnal Art: Orlan's Resurfacing* (Minneapolis: University of Minnesota, 2005), 133.

[15] Orlan, "I. Body and Action. II. Triumph of the Baroque," in *Orlan: 1964-2001*, ed. by María José Kerejeta, trans. by Brian Webster and Careen Irwin (Vitoria-Gasteiz, Spain: Artium; Salamanca, Spain: Ediciones Universidad de Salamanca, 2002), 227-28.

[17] *ibid.*

[18] Christopher D. Roy, *ART AND LIFE IN AFRICA* (Iowa City: University of Iowa Museum of Art, 1992), 38.

[19] Régis Durand, "Texts for Orlan," in *Orlan: Carnal Art*, trans. by Deke Dusinberre (Paris: Éditions Flammarion, 2004), 208.

CHAPTER 6: RASHOMON FACTOR

[1] Three quote from Ryunosuke Akutagawa's "In a Grove," in *Rashomon and Other Stories* (trans. By Takashi Kojima) (Tokyo: Charles W. Tuttle Company, 1952).

[2] From Andre Breton, in "Le Cas Dali," *Le Surréalisme et la peinture* (2nd edition) (Paris: Gallimard, 1928).

[3] Salvador Dali, "The First Dali Exhibition" (exhibition statement), in Breton, *What is Surrealism?* (London: Faber & Faber, 1936), 27-30.

[4] Dali, *Conquest of the Irrational* (trans. By David Gascoyne) (New York: Julien Levy, 1935), 12.

[5] Karen Kienzle identified the balancing of these kinds of elements in an interview with the artist conducted in February 2001. See Kienzle, "Realizing Meaning," in *Urban Invasion* (exhibition catalogue) (San Jose, CA: San Jose Museum of Art, 2001), 9.

[6] *ibid.*

[7] John Burroughs, "The Divine Soil," *The Atlantic* 101,no. 4 (April, 1908), 440-49.

[8] Friedrich Nietzsche, as quoted in Kaufmann, Walter, *The Portable Nietzsche* (New York: The Viking Press, 1954), 46-47.

[9] Most of the artist's views and comments in this portion of the text are based upon his commentaries in the Artist Statement that accompanied his M.F.A. Exhibition at San Francisco State University, spring 2006.

[10] *ibid.*, 8.

[11] *ibid.*, 13-14.

[12] Carl Jung, *Man and His Symbols* (Garden City, New York: Doubleday, 1964), 34.

[13] Interview conducted via email and finalized July 11, 2006.

CHAPTER 7: CHRON-ILLOGICAL TIME

[1] Arthur Funkhouser, "Three Types of Déjà vu," *Perspectives*, I/1, March 15, 1996, 1.

[2] Kuspit, *op. cit.*, 55.

[3] Jean-Francois Lyotard, "What is Postmodernism?" (from appendix in) *The*

Postmodern Condition: A Report on Knowledge (Manchester, England: Manchester University Press, 1984), 79.

[4] David Freedberg, *THE POWER OF IMAGES: Studies in the History and Theory of Response* (Chicago: The University of Chicago Press, 1989), 17.

[5] Jessica Walker, "Artist Statement," (unpublished), written June, 2006.

CHAPTER 8: THE NEW SALON DES REFUSÉS

[1] Giles Slade, *Made to Break: Technology and Obsolescence in America* (Cambridge: Harvard University Press, 2006).

[2] *ibid.*

[3] *ibid.*

[4] Lynn Becker's website describing this event is at http://www.lynnbecker.com/repeat/recycle/recyclewinners.htm.

[5] See http://www.moifa.org/exhibitions/past/recycledreseen/rrindex.html.

[6] From Reyhan Harmanci, "Visual Arts: Is it Garbage or Is It Art?" in *96 Hours* (*San Francisco Chronicle*), April 20, 2006, 10

[7] Artist's quote from his website at http://www.metaphorm.org/pages/portfolio/meter.html.

[8] *ibid.*

[9] *ibid.*

[10] *ibid.*

[11] Artist Statement from the artist's website at http://www.defenestration.org/bio.html.

[12] From an interview with Richard Whittaker, in *Works+Conversations*, Issue 3 (see http://www.conversations.org/mildred_howard.htm.

[13] *ibid.*

[14] Leah Ollman, "Mildred Howard at Porter Troupe," in *Art in America*, March 1998.

[15] Amalia Mesa-Bain, "Acts of memory: The Alternative Chronicle of Mildred Howard," from exhibition essay for a show entitled *Mildred Howard - Ten Little Children Standing in a Line*, San Francisco Art Institute, 1991.

[16] bell hooks, *WE REAL COOL: Black Men and Masculinity* (New York: Routledge, 2004), 162.

CREDITS

From cover: Orlan, *Defiguration-refiguration. Self-Hybridation précolombienne No. 4*, 1999. Aluminum-backed Cibachrome, 39 1/3 in. x 59 in. (100 cm. x 150 cm.). Courtesy Fonds National d'art contemporain, Paris.

Enrique Chagoya, *When Paradise Arrived*, 1988. Charcoal, pastel on paper, 80 in. x 80 in. Collection di Rosa Preserve, Napa, California. Courtesy of the artist.

Enrique Chagoya, *Untitled (Road Map)*, 2004. Charcoal and pastel on paper mounted on canvas, 60 in. x 80 in. Private Collection. Image courtesy of George Adams Gallery, New York and the artist.

Enrique Chagoya, *An American Primitive in Paris*, 1999. Detail of page 1 from within a 10-page artist's book. Acrylic and water-based oil with solvent transfer on amate, 12 in. x 12 in. (entire book 12 in. x 120 in.). Private Collection. Image courtesy of George Adams Gallery, New York and the artist.

Enrique Chagoya, *Illegal Alien's School of Art and Architecture*, 2006. Detail of pages 9 and 10 from within a 14-page artist's book. Water-based oil, ink, transfers on amate, 11 3/4 in. x 16 in. (entire book 11 3/4 in. x 112 in.). Image courtesy of George Adams Gallery, New York and the artist.

Ken Botto, *Fort Winnebago*, 1986. Ektachrome print, 20 in. x 24 in. Courtesy of the artist and Robert Koch Gallery, San Francisco, CA.

Ken Botto, *Red Shoe*, 1989. Ektachrome print, 20 in. x 24 in. Courtesy of the artist and Robert Koch Gallery, San Francisco, CA.

Ken Botto, *Enfant Terrible*, 2005. Ektachrome print, 24 in. x 20 in. Courtesy of the artist and Robert Koch Gallery, San Francisco, CA.

Ken Botto, *The Blind Leading the Blind*, 2005. Ektachrome print, 24 in. x 20 in. Courtesy of the artist and Robert Koch Gallery, San Francisco, CA.

Gail Dawson, *One Second at the Rijksmuseum*, 2002-03. Comprised of 90 pieces (30 are oil on board; 60 are watercolor on paper), each piece 8 in. x 10 in. Photo courtesy of the artist.

Gail Dawson, *Race*, 2005. Watercolor on paper, 3 ft. x 30 ft. Photo courtesy of the artist.

CREDITS

Gail Dawson, *Hurdles*, 2006. Watercolor on paper, 21 in. x 52 in. Photo courtesy of the artist.

Giuseppe Arcimboldo, *Earth, allegory*, 1570. Oil on wood, 27 ¾ in. x 19 in. Private Collection, Germany. Photo Credit: Erich Lessing/Art Resource, NY.

Ken Botto, *Séance*, 2005. Ecktachrome print, 24 in. x 20 in. Courtesy of the artist and Robert Koch Gallery, San Francisco, CA.

Orlan, *Documentary Study No. 1: Le Drape-le Baroque*, or *Sainte Orlan avec fleurs sur fond de nuages (Saint Orlan with Flowers, Against Clouds)*, 1983. Aluminum-backed Cibachrome, 47 ¼ x 63 in. (120 cm. x 160 cm.). Courtesy Fonds National d'art Contemporain, Paris. Photo: Anne Garde.

Orlan, *Defiguration-refiguration. Self-Hybridation précolombienne No. 4*, 1999. Aluminum-backed Cibachrome, 39 1/3 in. x 59 in. (100 cm. x 150 cm.). Courtesy Fonds National d'art contemporain, Paris.

Orlan, *Nuna Burkina Faso Sculpture with Scarification and the Body of a Euro-Saint-Étienner with Facio-Temporal Lumps*, 2000. Resin moulding with whig on a transparent plexiglas plinth, 39 1/3 in. x 70 in. (100 cm. x 180 cm.). Collection of the artist.

Salvador Dalí, *Invisible Afghan With Apparition of a Face on the Beach*, c. 1934-37. Private collection. © 2007 Salvador Dalí, Gala-Salvador Dalí Foundation/Artists Rights Society (ARS), New York. Photo courtesy Erich Lessing/Art Resource, NY.

Chester Arnold, *Crossroads,* 2006. Oil on canvas, 72 in x 87 in. Courtesy of the artist and Catharine Clark Gallery, San Francisco, CA.

Chester Arnold, *Thy Will be Done*, 2006. Oil on linen, 72 in. x 84 in. Courtesy of the artist and Catharine Clark Gallery, San Francisco, CA.

Luna Topete, *We Never Talk Anymore*, 2004. Mixed media environment with video, 96 in. x 120 in. X 96 in. Photo courtesy Luna Topete.

Luna Topete, *Contemplating My Next Move*, 2006. Mixed media with video, 96 in. x 48 in. x 48 in. Photo courtesy Luna Topete.

Jessica Walker, *Olympia Emerging* (general view with figure shown activating sensors), 2005. Interactive installation combining photo-projection, sensors, video projector, room size. Photo courtesy of the artist.

Jessica Walker, *Olympia Emerging* (close-up view of completed image of figure),

2005. Interactive installation combining photo-projection, sensors, video projector, room size. Photo courtesy of the artist.

Sniff, *Untitled Figure Sculpture*, 2001. Found driftwood, rope, c. 36 in. x 15 in. x 15 in. Photo courtesy Fletcher Oakes.

Brian Goggin, *Samson*, 1998. Two pillars comprised of luggage, luggage carts, each pillar is 23 ft. x c. 8 ft. x 8 ft. Sacramento International Airport Baggage Claim Area. Courtesy of San Francisco Arts Commission. Photo: Florencia Aleman.

Brian Goggin, *Defenestration*, 1997-2006. Tables, chairs, lamps, refrigerator, couches, and other discarded objects, attached to exterior of building at corner of 6th and Howard Streets, San Francisco, CA. Courtesy of the artist. Photo: Florencia Aleman.

Mildred Howard, *Salty Peanuts* (detail), 2000. 130 saxophones, silver coated steel musical notes, 29 ft. x 32 ft. x 2 ft. Collection of the City and County of San Francisco, commissioned for San Francisco International Airport by the San Francisco Arts Commission. Photo courtesy of the San Francisco Arts Commission.

Mildred Howard, *6639*, 2004. Steel, glass bottles, glue, 31 in. x 16.5 in. x 20 in. Courtesy of the artist and Gallery Paule Anglim, San Francisco, CA.

A

Adams, George (Gallery), 21, 24, 28, 38, 41

Adelita, 18

African masks, 96, 119, 121, 145-146

Akutagawa, Ryunosuke, 123

Albany Bulb, 157

Alexandre, Elizabeth, 56

Alice Waters "Edible Schoolyard", 163

Alice's Adventures in Wonderland, 21, 23, 78

Allan Ginsberg Portrait series, 51

Allison, Mose, 65

Altdorfer, Albrecht, 129

amate (paper), 24, 27-28, 34

American Ashcan School, 47, 59

An American Primitive in Paris, 24-25, 27

Andy Warhol Foundation, 158

animal husbandry, 2

anthropomorphism, 132

Apollonian, 29

Arcimboldo Effect, 7, 93-95

Arcimboldo, Giuseppe, 7, 93-95, 102-104

Arnheim, Rudolf, 47-48

Arnold, Chester, 8, 123, 127-132, 143

Art and Entropy, 147

Art World, 129

Arte Povera, 98

As Much as I like to Dream It, 135, 140-142

Assemblage, 62, 96

Auschwitz, 131

Autobiography of An Ex-Colored Man, 163

autogestion ciudadana, 15

Axis of Evil, 25

Aztec, 2, 33, 35

B

Bachelor and the Bride series, 51

Back Seat '38 Dodge, 61

Bakhtin, Mikhail, 112, 116

Balinese, 34-35

Banco de Mexico, 31

Barbie Doll series, 49-51

Barnie's Beanery, 61

Barsness, Sarah, 156

Bataille, Georges, 70

Baudelaire, Charles, 47-48

Baudrillard, Jean, 70, 72

Bay Area, 5, 6, 31, 67, 157

Becker, Carol, 50, 156

Belmer, Hans, 57, 70, 100, 102, 104

Bernardino de Sahagun, Fray, 34

Bernini, Gianlorenzo, 54, 56, 114-116

Bible, 33

Biblioteque Nationale (Paris), 34

Black Art series, 50

Black Mariah series, 51, 53-54, 58

Blind Leading the Blind, 57, 90

Blindness, 67, 69, 99

Body Sculpture called "Frog Against Black Ground", 114

Body-Sculpture No. 3 called "Shiva, or Many-Armed Tentacles", 114

hooks, bell, 164

border crossings, 4

Borges, Jorge Luis, 37

Bosch, Hieronymus, 131

Botox, 112

Botto, Ken, 5, 7, 42, 45-54, 56-58, 72, 98-101

Brando, Marlon, 109

BROWN TIDE RISING: Metaphors of Latinos in Contemporary American Public Discourse, 16

Brueghel the Elder, Pieter, 129, 131

Burkina Faso, 120

Burroughs, John, 131

Bush, George W., 10, 22-23, 25, 38, 40, 107

C

calavera, 26

California Civil Rights Initiative, 17

California College of the Arts, 67

Cantor Art Center (at Stanford University), 37

Caprichos series, 38

Caravaggio, 101

carnivalesque, 116

Carroll, Lewis, 21, 23

Catastrophism, 95

Catlin, George, 118

Cervantes, Miguel de, 37

Cézanne, Paul, 145-146

Chagoya, Enrique, 5, 7, 10-14, 18-24, 26-30, 42, 43

Chicano, 10, 11, 13-15, 18, 26, 28, 42

Chilan-Balan, 34

Chron-illogical, 143

Clark, Catherine (Gallery), 128, 130

Clean Air Act, 17

Climbing Frenzy, 158

cloning, 90-91

codex, 18, 23, 24, 27, 30, 33-36

Codex Borgia, 23, 27

Codex Espangliensis: From Columbus to the Border Patrol, 36

Codex Madrid, 34

codice, 13, 14, 18, 24, 33, 42

collage, 37, 38, 50, 59, 96, 155

collaging, 96

compost, 154

Conner, Bruce, 62, 98

body, the constructed, 45-46, 100

Contemplating My Next Move, 134-135, 139-140

Conversation series, 51, 58

Corinthian, 28-29

Cornaro Chapel (Rome), 55

Corot, Jean-Baptiste-Camille, 155

Corpus Transitus, 8, 105, 106

Coulombe, Maxime, 105

Courbet, Gustave, 48, 155

Crossroads, 128-130, 131

Crumb, R., 59, 60, 72

Cubism, 96-97, 121, 151-152

D

Dada, 66, 94, 97, 98

Dadaist, 97

Dalí, Salvador, 125-127

Danny O'Day, 58, 99, 100

Darwin, Erasmus, 91

Das Kapital, 31

Daumier, Honore, 66

David Copperfield, 144

Dawson, Gail, 5, 7, 73, 76-80, 82, 89

Chirico, Giorgio de, 62

de Saint Phalle, Niki, 98

Defenestration, 158, 160-161

Defiguration-refiguration. Self-Hybridation précolombienne No. 4, 118

Degas, Edgar, 85

déjà senti, 144

déjà vécu, 144

déjà visité, 144

déjà vu, 144

DeLillo, Don, 44, 67, 68, 72

Dia de los Muertos, 26, 30

diachrony, 121

Dias de los Muertos, 13

Dickens, Charles, 144

Diego de Landa, Fray, 34

digital, 8, 79, 86, 105, 113, 117, 118, 121

Dionysian, 29

DNA, 2, 93, 105

Documentary Study No. 1: Le Drape-le Baroque, or *Sainte Orlan avec fleurs sur fond de nuages (Saint Orlan with Flowers, Against Clouds)*, 114

Documentary Study No. 1: Plaisirs Brodés (Embroidered Dissipations, or, Chiaroscuro Couture), 114

Dorfman, Elena, 56, 57

Doric, 28-29

Dr. Victor Frankenstein, 91

Driftwood Figure series, 51, 54, 58

Dubuffet, Jean, 94, 98

Duchamp, Marcel, 55, 56, 85, 97, 114

Dummies, 99

Durand, Régis, 121

E

e pluribus unum, 11

Earth, allegory, 93

East Coast, 98

Eastern mysticism, 98, 109

Echeverria, Luis, 32

eco-art, 155, 157

Ecstasy of Saint Teresa, 114, 115

Edwards, Benjamin, 86

Egu Orumamu, 111, 156

El Santo comic books, 37

Elvis, 35, 109

Emerging, 147-149, 151

Emperor of Ch'in, 120

Enfant Terrible, 53-54, 71

English for the Children Act, 17

entropic, 47

entropy, 47, 145, 186

ephibism, 120

Ernst, Max, 62

Escher, M. C., 131, 132

Escuela Nacional de Pintura y Escultura, 31

Étant Donnés, 55

Ethno-techno, 10, 15

Exoskeletal, 161

ex-votos, 13

F

Fantastic Art, Dada, Surrealism Exhibition, 94

Fantastic Voyage, 78

First Take Off, 78

Fischer v. Spassky, 80

Fischer, Bobby, 80

Five Stages of Rites of Passage, 107, 109, 110

Fluxus, 98

Fort Winnebago, 51-53, 68

Frankenstein: or The Modern Prometheus, 7, 90, 91

Frankenstein's monster, 93, 116

Franklin, Benjamin, 91

Freedberg, David, 147, 149

French Academy, 48, 155

Friedrich, Casper David, 129, 132

FRIENDLY CANNIBALS, 36

Funkhouser, Arthur, 144

G

Galassi, Peter, 68

Gallery Paule Anglim, 38, 163

Garagía Canclini, Néstor, 12

Gauguin, Paul, 30

German Expressionist, 55, 66

Giorgione, 147, 149, 150, 153

Giverny, 27

Goggin, Brian, 8, 154, 158-161

Goldman, Shifra M., 20

Goya y Lucientes, Francisco, 34, 38, 48,

graft *or* grafting, 2, 104-105

Greenbergian, 84

Grosz, George, 66

Guillermo Gómez-Peña, 10, 15, 18, 25, 36, 37

Guston, Philip, 34, 38, 41

H

Hals, Frans, 77

Hamilton, Richard, 85

Haystacks, 84

Headlands Center for the Arts, 163

Healthy Forests Initiative, 17

Hellenistic Greek sculpture, 114

Henri, Robert, 47, 60

Herd Morality, 158

Herms, George, 98

hieroglyphic, 14, 33, 131

History in the Making, 25

Hitler, 61, 66

Hitler Moves East, 61

horticulture, 2

Horus, 164

Howard, Mildred, 8, 154, 158, 160, 162-165

Hulten, Pontus, 94

Human Race, 84

Hurdles, 80-81, 87

hybrid, 1-15, 26, 28, 30, 35, 55, 58-59, 72, 74, 82, 84, 89, 95-98, 100-101, 104, 105, 117-121, 125, 127, 143, 147, 152-155, 160-162, 164-165

hybridic, 72

Hybrid Cultures: Strategies for Entering and Leaving Modernity, 12

hybridization, 1-4, 6, 8, 11-12, 14, 26, 42, 58, 59, 82, 89, 96, 98, 100, 105, 118-121, 125, 127, 143, 152-154, 160-162, 164-165

hybridized, 1-2, 6, 13-14, 26, 28, 30, 96, 104-105, 147, 155

hyphen-space, 4, 7, 72, 74-76

I

illegal alien, 16, 25-29, 41-42

Illegal Alien's School of Art and Architecture, 27-29, 42

illegal immigrant, 17

illegal immigration, 17

Impressionism, 48

In a Grove, 123

In the Line of Fire, 164

individualist, 109

industrialization, 12, 108

Invisible Afghan With Apparition of a Face on the Beach, 125, 126

in vitro, 44, 45

Iraq (War), 17, 22, 23, 25, 30, 58

Irwin, Robert, 75-76

Isis, 121, 164-165

J

Janus-faced mask, 111

jazz, 65, 109, 152

Johnson, James Weldon, 163-164

K

Kafka, Franz, 116, 131

Kahlo, Frida, 13, 103, 113

Kaprow, Allan, 48, 98

Keller, Gary D., 14

Kentucky Derby, 86-87

Kienholz, Edward, 61, 62

Koch, Robert (Gallery), 49, 51, 52, 53, 57, 99

Kokoschka, Oskar, 56

Konjaku Monogatari, 123

KQED panel, 37, 40, 41

Kurosawa, Akira, 8, 123, 138, 142

Kuspit, Donald, 47, 48, 145

L

laser surgery, 90

Latin America, 12-16, 18, 39

Latin American cultures, 12-14

Latino and Latina Writers, 12

Legion of Honor, 62

Les Demoiselles d'Avignon, 96, 119

les enfants terribles, 53

Levinthal, David, 61, 72

Leviticus, 10

Lichtenstein, Roy, 77

liminal zone, 107-108, 110

linear tracings, 81

Lury, Celia, 112

Lyotard, Jean-Francois, 145

M

Made to Break: Technology and Obsolescence in America, 154

Madonna, 19, 114, 115

Mahler, Alma, 56

Manet, Édouard, 48, 144, 147, 149-151, 153, 155

Mannequin, 46, 54, 56-58, 71

Marcuse, Herbert, 99, 101, 102, 104, 50

Martin Luther King Middle School (Berkeley), 163

Masaccio, 84

mask, 3, 96, 110, 111, 119, 121, 145, 146

material culture, 55, 128, 146

Mayan, 14, 27, 29, 33-35, 42, 118

McGrath, Tom, 86

medical, 2, 6, 7, 44, 56, 63, 72, 90, 105

medicine, 52, 92, 93, 133, 134, 137, 138, 141

melting pot, 3

Memin Penguin, 37

Memory Garden, 163

Merleau-Ponty, Jean, 73, 75

Merzbau, 97

Mesa-Bains, Amalia, 164

Mesoamerica(n), 11, 13, 14, 18, 23, 24, 26, 27

mestizo, 13, 26, 35

Metamorphology, 6, 8, 105

Metamorphosis, The, 105, 116

metaphor, 16-18, 21, 22, 35, 73, 74, 132, 136, 138

Metered Growth, 158-159

Mexican, 10-16, 18, 19, 25, 26, 30, 31, 34, 35, 38, 42, 103

Mexican-American War, 25

Mexico, 7, 10, 12-16, 20, 25, 26, 28, 30-35, 39, 41, 42, 135, 140

Michelangelo's Sistine Chapel, 20

Mickey Mouse, 18, 20

milagros, 26

minotaur, 2

Mixtec, 33, 35

Modernism, 4, 73, 145-146

modernist, 146, 151-152

Monet, 18, 26-27, 84-85

Mossi, 120

multiverse, 72, 74, 76

Museo de America, 34

Muybridge, Eadweard, 84-85

N

NAFTA, 12

New York City, 6, 21, 24, 28, 48, 49, 63, 68, 98

New York Museum of Modern Art, 68

Nietzsche, Friedrich, 29, 132

Nigeria, 111

Night of the Living Dead, 103

Nike of Samathrace, 114

9/11, 10, 15, 22, 25, 51, 58, 63

9/11 series, 51

"Nip/Tuck", 106, 112

No Child Left Behind Act, 17

Norcal Visiting Artist Program, 156

NTSC standard, 87

Nude Descending the Staircase, 85, 114

Nuna, 119-120

Nuna Burkina Faso Sculpture with Scarification and the Body of a Euro-Saint-Étienner with Facio-Temporal Lumps, 120

O

O'Bryan, C. Jill, 118

ofrendas, 13

Ollman, Leah, 164

Olympia, 8, 144, 147-149, 151-153

Olympia Emerging, 147-149, 151

One Second at the Rijksmuseum, 76, 77, 79, 80

organ transplants, 2, 90

Orlan, 6, 8, 105-106, 113-122

Osirian myth, 164

Osiris, 164-165

Osiris, Myth of, 164

Ovid's *Metamorphosis*, 116

P

Palazzo Grassi Museum (Venice), 94

parallel micro-worlds, 4, 7, 44

Paris series, 51

Parkinson's disease, 2, 90

Past Joys, 49

Pastoral or Arcadian State Illegal Alien's Guide to Greater America, The, 42

Paz, Octavio, 37

petri dish, 7, 44, 72, 90, 98, 145, 155

phenomenological body, 118

Phenomenologie de la Perception, 73

Phoenix, 8, 154, 165

Phoenix Factor, 154

Photoshop, 87

Picasso, Pablo, 18, 94, 96, 97, 103, 119, 121, 145, 146, 152

piercings, 109, 113

Pierre et Gilles, 117

Pisarro, Camille, 155

Pleasures and Terrors of Domestic Comfort Show (NYMOMA), 48, 52

Popol-Vuh, 34

Portrait series, 51

post-Cortesian, 13

Post-Impressionism, 30, 96

Postmodernism, 50, 144, 145, 152

Poupée, 100

pre-Columbian, 7, 24, 33, 34, 37, 105, 118, 119

pre-Conquest Mesoamerica(n), 11, 22, 26-30, 34, 42

Promethean Creation Myth, 91

Prometheus, 7, 90, 91, 113

Proposition 187, 16

Proposition 209, 16

Proposition 227, 17

prosthetic, 90, 112

Prosthetic Culture, 112

Q

Quetzacotl, 2, 27

INDEX

Quick, Change That Channel, 63

R

Rabelais and His World, 105
Race, 79, 81, 84, 88
Rashomon, 8
Rashomon Factor, 8, 95, 122, 125, 142, 143
Readymades, 97, 155
Realism, 48, 94, 127
Recollection Series, 140
Red Shoe, 52, 53, 62
Redon, Odilon, 94
Relation{ships}, 139
Renaissance, 7, 70, 73, 74, 84, 94, 96, 102, 147
René Yáñez, 10, 95
Renoir, Pierre-Auguste, 145
retablos, 13
Reverse Anthropology, 24
Rites of Passage, 107-110
Road Art series, 50
Road to Aztlan, The, 33
Rouen Cathedral, 84
Rugley, Cousin Ickles, 164

S

Saint Orlan, 114-116
Saint Teresa of Âvila, 55, 114-116
Salon des Refusés, 5, 8, 153, 155-156
Salty Peanuts, 162
Samaras, Lucas, 137
Samsa, Gregor, 105, 116
Samson, 159-160
San Francisco,5, 6, 10, 38, 48, 49, 51-53, 57, 99, 128, 130, 156, 158, 158-163
San Francisco Arts Commission Gallery, 159, 162

San Francisco Bay Area, 5
San Jose Museum of Art, 129
Saramago, José, 67, 69, 156
scarification, 107, 108, 120
Schwitters, Kurt, 97
screenfold, 14
Séance, 7, 98-100, 102, 103
Seeing, 67, 69
Self-Hybridation Précolombienne series (Orlan), 105, 117, 118
Self-Hybridations Africaine series (Orlan), 118
Seth, 164
Shelly, Mary, 7, 90-93, 95, 116
Sickle Cell Anemia, 2
Simmons, Laurie, 49, 61, 72
Simulations, 70
6639, 163
Slade, Giles, 154-156
Sniff, 157
Southern California, 6
Spanglish, 15
Spassky, Boris, 80
Steinbeck, John, 66, 154
Stepford Wives, The, 56
Still Life With Chair Caning, 96
sub-Saharan societies, 107-110
Superman, 30, 35, 37
Surrealism, 94, 127
Surrealist, 94, 95, 97, 98, 102, 125-127
synchrony, 121

T

tattoos, 107, 109, 113
Tezcatlipocas, 27
The End of Art, 47, 145
The New Salon de Refuse, 5, 153, 155
The Subversive Imagination, 50

The Will to Power, 29

Third World Nations, 11

Thy Kingdom Come, 129

Thy Will be Done, 130

Titian, 147, 149, 150-151, 153

Topete, Luna, 5, 6, 8, 123, 127, 132-135, 143

Travels With Charley, 154

Tribute Money, 84

Trudeau, Gary, 61

TV raster, 88

U

Untitled (Road Map), 21

Untitled Figure Sculpture, 157

Urban Archeology (Ken Botto), 46, 50, 52, 63, 72

Urban Nightmare series, 50, 52, 59

V

vanita(s), 58, 100, 103, 129

Venus, 50, 147, 151

Venus Hotel series, 50

Venus of Urbino, 147, 151

video time, 77

Villeneuve, Pat, 14

Virgin of Guadalupe, 19

Vitalism, 91

W

Walker, Jessica, 8, 147-153

Ward, Kyle, 25

Warhol, Andy, 64, 158

We Never Talk Anymore, 132, 133, 136, 138, 139-142

West Coast, 98, 101

West-Duran, Alan, 12

Westerman, H. C., 62

Western culture, 4, 26, 28, 29, 68, 90, 91, 95, 108, 110, 111, 114, 116, 118

When Paradise Arrived, 18, 19

Whistler, James McNeil, 155

White Noise, 44, 67, 68, 72

Whittaker, Richard, 163

WMDs, 22, 23, 30

WW II, 20, 30, 52, 103

Y

Yerba Buena Gardens, 158

yuxtaposición, 14